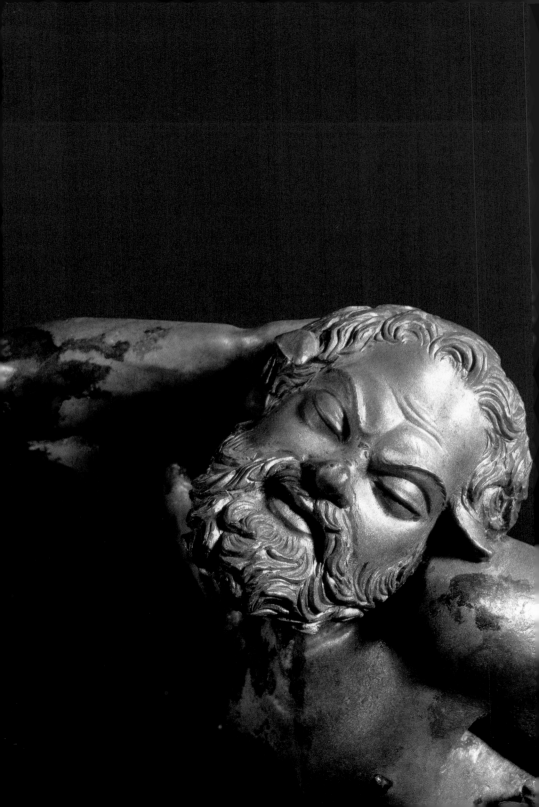

GUIDE

TO THE ARCHAEOLOGICAL
MUSEUM OF THESSALONIKE

KAPON EDITIONS

ISBN 960-7254-33-3

JULIA VOKOTOPOULOU
Director of the
Archaeological Museum of Thessalonike

GUIDE

TO THE ARCHAEOLOGICAL
MUSEUM OF THESSALONIKE

PROLOGUE

This Guide to the Archaeological Museum of Thessalonike is designed to meet a need long felt by visitors to it who wish to be well informed. The lack of any general guide to the Museum is due partly to the continual changes in the display of antiquities, resulting from the rapid increase over the last twenty years in the number of objects for exhibition.

The catalogues-guides published in the past were either devoted to particular sections of the exhibition or included only a selection of the masterpieces housed in the Museum.

The Guide to the Archaeological Museum of Thessalonike will, it is hoped, be of assistance to visitors who wish to form a general idea of the contents of the Archaeological Museum of Thessalonike, and a more detailed appreciation of the particular units within it, as they are guided by the book to the most important exhibits on display in each room, from showcase to showcase.

The Introduction to ancient Macedonia, and the brief surveys prefixing each individual unit are designed to set the objects on display in the historical context in which they came into being. It is also our belief that the rich illustrative material will help to keep alive in the visitor's mind the memory of the most impressive of the items in the Thessalonike Archaeological Museum.

<div style="text-align: right">

JULIA VOKOTOPOULOU
July 1995

</div>

Mount Olympos.

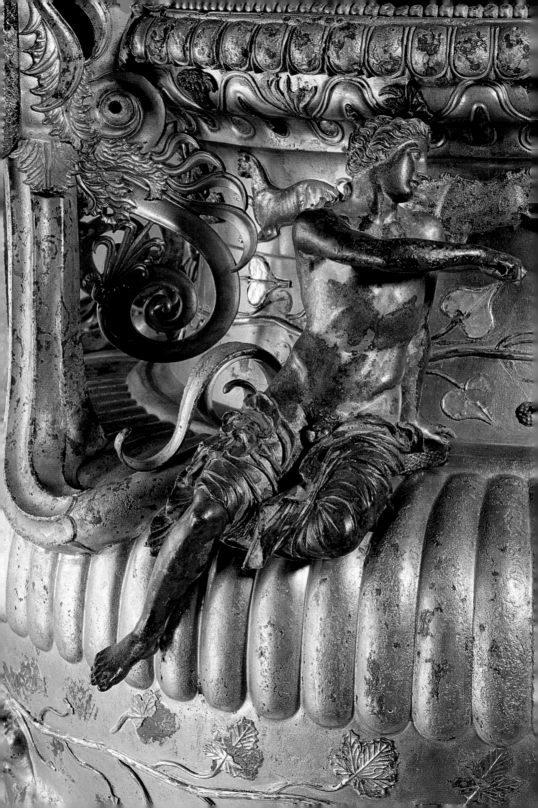

CONTENTS

INTRODUCTION TO ANCIENT MACEDONIA

The Macedonia of Philip II and his son, Alexander III, the Great, is no longer an unaccountable phenomenon of the 4th century BC – the rapid rise of a new power in the North at the expense of a weakened Greece in the South – as was asserted in historical handbooks until quite recently. Highly significant data yielded by archaeological excavations since the Second World War, and especially during the last twenty years, together with the scanty but pertinent information to be found in the ancient authors, have demonstrated that the acme of the 4th century represents the climax of a long historical process, the first roots of which go back to the second millennium BC. At this period, a number of different Greek tribes – Herodotus calls them *ethne* (races, or nations) – dwelt in the mountains of the Pindus range, and the written tradition has preserved several statements about the relations between these tribes and their migrations to neighbouring plains, or to the South.

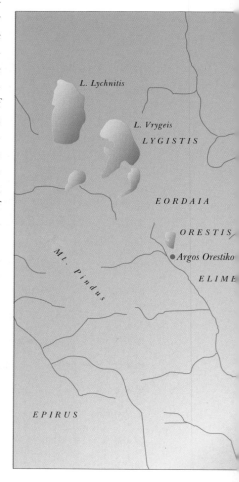

The Macedonians were one of these north-west Greek, or Dorian tribes. Hesiod (*Eoiai* Fr. 7,2) states

that the founding father of the tribe, Makedon, was brother of the Thessalian Magnes, both being the offspring of Zeus and Thyia and cousins of Doros, Xouthos and Aiolos, the children of Helen. Herodotus, the father of history (*Histories* I, 56) provides scholarly-ethnological support for the mythological tradition, stating that the 'much-travelled Greece *ethnos*', under a variety of different names, moved around central Greece and the mountains of Pindus, where it was called 'Makednon', before finally settling in the Peloponnese, where it was called 'Dorikon'.

Map of ancient Macedonia.

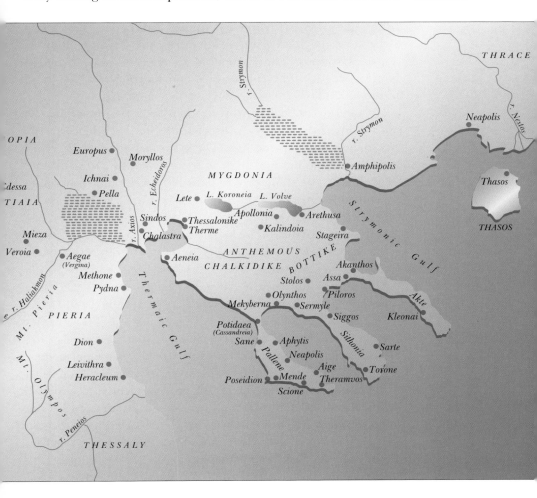

Elsewhere in his *Histories* (VIII, 43), Herodotus includes the Peloponnesians, Lacedaemonians, Corinthians, Sicyonians and Epidaurians in the 'Dorikon and Makednon *ethnos*'. Both Hesiod (end of the 8th-beginning of the 7th century) and Herodotus (5th century), two of the earliest and most important of the ancient Greek authors, thus leave no doubt in their works that the southern Greeks were aware that the Macedonians were a Greek *ethnos*, and belonged to the group of Dorian Greek tribes, along with the Dorians, Spartans, Corinthians, and Thessalians.

Macedonia was regarded as the cradle not only of Greek tribes, but also of the Greek Olympian pantheon. The ancient Greeks located the earthly residence of the Olympic gods on Mount Olympos. The Muses hid themselves away in neighbouring Pieria, and Orpheus died and was buried at Leivithra in the foothills of Olympos.

In the 5th and 4th centuries, when the rising power of the Macedonians constituted a threat to the independence of the city states, Athenian authors began to call them barbarians, partly out of political hostility, and partly because the Macedonian dialect was difficult for them to understand. It is quite clear from many other writers that it was a Greek dialect. Inscriptions incised on the bodies of pots are evidence that in mountainous Aiane in western Macedonia, ordinary people spoke and wrote Greek at the beginning of the 5th century BC. Greek votive inscriptions found in sanctuaries are dated to the 6th and 5th centuries BC. Inscriptions on grave stelai from Aiane and Vergina have added significantly to the list of Greek names known to have been in use in the 5th and 4th centuries BC. The names of Macedonian kings of the beginning of the 7th century are known, and they, too, are Greek proper names.

The Macedonian *ethnos* itself was divided into smaller groups with their own names, such as the Elimiotes, Orestai, Eordoi and so on, who lived scattered amongst the geographical units defined by the Pindus mountains. The north-east Pindus region was called Upper Macedonia, and Macedonia 'by the sea', the plains of Pieria and Emathia, was called Lower Macedonia.

From the end of the second millennium onwards, one of

these groups, the Argeadai Makedones, who perhaps came from Argos Orestikon (near Kastoria), dwelt in the foothills of Olympos – the 'Macedonian mountain' (Herodotus, *Histories* VII, 131), in Pieria and the plain to the south of the Haliakmon. The capital of their kingdom was Aegae, the modern Vergina. At this early period of Macedonian history, which coincides with the Early Iron Age (11th-8th centuries BC), there was much production of iron weapons and bronze jewellery. Their ties of kinship with the tribes of Upper Macedonia and Thessaly are attested by the Geometric matt-painted pottery, which is a continuation, without interruption, of the pottery tradition of the middle of the second millennium BC.

The Macedonian population swiftly increased, as is clear from the extensive cemeteries with Early Iron Age burial mounds. They were obliged by the lack of cultivable land and pasturage to migrate to the north-east, led by their kings. At the beginning of the 7th century, as they continued to expand across the Haliakmon, they drove the Bottiaeans from the area of the river Axios towards Chalkidike. By the 6th century, the Macedonians had reached the edge of Chalkidike. During this same period, Upper Macedonia attained a significantly advanced cultural level, and made a creative contribution to the unified Archaic culture brought to light by the excavations at Aiane, Vergina and Sindos. At this period, local gold-work and metallurgy reached a very high level of artistic and technical competence. The workshops of Chalkidike were outstanding in the sphere of pottery, creatively blending elements from the local Macedonian tradition with new decorative motifs and pottery shapes brought by the wealthy colonists from the Cyclades or the north-east Aegean.

The Persian Wars (late 6th-early 5th centuries BC) marked the beginning of a new epoch. Macedonia and Chalkidike were subjugated by the Persians, though king Alexander I lost no opportunity to supply valuable information to the Athenians, because, 'I myself, men of Athens, have been a Greek from ancient times, and I would not wish to see Greece enslaved, rather than free' (Herodotus, *Histories* IX, 45). At the end of the

Vergina.
The Royal Palace.

Persian Wars, the Macedonians extended their kingdom to the river Strymon.

The Macedonians indirectly played an important role during the Peloponnesian War (431-404 BC), since they owned huge tracts of forest, the timber from which was essential to the construction of the Athenian fleet. At the end of the 5th century BC, king Archelaos transferred the administrative seat of the kingdom to Pella. Archelaos was an important figure who built cities, opened roads, reorganized the army, developed close relations with the Athenians, and invited Euripides to Macedonia.

The pinnacle of Macedonia's power and influence was attained in the 4th century BC, under the rule of Philip II, who imposed Macedonian authority on the entire Greek world. Philip was murdered at Aegae in 336 BC, at the height of his

Pella.
Private house.

glory, and during the course of the preparations for his campaign in Asia. He was succeeded by his son, Alexander III, the Great, who immediately demonstrated his military and administrative abilities. He was given command of the campaign against Persia by the Greek city states. In 334 BC he crossed the Hellespont and three years later captured Persepolis. The objective of the campaign had been achieved, but Alexander continued his advance to India. He founded cities bearing his name in order to secure the trade routes, and form centres of the Macedonian administration. His death in 323 BC brought an end to his planned advance to Arabia.

The political acme of the 4th century was accompanied by a similar cultural flowering. The field of literature was dominated by the towering figure of the philosopher from Stageira, Aristotle. The names are also known of many Macedonian his-

torians, such as Amerias, Kallisthenes and others, though their works have not survived.

The cities of Macedonia in the 4th century reveal evidence of a high cultural level and standard of living. The ruins of Olynthos, Pella and Amphipolis demonstrate a knowledge of contemporary principles of town-planning with regard to the layout of the streets, which was on the Hippodamean system, and the drainage system; they also reveal the application of new theories in spacious residences adorned with wall-paintings.

The palaces at Aegae and Pella and the famous Macedonian tombs, the brilliant funerary structures erected by the Macedonians, are worthy monuments to the new conception of royal magnificence introduced by the Macedonian kings.

The vast number of monuments uncovered in recent years show that Macedonia played a pioneering role in the development of painting and the art of the mosaic. The

B 1

artistic trends of Hellenistic painting, which were inherited and further developed by Rome (at Pompeii and elsewhere), were formed in the Macedonian palaces and monumental tombs.

Matchless masterpieces, supreme creations of Greek art, were produced in miniature art, in gold-working and metallurgy in general.

The Hellenistic period conventionally begins with the death of Alexander the Great (323 BC), and continues even after Macedonia was finally subjugated by the Romans in 148 BC. Alexander's empire was divided into four great kingdoms: Macedonia, Pergamon, Syria and Egypt. The kingdom of Macedonia was an apple of discord between the successors, since it still controlled the political condition of Greece. On the model of Alexander, Cassander founded two new cities, Thessalonike (316/315 BC) and Cassandreia (315 BC), and his brother Alexarchos founded Ouranopolis in Chalkidike (315 BC).

Although the main centres of the arts and letters were transferred to the new kingdoms by Alexander's successors (Pergamon, Alexandria), the Macedonian cities, both old and new, engaged in significant activity in the fields of architecture, sculpture, painting and miniature art.

Pella was the major artistic and cultural centre. The large agora, the palaces and the vast private houses with their wall-paintings and mosaics provided work for large numbers of craftsmen and artists. Veroia, Thessalonike and Amphipolis were populous cities which were particularly active in the production of figurines and pottery, a tradition that continued down to Roman times.

The strong personality of Philip V, the last important king of Macedonia, was not enough to check the Romans. The defeat at Pydna (168 BC) led to the dissolution of the Macedonian kingdom, and from 148 BC Macedonia became a Roman province. The administrative capital was Thessalonike which, under Augustus (42 BC), was proclaimed a *civitas libera* (free city). It became the 'Metropolis of Macedonia' in the imperial period, since it was the largest city in Macedonia, with a flourishing economic and cultural life. The luxurious houses and public buildings were decorated with wall-paintings, mosaic floors and sculptures, especially portraits.

B 1

Even during the difficult times at the end of the Roman empire and the victory of Christianity, it is clear from the wonderful portraits surviving from the 4th and 5th centuries AD that artistic activity continued in the cities of Macedonia, especially Thessalonike. A new palace complex, including a triumphal arch, the Rotunda and the Hippodrome, was built in the city by Galerius at the beginning of the 4th century, and marks the transition from Antiquity to Christianity. During the centuries that followed, these monuments were associated with important historical events. The Rotunda and the Arch of Galerius are still today revered symbols of eternal Macedonia.

HISTORY OF THE MUSEUM

Fifty years of unremitting effort were needed before the antiquities of Thessalonike were housed in a building of their own. Georgios Ikonomos, the first Ephor of Antiquities 'at the General Administration of Macedonia', took up his duties on 9th November 1912, fifteen days before the Greek army entered Thessalonike. His earliest papers indicate that under the Ottoman administration there was an Archaeological Collection in the garden and the courtyards of the Idadie School (now the building of the Philosophical School of Thessalonike University). The bulkier of the sculptures and inscriptions remained where they were, while new acquisitions were housed either in the Administrative Building, the home of the offices of the Ephorate, or in the church of Ayia Paraskevi (known as the Acheiropiitos), which was repaired in 1916 in order to be used as a Museum. There is no positive evidence that Ayia Paraskevi was ever actually used as a Museum – as opposed to a storehouse for antiquities – but what is certain is that in 1922 it was ordained that 'the Holy Church be dedicated to worship, and the archaeological Museum be housed elsewhere'.

In 1925 the Yeni Mosque was transferred to the Ephorate of Antiquities to be used as a Museum of Antiquities. The first permanent exhibition of ancient objects was held there, and an entrance fee of 10 drachmas was instituted in 1931. On the declaration of War in 1940, the sculptures were buried in deep trenches, where they remained until after the end of the Second World War, until 1951. In 1952-53, they were put on display again, in the same building, by Charalambos Makaronas, with Manolis Andronikos, a young Curator of Antiquities, as his chief assistant.

There was insufficient space available in the Yeni Mosque. Correspondence on the question of finding a plot of land on which to erect an Archaeological Museum began in 1924, and was brought to a conclusion in 1949 with the purchase of a plot of 12 *stremmata* (3 acres) opposite the YMCA building.

Work on the construction of the new Museum began in February 1961, to designs by the architect Patroklos Karantinos, and the building was inaugurated on 27th October 1962, during the celebrations of the fiftieth anniversary of the liberation of Thessalonike. In 1971, the displays were brought to completion in all the rooms. They included sculpture, a prehistoric collection, miniature art of the Archaic and Classical periods, and the brilliant group of finds from the tombs at Derveni, which was first presented to the public on the day of the inauguration ceremony. A few years later, in 1978, the astonishing discoveries at Vergina led to the first changes in the display: finds from the royal tombs were exhibited in the rooms housing the prehistoric collection and miniature art, as part of the exhibition 'Treasures of Ancient Macedonia'.

The treasures from Vergina, and other precious discoveries of the '70s, made the construction of an extension to the Museum inevitable: the New Wing was inaugurated in July 1980 with the exhibition 'Alexander the Great'. This same year saw the beginning of the excavation of the cemetery at Sindos, with its rich finds of gold, and the 'Sindos' exhibition was opened to the public in October 1982.

There followed in 1984 a repeat of the exhibition of finds from Vergina and Derveni, in 1985 an exhibition on ancient Thessalonike, and in 1989 an exhibition of new finds dating from the Archaic and Classical periods on the ground floor of the New Wing.

No other Museum in Greece has had to deal with as rapid an increase in the number of exhibits as that faced by the Thessalonike Museum in the last twenty years. This has resulted in frequent changes and additions to the original display of 1971, and in the partial violation of the chronological organization of exhibits. The exhibition of sculpture has been retained, with only minor changes, from the 1971 presentation.

B 1

GUIDE FOR VISITORS

The visitor to the Museum may visit particular exhibitions (Vergina, Thessalonike, Sindos), depending on the amount of time at his disposal. Anyone wishing to gain a picture of the cultural evolution of central Macedonia through time should begin on the ground floor of the New Wing, where objects from the prehistoric (room 11), Archaic and Classical periods are exhibited temporarily (rooms 10), and then return to the ante-

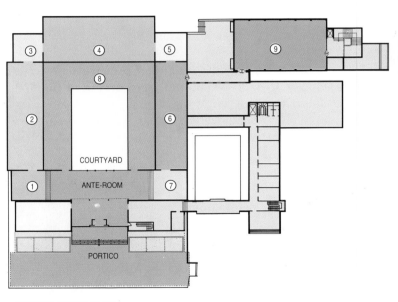

GROUND-FLOOR PLAN

GROUND-FLOOR PLAN
(NEW WING)

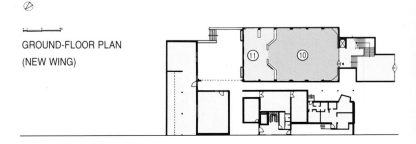

room of the old building, in order to commence in room 1 with the sculpture collection (rooms 1-3, 5,6); this is organized in chronological groups dating from the 6th century BC to the 5th century AD, and includes the Thessalonike room (no. 4), which is also organized chronologically. The visitor may then proceed to the Sindos room (no. 8), with exhibits dating from the 6th and 5th centuries BC, and end with the Macedonian tombs (room 7) and the masterpieces of metal-working in the Vergina and Derveni room (no. 9).

PORTICO - ANTE-ROOM

TICKET OFFICE - SHOP

TEMPORARY EXHIBITIONS ROOM

ROOM 1 Temple 'of Therme'

ROOM 2 Sculpture Exhibition

ROOM 3 Sculpture Exhibition

ROOM 4 Thessalonike Exhibition

ROOM 5 Sculpture Exhibition

ROOM 6 Sculpture Exhibition

ROOM 7 The Macedonian Tombs

ROOM 8 Sindos Exhibition

ROOM 9 Vergina and Derveni Exhibition

ROOM 10 Archaic and Early Classical Periods

ROOM 11 Prehistoric Collection

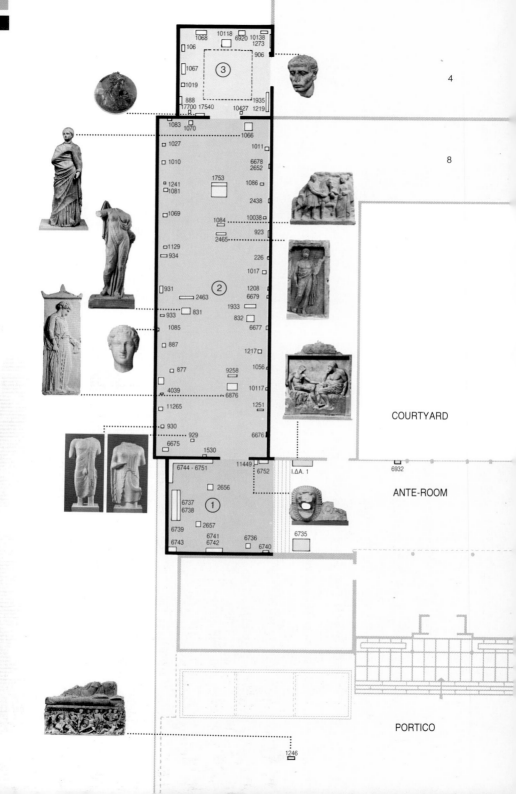

4

8

1068　10118　10138
6920　1273
106
1067
906
1019
3
888　17700　17540　1935　10427　1219
1083　1070
1066
1027　1011
1010　6678　2652
1241　1081　1753　1086
2438
1069　1084　10038
923
2465
1129　226
934
1017
931　1208
2463　6679
2　1933
933　831　832
1085　6677
887　1217
877　9258　1056
4039　6876　10117
11265　1251
930　6676
929
6675
1530
6744 - 6751　11449
6752　I.ΔΑ. 1
2656

6932

COURTYARD

ANTE-ROOM

6737
6738
1
6739
2657
6741
6742　6736
6743　6740
6735

PORTICO

1246

PORTICO - ANTE-ROOM Sculpture Exhibition

The portico in front of the entrance to the Museum houses two marble sarcophagi from Thessalonike. Their lids are in the form of a mattress, on which the dead couple are at rest. The sarcophagus to the left of the entrance (1246)* has a multi-figural scene of an Amazonomachy on all four sides. The sides of the one to the right of the entrance (283) have a variety of different subjects: the battle scene on the front showing warriors disembarking from boats is continued on one of the ends. The opposite end has a representation of Orpheus enchanting goats and wild animals with his kithara. On the back is a scene from mythology – the hunting of the Calydonian boar. These monumental sarcophagi are the products of Attic workshops of the 2nd and 3rd centuries AD. The heads of the couple at rest, and of the main figure in the scene on the front were left half-finished, so that they could be worked into portraits of the deceased, by the addition of their personal features, after the sarcophagus was sold.

1246

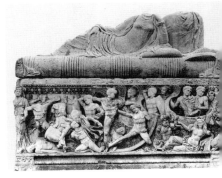

* The numbers accompanying the exhibits are the Museum Inventory numbers.

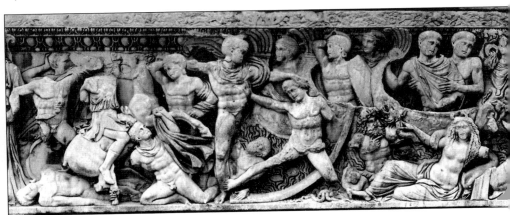

The wide ante-room of the Museum, to the left of the entrance to the Sindos room, has a recent (November 1991) acquisition on temporary display: the grave stele of Agenor (I.ΔA.1), from Ierissos in Chalkidike (ancient Akanthos). The stele is of imposing height (2.06 m high, 1.65 m wide) and made of Thasian marble. It depicts two male figures. At the left is a naked youth, sitting listlessly on a rock. The tips of the fingers of his left hand are touching the mature man opposite him, who gazes at the youth in grief, with his head resting in his right hand. The fact that the head of the youth is missing is of some importance, since it was the central point of reference of the composition. Nonetheless, the complete abandon indicated in the posture of his body, and the way the bearded man turns towards him leave no doubt that the youth was the dead person honoured. His name is carved in official letters of the 5th century BC on the left border of the relief, reading from right to left: Ἀγήνορος [τόδε σῆμα] (This is the tomb of Agenor). In the background of the relief, between the two figures, is carved the name of the mature man, Ἀγλωνίκης (Aglonikis), in plainer 4th century letters; he was probably buried in the same tomb several years after the death of the youth.

I.ΔA. 1

The pedimental finial of the stele is dominated by the imposing figure of a lion. With the frugal means permitted by the low relief, the sculptor has produced an image of the beast crushed by grief which has a striking power and expressiveness. The lion was the emblem on the coins of Akanthos in the 5th century BC, and its appearance on the crowning member of the stele, together with the unusual size and quality of this grave stone, suggests that Agenor came from one of the ruling families of Akanthos at the end of the 5th century BC.

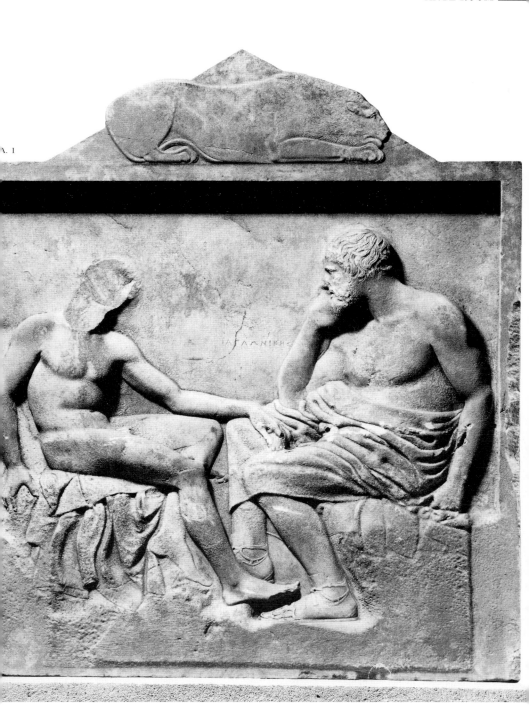

A. 1

ROOM 1 Temple 'of Therme'

The Ionic capitals, parts of columns and bases, and the many fragments of cornices and thresholds carved with Lesbian and Ionic mouldings exhibited in Room 1 were found lying scattered to the west of the Ancient Agora of Thessalonike. They belonged to a large Ionic temple of the end of the 6th century BC, the foundations of which have not yet been discovered, but which is reckon-

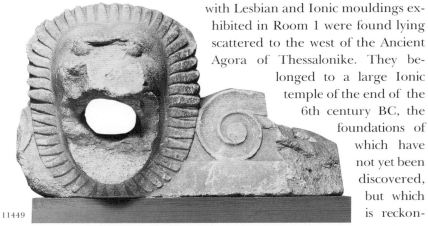

11449

6737

2656

ed to be in the area of Krystalli and Diikitir-
iou Streets. To the same temple belongs a
section of a marble gargoyle with a lion's
head spout (11449). The relief head of a
youth (1530) at the beginning of the next
room 2, possibly comes from the sculp-
tural decoration of the temple.

This temple is usually known as
'the Archaic temple of Therme',
since it has been connected with an-
cient Therme, the city that occupied
the head of the Thermaic Gulf prior
to the founding of Thessalonike.
Some researchers believe, on the basis
of traces of second use, that the temple
was moved and rebuilt in Thessalonike
several centuries after its original construction
at some unknown place.

1530

ROOM 2 Sculpture Exhibition

Room 2 marks the beginning of the chronologically organized section of the sculpture exhibition.

Two Archaic statues from the collection of the Society of Redestos in East Thrace, which were brought to Thessalonike in 1922, date from the end of the 6th century: the torso 930 from Redestos, a rare example of a kouros dressed in an oblique Ionian himation, and the torso of a kore (929) from Vizye: she wears a chiton with rich drapery and an oblique himation over it.

930 929

The monumental marble phallus 6675 is also from the Archaic period; this was found in second use in a burial near the mouth of the Strymon, and will originally have belonged to a structure connected with the cult of Dionysos.

Two fragmentary reliefs from Thessalonike are important works for our knowledge of local 5th century BC sculpture in the region of ancient Therme: the grave stone 11265 depicting a girl with her hair bound with a kerchief (kekryphalos), whose gaze and arm are directed upwards, is a work of around 440 BC, influenced by Thessalian models; and the stele crowned with volutes from Oreokastro (9258), carved with the relief head of a youth, is a work of around 430-420 BC influenced by the Aegean islands.

The superb stele from Nea Kallikratia (6876) is clearly a Parian work: the grave stone of a young girl, which was made about 440 BC by a Parian sculptor, it is a work from the height of the Classical period by an artist who was the equal of those who carved the sculptures for the Parthenon frieze. The dead girl wears a Dorian peplos, open at the sides, and holds a dove, an iconographic motif known from other funerary stelai of the 5th century BC.

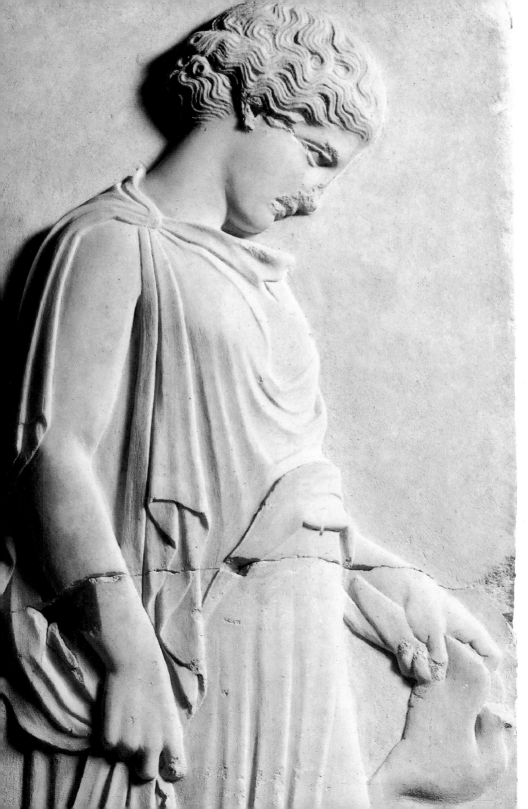

The fragmentary grave stele from Komotini (1251) dates from a decade earlier: on it is depicted a young maidservant offering a mirror to the seated dead woman. Ionian-island work about 450 BC.

We are transported to the end of the 5th century by two finds from Olynthos, the seat of the Chalkidian League (an alliance of the cities on Chalkidike). After 432, when its population was increased as a result of a *synoecism* (merger) with a number of neighbouring towns, Olynthos evolved considerably until 348 BC, the year in which it was destroyed by Philip II. The clay protome of a goddess (6677) hung on the wall of a house in the south Hill of Olynthos. It possibly depicts Demeter, and exhibits its stylistic affinities with works of plastic art from Sicily. The marble head of a youth or a god, wearing a ribbon diadem (1085) is one of the rare original works of sculpture surviving from the 5th century.

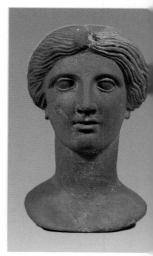

6

1085

Also from the end of the 5th century is the fragment of the grave stele of Theognetos, son of Peiraios, from the Kassandra peninsula in Chalkidike (2463). Only the head of the young man survives, and in it the island tradition is overshadowed by the Classical Attic ethos of the 5th century BC.

During the Roman period, Thessalonike preserved a number of good copies of 5th century sculptures, such as the fragments of an acrolithic statue of Athena, in the type of the Medici Athena (877), dating from the beginning of the 3rd century AD, in which the facial features are those of the empress Julia Domna.

This is followed by another three heads (1217, 1056, 887), also modelled on works by Pheidias; the small head 10117, in the Aspasia type, is a copy of a bronze original of the Early Classical period, which is attributed by some scholars to the sculptor Kalamis.

The exceptionally high quality copy (831) of Aphrodite unveiling herself, in the so-called *Fréjus* type, is a very im-

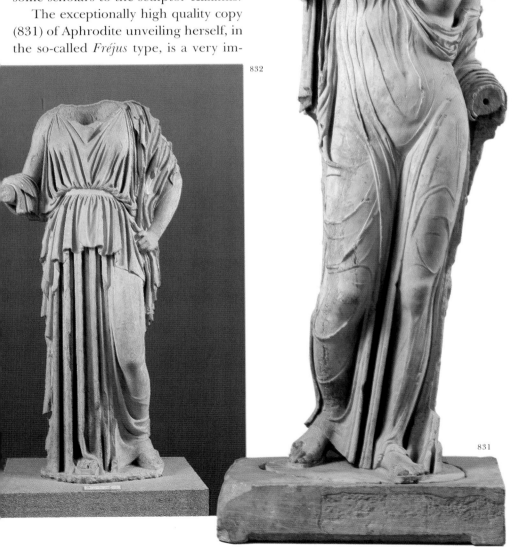

832

831

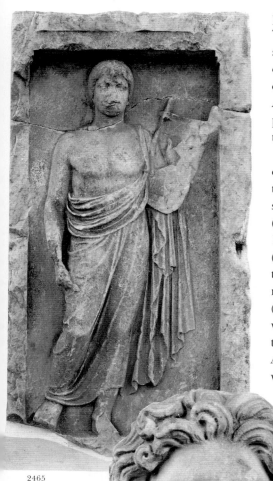

2465

1017

portant work. It is from the Sarapeion in Thessalonike, and Manolis Andronikos suggested that the original should be dated to before 421/420 BC. It is probably a copy of the Aphrodite of the Gardens by Alkamenes. Also from the Sarapeion is the peplos statue 832, a work of the 2nd century AD based on a 5th century model.

The following group consists of works dating from the 4th century BC, centring on the Vergina stele (1933) and the stele of the lyre-player from Potidaea (2465). The former was discovered in 1948 on the surface of Megali Toumba (Great Tumulus) at Vergina which, thirty years later, proved to be the funerary mound above the royal tomb of Philip II (see room 9). Other pieces of the stele were discovered in the modern excavation, and it has a restored palmette finial. A standing man greets the dead woman, who is seated on a throne, with a handshake; there is a small child between them, and another behind the man. At the top left is part of a metric inscription, in which no name is recorded. The stele is the work of a Macedonian craftsman, with clear Attic and Ionian influence, dating from about 350 BC.

The Potidaea grave stele (2465) which is dated about 380 BC, has a frontal depiction of a youth wearing a himation. He holds the lyre in his left hand and has the plectrum in his right, ready to interpret the divine music for eternity.

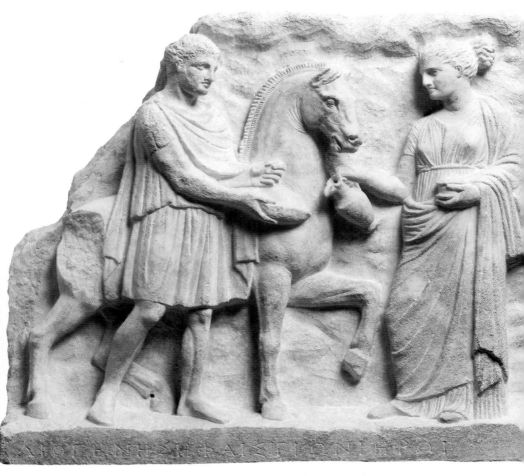

On the left side of the room are three reliefs dating from the 4th century BC, from the Redestos Collection (931, 933, 934). On the right wall is a fine head of Asklepios (1017), from the Sarapeion in Thessalonike, dating from the 2nd century BC, flanked by votive reliefs (923, 1208), a small altar (6679) and a headless statuette (226), all of them connected with the cult of the god of medicine.

Behind the stele of the lyre-player is displayed a unique votive relief from Pella (1084), dedicated by one Diogenes to Hephaistion, the heroized bosom companion of Alexander the

Great. Hephaistion is portrayed riding upon a horse, as heroes often were in Macedonia, at the point when he is appearing to his trusty friend Diogenes. The stele is dated to the end of the 4th century BC, a few years after the cult of Hephaistion was established by Alexander himself. That this is a scene of the epiphany of the hero is also indicated by the symbolical offering of a libation, with the aid of the young girl who is welcoming him.

The rest of room 2 is devoted mainly to sculptures from the Sanctuary of Demeter and Kore in the region of ancient Lete (Derveni near Thessalonike). In the centre is a marble offering table (1753) from the 3rd century BC, which was dedicated to Demeter by Stratto, daughter of Nikostratos, Melis, daughter of Kleon, and Lysidika, daughter of Antigonos, in the year when Berenika was priestess of the goddess. The headless statues of

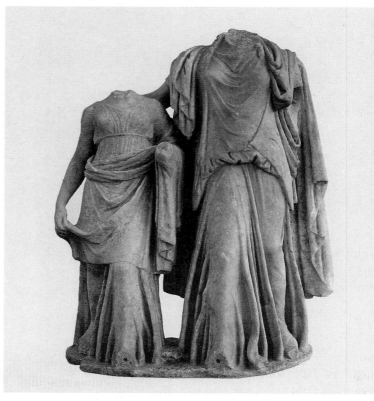

1070

female figures 1129, 1069, 1081 are also
from this sanctuary, as is 1083, of unknown
provenance, and the huge statue 1066 in the
type of the 'Small Herculaneum Goddess',
which has the facial features of the
woman who made the dedication.
They all date from the Hellenistic
period, as does the group of De-
meter and Kore shown in head-
long movement (1070).

The two female heads 1010
and 1027, which were fixed
onto the bodies of statues, are
probably from Thessalonike; the
heads on the opposite wall, 1011
and 10038, which were also fixed
onto bodies, are from the Ancient
Agora of Thessalonike and are
copies of a Peloponnesian original
of the 4th century BC known as
the Artemis Colonna.

The display in this room is com-
pleted by the painted grave stele
of Sosikrates from Istiaea (2438),
which comes from the eastern ce-
metery of ancient Thessalonike;
the 4th century BC relief from
Potidaea (1086) with a sympo-
sium scene (of a funerary ban-
quet) in which two men on cou-
ches drink wine served to them
from a kalyx krater by a young
servant; two heads of Helle-
nistic statues (2652,
6678); and a small
head of Isis from
Potidaea (1241).

1066

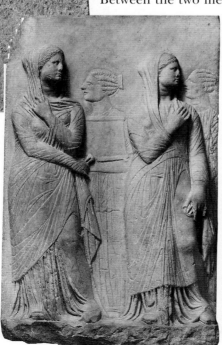

ROOM 3 Sculpture Exhibition

In room 3 are displayed works from the Late Hellenistic and Early Roman periods (2nd-1st centuries BC). After the entrance we encounter, on the right, a female head (10427) from the private Papailiakis Collection, which was donated to the Museum. A votive relief (1219) from Kalamaria is worked in the shape of an Ionic temple containing a portrait of Artemis in the type of the Huntress. This is followed by two relief slabs from an imposing funerary monument from Lete (1935). The two women on the first slab are turned to the right, as is the first of the two men on the second slab; the second male figure is depicted frontally. Between the two men is a boy servant and the bust of

6920

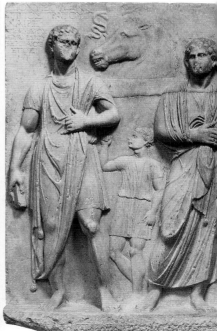

1935

1935

a horse, which is either an indication of some special skill enjoyed by the dead man, or a chthonic element, relating to the underworld like the snake next to it. A carved inscription indicates that the dead man is Dionysophon, son of Hippostratos, and the sculptor who made the relief Euandros, son of Euandros, from Veroia.

In this same room are displayed two other reliefs from Veroia, where there was a flowering of sculpture in the Hellenistic period: 1067 and 1068, depicting frontal male figures wearing himatia and holding scrolls in their right hands.

The head 906 is a portrait from a funerary relief of the 1st century BC from Thessalonike strongly influenced by naturalistic portraiture in the style of the Roman period. The rectangular relief from Thessalonike next to it (1273) depicts the dead woman Berenike seated, with three women standing in front of her. Contemporary with it is the grave stele of Gaius Popilius, a Roman citizen of Thessalonike, which has a bilingual inscription in Greek and Latin, while the stele of Phila, daughter of Demetrios, with a palmette finial (6920), is earlier (3rd-2nd centuries BC), and comes from the city of Kalindoia (Kalamoto near Zangliveri). In this same city was found the relief 106, dedicated to Apollo and Artemis and depicting the two gods in front of a temple.

The headless statue of a man wearing a himation (10118) displayed in the centre of the room, is a very good example of representational sculpture at Thessalonike in the Late Hellenistic period, and the larger than life-size head of a god (1019), probably Poseidon, is a superb masterpiece of unknown provenance.

906

The relief of the hero Hippalkmos (888), from Thessalonike, dates from the first half of the 2nd century BC. The hero is portrayed on horseback, like the other named and anonymous heroes of the Hellenistic and Roman periods.

The bronze fittings of a wooden chariot, a unique masterpiece of bronze sculpture from Late Hellenistic Thessalonike, are a new find from the same period. They consist of a circular medallion with a relief protome of Athena (17540) (diameter: 0.27 m) from the front of the chariot, and four cast animal's heads (two dogs and two panthers), which probably protected the wooden ends of the pole and the yokes. In place of a helmet, Athena wears the humanized mask of Medusa, and has her head turned slightly up and to the rear. The piece was found during the excavation of Iroon Square opposite the area in which the sanctuaries of Hellenistic and Roman Thessalonike are located.

The female head 17700, possibly of a goddes which was also found in Diikitiriou Square, belongs to the Late Hellenistic period.

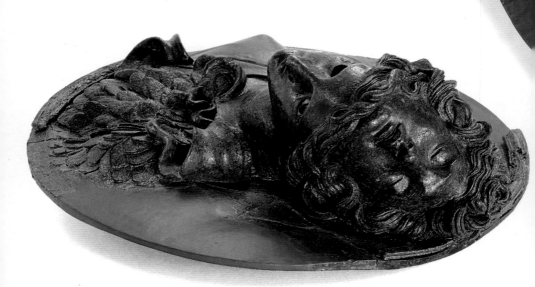

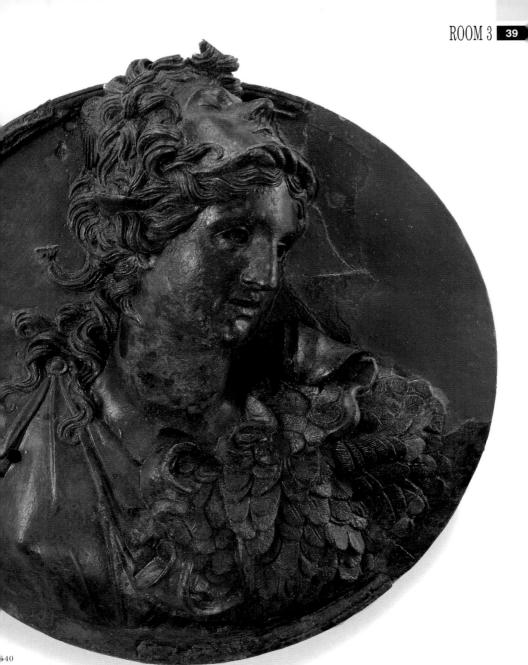

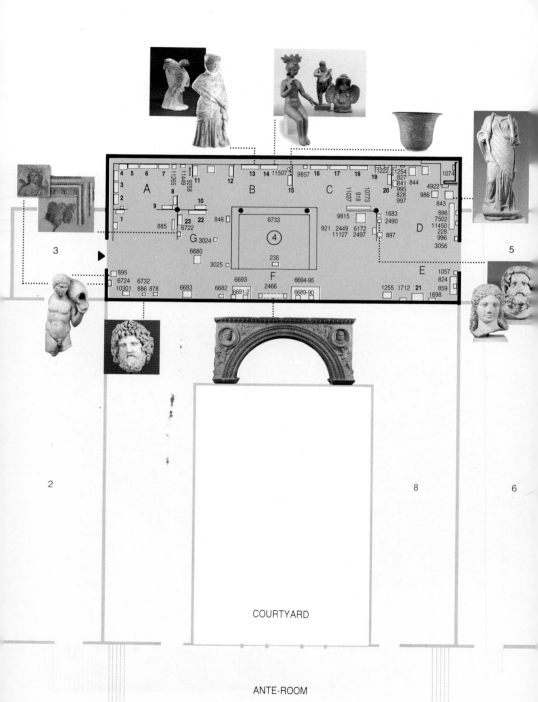

4 **5** **6** **7** 11265 11449 9258 **11** **12** **13** **14** 11507 9857 **16** **17** **18** **19** 11222 1254 827 841 995 828 997 844 4922 986 1074

3 **A** **8** **B** **15** **C** 11037 918 10773 20 843

2 **9** **10** 9815 896 7502 11450 228 996 3056

1 **23** **22** 846 6733 921 2449 6172 11127 2497 1683 2490 897 **D**

885 6722 **G** 3024

6680 236

3025 **F**

895 **E** 1057 824 859 1698

6724 886 878 6683 6682 6693 6694-95 1255 1712 **21**

10301 6732 6691-2 2466 6689-90

COURTYARD

ANTE-ROOM

3 5

2 8 6

1 7

ROOM 4 Thessalonike Exhibition

As part of the celebrations of the 2,300th anniversary of the foundation of Thessalonike, an exhibition was organized in 1985 on the theme of the archaeology of the city from the prehistoric period to Christian times. This exhibition was housed in room 4 and included the sculptures and mosaics from the city of Thessalonike that were already on exhibition there.

Thessalonike was founded in 315 BC by king Cassander, who named it after his wife, the daughter of Philip II and sister of Alexander the Great. The emblem used for the exhibition was the inscribed base of a statue of Thessalonike (885) dating from the 2nd century AD, which was found in the area of the Ancient Agora and formed part of a group of statues of the family of Alexander the Great.

885

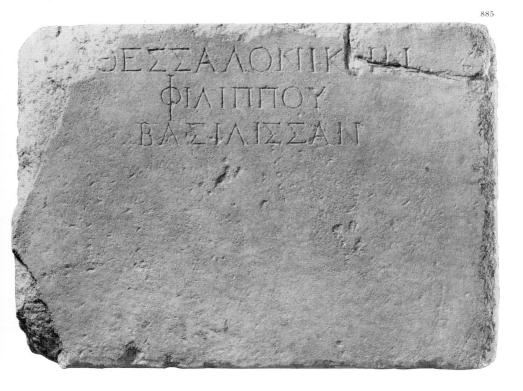

AREA A Therme

The foundation of the new city was achieved by the compulsory *synoecism* (merger) of 26 townships on the Thermaic Gulf, amongst which was Therme, the most important city before Thessalonike. Finds from two of these townships, which are the most likely candidates for identification with ancient Therme – the tumuli at Karambournaki and Toumba – are presented in Area A of the exhibition, along with those from a third, the Gona tumulus near the airport.

The imported pottery of the Mycenaean and Geometric periods is evidence of direct contact between the coastal cities on the Thermaic Gulf and southern Greece, which became more frequent in the Archaic and Classical periods. Local jewellery of precious metals is quite common in burials, in which choice clay pottery from Ionia, Corinth and Attica, and glass perfume vases from Phoenicia are also found; the local pottery is found in great quantities in every period.

Case 1. The map of the inner Thermaic Gulf shows the tumuli (mounds of earth created by the ruins of successive mudbrick houses) of the settlements that existed before the *synoecism* of Thessalonike. Next to it are displayed examples of the local Bronze Age pottery and a Mycenaean cup (Π 601) from Gona tumulus, dating from the 13th century BC. The local pottery is handmade, with a shiny surface and often with incised designs, or with matt-painted decoration (Π 785).

Cases 2-4 contain the finds from the tumulus at Karambournaki near Thessalonike. An aerial photograph from 1917 and a model based on the topographical survey made by L. Rey show the form of the settlement during the First World War. The naturally strong, coastal site occupied by the settlement, and the two natural harbours it provided for ships, taken together with the literary sources, suggest that Karambournaki may be the site of Halia Therme (coastal Therme).

Case 2. Pottery from the tumulus at Karambournaki dating from the Late Bronze Age (2nd millennium BC) and the Early Iron Age, down to the beginning of the 7th century BC. At the bottom left are bobbins, spindlewhorls, perforated plaques and clay vessels of the Bronze Age. Many of the sherds of Early Iron Age pottery are decorated, like the amphora 10131, with concentric semi-circles or circles, a motif commonly found throughout Greece. The panel in the centre of the case shows sherds from Ionian 'bird kylikes' from the end of the 8th-beginning of the 7th centuries BC.

Case 3. Finds from Karambournaki. The black-figure krater 2927 belongs to the circle of the Lydos painter, and perhaps came from a workshop in Chalkidike in the third quarter of the 6th century BC, which produced many vases in this same shape, with scenes of goats and aquatic birds. On the bottom of the case are three miniature Corinthian vases, part of an Ionian plate with a guilloche and a sherd from a Corinthian krater with a representation of a sphinx (10226). The reddish kylix T 177 in the middle is a typical example of the local monochrome pottery of the Archaic period. The fragment of an Attic amphora (2883) depicts a Satyr and a Maenad.

The bronze hydria 5243, from the second half of the 5th century BC, has an inscription on the rim – Ἀθηναῖοι ἆθλα (ἐ)πὶ τοῖς ἐμ τõι πολέμõι– indicating that it was a prize in athletic games held in honour of those fallen in war. The games in question were the Epitaphia, which took place in the Academy at Athens in the Classical period, in honour of the dead heroes of the Persian Wars.

10226

343-344 384

Case 4 contains finds from the 6th and 5th centuries cemetery that extended around the tumulus at Karambournaki: gold mouthpieces, used to seal the mouths of the dead, like those found in the tombs at Sindos (room 8), 5th century Attic vases, the base of a cup incised with the name of Pyrrhos (T 291). Corinthian spherical aryballoi and exaleiptra, containers of aromatic oil were indispensable to the dead person. The clay model of a lotus flower (3536) was found, along with the Corinthian exaleiptron 9831, the Attic lamp 9830, and the silver double pin 7476, in a tomb dating from the end of the 6th century BC.

In *cases 5-7* are displayed finds from the large tumulus called Toumba in Thessalonike, an aerial photograph and model of which are displayed to the left of case 5. Toumba is a conical hill, 23 m high, formed from ancient deposits dating from the end of the Neolithic period (the lowest deposits) to the Iron Age (surface deposits); it rises at the edge of a natural plateau, over which the settlement spread in the Archaic and Classical periods. The ancient township at Toumba is the closest to the site on which Thessalonike was founded, and is more likely than any of the other sites to be identified with Therme.

Case 5 contains vases and spindlewhorls from the Late Bronze Age. The kantharos (H 455), with matt-painted decora-

340 362 375

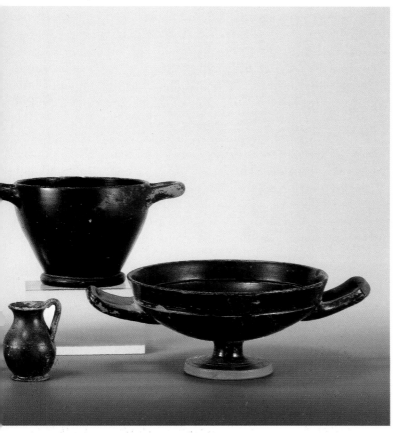

tion, is a typical example of the local pottery of central and
western Macedonia from the 15th to the 7th centuries BC. The
cups with pendent concentric semi-circles (5710), and the
handmade kyathos 11304 with high-flung handle are dated to
the Early Iron Age (beginning of the 1st millennium BC).

Cases 6-7 contain finds from the cemetery dating from the
6th-4th centuries BC excavated in 1918 to the north-east of
Toumba. An unknown number of cist graves yielded vast num-
bers of discoveries attesting to the wealth of the town and its
highly developed commercial relations with other Greek cities.

Case 6. In the centre of this case are pieces of gold and sil-

ver jewellery, lozenge-shaped mouthpieces that covered the mouth of the dead person and rectangular gold strips that adorned the dress. The ribbon diadem with rosettes (751) possibly comes from a child burial. Of the two pairs of earrings, 752 is the finer, with its exquisite filigree technique. Other silver objects include the bow fibula 722, the earrings 724 and the bracelets 755.

The black-glaze Attic cup 4296 at the bottom right was found in the same tomb as the four gold mouthpieces and the Corinthian aryballos 3407.

In the centre is a Corinthian perfume vase in the form of a hedgehog (407). Amongst the Ionian vases – such as the kylikes 373, 374 – and the many Corinthian vases (402-404) in this case may be distinguished three local monochrome pots, the two ky-

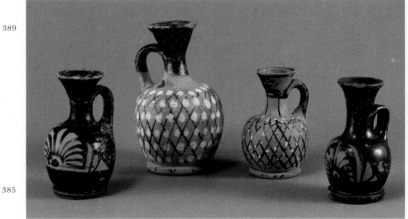

389

385

38

38

likes 324, 325, and the exaleiptron 330, which imitates a Corinthian model. The two glass perfume vases 408, 409, of Phoenician type, are possibly the products of Greek workshops.

Case 7 contains mainly Attic vases from the 5th and 4th century BC tombs of Toumba. The small pitcher 382 is a local product, as is the protome of Aphrodite 685, with white slip and painted eyes, which dates from the 4th century BC.

At the right of case 7, below the cast of the lion's head waterspout 11449 from the Late Archaic temple at Therme dating

from the Late Archaic period, are displayed casts of pillar 11265 and stele 9258, as examples of the local 5th century carving (the originals are on display in room 2).

Case 8 contains mainly finds from a burial in Kotyoron Street, Kalamaria, near Thessalonike, dating from 430-420 BC. A bronze situla and a small bronze cup (7477, 7478) were found together with the black-glaze fluted lekythos 7480, the small lekythos 7449 and the iron sword 7462. The red-figure pelike 11572 with the busts of an Amazon, a horse and a griffin, is an Attic work from 340-330 BC, found near the Macedonian tomb near the Maieuterion (Maternity Hospital).

Case 9. All the objects in this case come from a cist grave near the Alatini factory, and are roughly contemporary with the finds from Vergina (350-325 BC).

11605

The gilded clay plaques 5201, 5202 with griffins tearing at horses probably adorned a clay bier. The necklace 5222 is made of gilded wooden beads. A glass alabastron, three Attic lamps, two Attic red-figure vases (bell krater 5206 and lekythos 5207 showing Eros flying towards a seated woman), and two bronze vases (the beaked jug of Italian type 5196 and the round ewer 5158) were all part of the grave offerings accompanying a not particularly rich grave from the period of Philip and Alexander.

AREA B Hellenistic Thessalonike

This area of the exhibition is devoted to Hellenistic Thessalonike, the city of Cassander.

The city founded by Cassander in 315 BC by the compulsory *synoecism* (merger) of 26 townships, lies at the centre of modern Thessalonike, between Tsimiski Street and Kassandrou Street. There are very few remains of buildings, which were destroyed by the buildings of the Roman period. One of the sanctuaries in the city, the Sarapeion, flourished from the 3rd century BC.

Case 10 contains typical examples of Hellenistic pottery from the lower levels of the building sites in Thessalonike, dating from the end of the 4th to the beginning of the 2nd centuries BC. The large black-glaze plate 9974 was discovered in a building plot in Philippou Street. The boss of another large plate 9967 has a relief depiction of a young Eros riding on a dolphin. The lamps 9959, 9960 have two nozzles, and the vertical lug with the suspension hole is preserved.

To the bottom right is the bone die 9958, used for games of chance. In the centre are typical examples of Hellenistic pottery with relief decoration and painted or incised floral or geometrical designs; this type of vase is known as 'West Slope Pottery' after the West Slope of the Acropolis in Athens, where it was found in large quantities.

We learn more about Early Thessalonike from the tombs of this period. They are not particularly wealthy, but the six Macedonian tombs discovered so far around the city certainly attest to the existence of a social class of some economic well-being. These tombs are small, and consist only of a single chamber. When they were found, they had been plundered of their valuable grave offerings, though clay vases and figurines had survived.

Case 11, next to the model of the Macedonian tomb from the area of Charilaou, the vault of which was made of columns taken from another building, contains the finds from inside this tomb (250-200 BC). At the left is a female figurine, with

white slip (9787); the elegant lady, dressed in a sleeved chiton and an oblique himation, is wearing earrings and has a diadem in her hair. The three cylindrical boxes 9779, 9780, 9783 are called pyxides and were used to keep cosmetics and jewellery. The four vases like them (9769-9772) at the back of the case are perfume vases.

At the bottom right are bronze spurs (9790), three knuckle-bones (9799), a toy often deposited in child burials, a bone spoon (9798), and a gold danake (9796) with a head of Medusa; this is a model of a coin placed in the grave to pay Charon who ferried the souls of the dead in his boat across Lake Acheron to Hades.

Case 12. With the exception of the clay figurine of a youth wearing a himation (5282), which was found in the Macedonian tomb near the Maieuterion, the objects in this case are from the Macedonian tomb in Syntrivaniou Square (300-250 BC). The

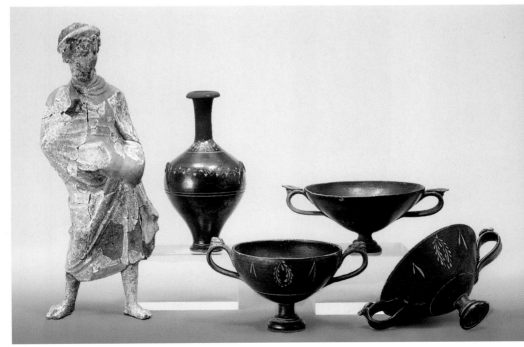

| 5282 | 2801 | 2796 | 2795 | 2797 |

9836 9843 9835

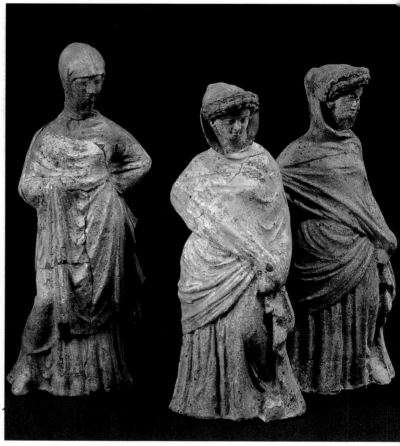

black-glaze vases from this tomb (kylikes 2795-2798, cylindrical pyxides 2766, 2784, 2785, a large perfume vase 2801, semi-globular cups 2793, 2794, and others) are products of local pottery workshops of exceptionally high quality, with a metallic glaze and 'West Slope' decoration. The four white alabastra at the back of the case are typical examples of perfume vases; at the right end is a clay rattle in the shape of a pig (2800).

Case 13. The objects in this case come from simple rock-cut graves in K. Melenikou Street, against the east wall of Thessalonike. They date from the end of the 3rd to the 2nd centuries BC.

9838

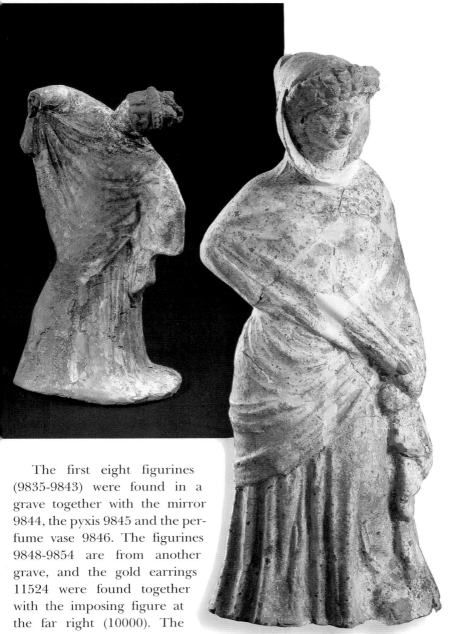

The first eight figurines (9835-9843) were found in a grave together with the mirror 9844, the pyxis 9845 and the perfume vase 9846. The figurines 9848-9854 are from another grave, and the gold earrings 11524 were found together with the imposing figure at the far right (10000). The

9839

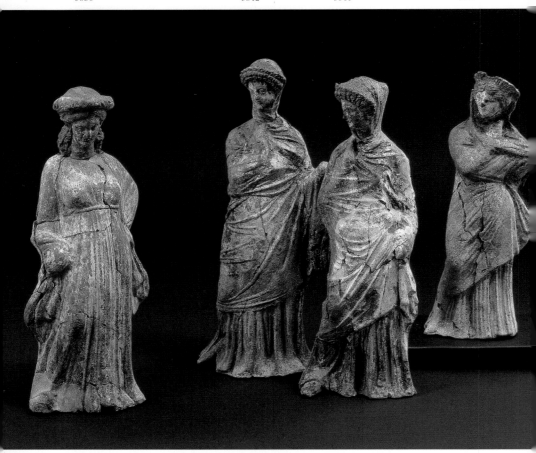

winged Eros 9856, carrying grapes and other fruit, is rather out of place amongst all these charming beings. These works of miniature sculpture convey much more intimately than the marble statues contemporary with them the grace and mysterious charm of a woman which is revealed, rather than concealed by the sleeved chitons, himatia and peploi. The easy natural grace of the figures is emphasized by the paint; the charming movement of the dancer 9838 is peerless. It is quite clear that the art of the figurine flourished in Thessalonike at this period.

10871 3125 10870

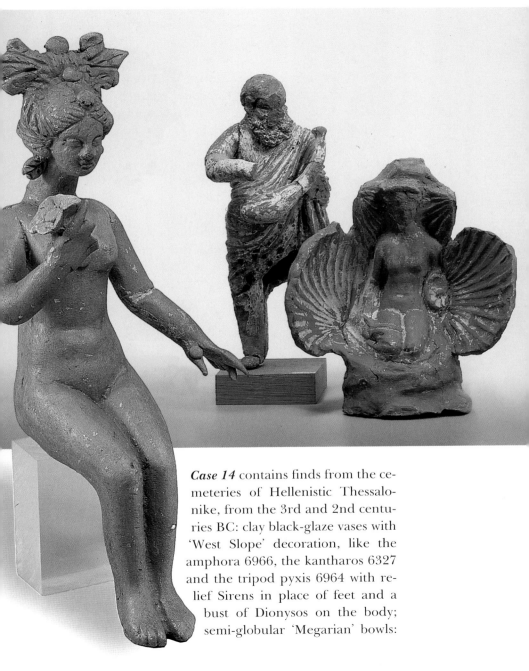

Case 14 contains finds from the cemeteries of Hellenistic Thessalonike, from the 3rd and 2nd centuries BC: clay black-glaze vases with 'West Slope' decoration, like the amphora 6966, the kantharos 6327 and the tripod pyxis 6964 with relief Sirens in place of feet and a bust of Dionysos on the body; semi-globular 'Megarian' bowls:

the fragment 5441 has a scene from Euripides' tragedy *Sisyphos*, 5442 preserves a scene from the killing of the suitors of Penelope, and on 9972 there is a depiction of Ajax and Achilles. 'Homeric Megarian' bowls with scenes from the Iliad and Odyssey were very common. In general, relief 'Megarian' bowls formed an important category of Hellenistic pottery for two centuries (middle of the 3rd-middle of the 1st centuries BC). They were made with the aid of a mould and imitated contemporary vases made of precious metals.

Of the clay figurines in this case, we may note the Hermaphrodite 6963 in the centre: the bisexual son of Hermes and Aphrodite wears two wreaths and leans casually against a stele. The emergence of the new-born Aphrodite from a shell-fish in the sea was also a popular subject at this period (10870), as was the naked puppet 10871, a charming female figure with a richly decorated head and flowers in her hand, emphasizing even fur-

11507

ther the beauty of her naked body. The clothed lady 3096 is no less beautiful, however; the old Silenus 3125 at the right end holds a string instrument.

The relief stele 11507 was found in the area of the east cemetery of Thessalonike, and was probably a grave stone, with a scene of a funerary banquet in honour of the dead man, at rest. Next to the dead man is his wife, with the cupbearer in the centre and his relatives on a smaller scale at the left. The bust of the horse is perhaps a highly significant chthonic symbol. It is dated to the end of the 4th century BC.

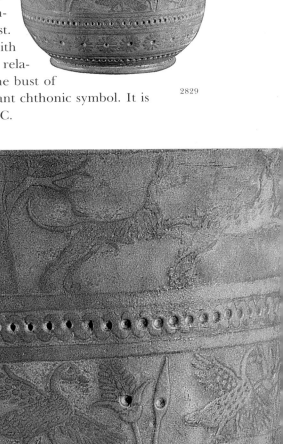

2829

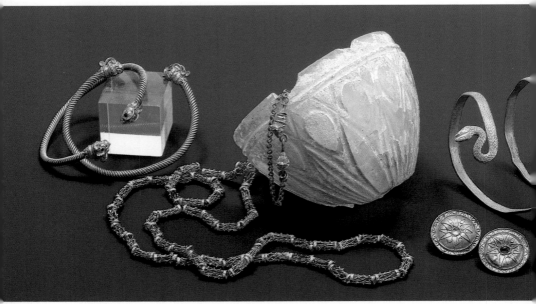

Case 15 contains the finds from the grave of a young girl at Neapolis near Thessalonike (200-150 BC). This grave is of particular interest for the variety and rarity of the objects accompanying the dead girl.

The cast glass cup 11545 and the faience basket 2829 are products of Egyptian workshops. Both are rare finds in Greece, and the basket in particular is unique. It has impressed decoration in horizontal zones, the first having a hunting scene, the second aquatic birds and lotus flowers, and the third rosettes.

The rich group of objects adorning the body of the dead girl consisted of a bronze mirror, and gold jewellery: three necklaces (2835-2837), two earrings with small figures of Eros (2833, 2834), a bracelet in the form of a snake (2830), a pair of twisted bracelets with finials in the form of horned lion's heads (2831, 2832), a pair of disc-shaped fibulae (2838, 2839), five roundels with rosettes (2841-2845), and two finger-rings (2840, 2847).

The eleven clay figurines from this grave are of exceptional

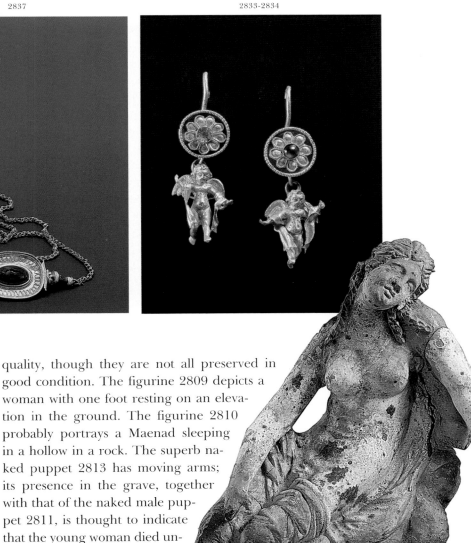

2837

2833-2834

2810

quality, though they are not all preserved in good condition. The figurine 2809 depicts a woman with one foot resting on an elevation in the ground. The figurine 2810 probably portrays a Maenad sleeping in a hollow in a rock. The superb naked puppet 2813 has moving arms; its presence in the grave, together with that of the naked male puppet 2811, is thought to indicate that the young woman died unmarried. Also of interest are the figurine of a comic actor 2818 parodying the messenger in a tragedy, and that of Eros sitting on a larger than life-size goose (2819).

AREA C Late Hellenistic and Roman Thessalonike

In this area are displayed the finds from Thessalonike of the Late Hellenistic and Roman periods, when the city enjoyed special privileges from Rome and flourished in both economic and artistic terms, being known as the 'Metropolis of Macedonia'.

The alabaster lagenos (flask) 9857 was found in a grave in the area of Ayios Dimitrios, and is dated to the end of the 2nd century BC.

Case 16 contains finds from the west cemetery of Thessalonike, especially from the area of Ramona. Two grave groups may be singled out, at the left and in the centre, which are characterized by the large number of figurines found in them together with a few clay vases. Subjects taken from the Aphrodite

cycle and scenes from everyday life are especially popular. Small Erotes, either alone or riding on the Egyptian bull-god Apis, the milking of a goat (10860), the seed-seller with his donkey (10859), the hooded demon Telesphoros who was the patron god of children (10866, 10864), Aphrodite in the Cnidian type (2955), figurines of actors (125, 126), Aktaion being torn by the dogs (11071) – these are indicative of the variety of subjects treated in the coroplastic art of this period.

From the Hellenistic period onwards use was made in jewellery of semi-precious stones, and the pendants 11207, with an engraved figure of a Satyr with a thyrsos, 10983 and 10984, are fine examples of the new aesthetic.

Case 17 contains glass vases from the graves of Thessalonike, dating from the 1st century BC to the 4th century AD.

The technique of glass-blowing was invented at the begin-

11551-11552
11195-11196
11573-11574

ning of the second half of the 1st century BC at some of the traditional centres of glass-working in the Eastern Mediterranean, possibly on the coast of Palestine. It immediately spread throughout the Roman world, since the new technique made possible the production of glass objects cheaply and in large quantities, and these now became common offerings in the tombs of the Roman period.

10290

The glass birds of Thessalonike (11551-2, 11195-6, 11573-4) are a comparatively rare form of perfume vase – the opening was in the bird's tail – of the 1st century AD. A simplified version of their shape was copied by the glass feeding bottles 517-520. The two-faced perfume vases 11053, 11527, 5953 of the 2nd and 3rd centuries AD are probably of Syro-Palestinian origin. The rectangular perfume vases 515a-c are also known as lachrymal vases. The spherical perfume vase 7224 has an engraved hunting scene.

2970

The simplest of shapes, like the drinking glasses 513, 5951 and the cup 511 enchant us with the harmony of their proportions and the perfection of their technique.

Case 18. In this case are displayed finds from Roman tombs in the east cemetery of Thessalonike.

At the top left are three bronze figurines, one of

Herakles and two of Hermes, in the type of Kerdoos, the patron of merchants (9955-9957).

At the bottom left is a group of finds from a female burial. Of the clay figurines, three portray Aphrodite, and 7095 is a group of Eros and Psyche, set on a base with a relief bust of Pan. In the centre, towards the top, Eros and Psyche seated on the back of a peacock (10290). The figurine of Aphrodite 10263 in the type of Aphrodite of the Gardens – like the marble statue in room 2 – has excellently preserved paint; on the base is a relief Eros and on the back is incised the name of the maker of the figurine, Μονομάχου (Monomachos).

The group of figurines at the bottom right are a selection from the 47 found in a single grave in Stratou Avenue. Outstanding amongst them are the figurine of Aphrodite 2931 naked after her bath and holding a folding mirror in her left hand; the group of Eros and Psyche 2970, the seated puppets 2959, 2961 and the throne 2964.

The tombs of the Roman period contained fewer items of jewellery, and were poorer in precious metals than those of earlier times. Much use was now made of semi-precious stones and glass.

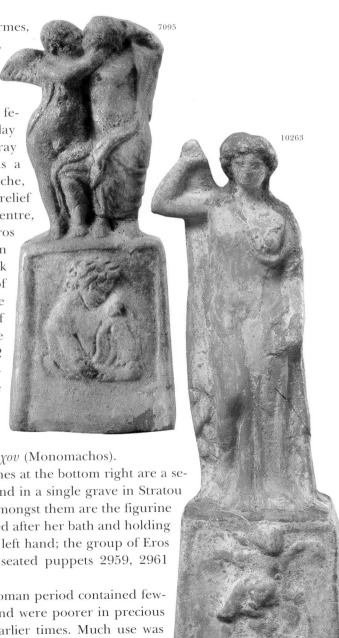

7095

10263

11602 11601

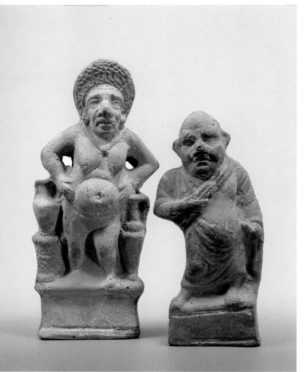

Case 19. A child burial in Filikis Eterias Street contained eleven clay figurines of oxen – toys for the dead child; they were found inside and outside the grave, together with two perfume vases (end of the 2nd century BC). On the wall are two clay antefixes with tragic masks (1122a-b).

Case 20 contains finds from tombs of the Roman Imperial period.

The two clay figurines at the right were found in a grave near the Arch of Galerius. They are signed by the figurine maker Alexandros, and depict figures from contemporary comedy: 11601 is possibly an orator and 11602 Aphrodite (?) (1st century AD).

The plate 11250 is a typical example of Pergamon pottery (2nd century AD); the oinochoe 11577 with relief decoration and orange-red glaze, from the first half of the 3rd century AD, comes from North Africa. The necklace 11589 is made of glass beads.

Opposite cases 18-20, on either side of the dividing wall, are displayed funerary stelai from the cemeteries of the Roman period.

Stele 10773. According to the bilingual inscription, this stele was dedicated to Lucius Cornelius Neon by Poplius Tetrenius Amphion. Set in a scene of everyday life, with a servant leading a horse to his master and a maidservant bringing a box containing jewellery to her mistress, the dead man, standing, bids farewell to his seated wife (1st century AD).

Stele 918. Late Hellenistic stele in which the dominating fig-

ure is that of a woman seated on a throne, with two others walking towards her.

Stele 11037. Below a scene of a funerary banquet we read that the stele was dedicated by Popillius Maximus to his wife Auge (1st century BC).

Funerary altar 9815. The relief is of particular interest both for the subject and for the good state of preservation of the paint. Within a rectangular border a man is portrayed frontally wearing

10773

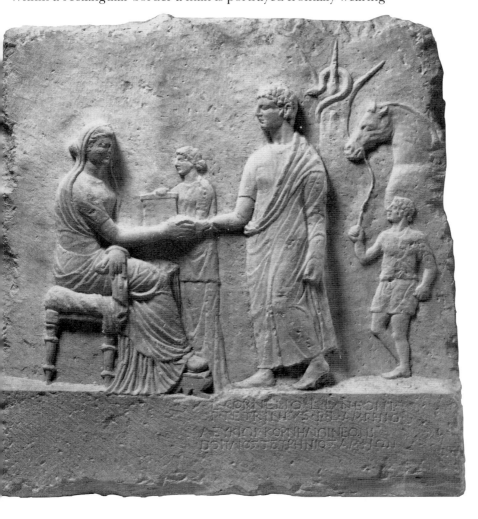

military uniform and in an attitude of farewell; the theatrical mask at the top left suggests that the dead man was an actor. The inscription gives us his name: Marcus Varenius Areskon. The altar (second half of the 2nd century AD) was dedicated by his mother μνήμης χάριν (in memoriam).

918

The reliefs depicting a bust of the dead man, and sometimes members of his family, like 11127, are usually works of popular art.

The relief of the hero-horseman (921) was dedicated by Proklos and Quinta to the memory of their father (3rd century AD).

On the small stele 2449, dedicated by Dionysia to the memory of her small child, Eros with his down-turned, extinguished torch, symbolizes death (3rd century AD).

Stele 6172 was dedicated to Aurelius Asclepius by Aurelius Papianus ἐκ τῶν ἰδίων (at his own expense) μνείας χάριν (in memoriam). The dead man was a fisherman and the low, almost two-dimensional relief depicts him in his boat (3rd century AD).

Stele 2497 from the end of the Hellenistic period has a relief scene of everyday life. It was commissioned by Hegesandra, daughter of Philotas, for her husband Dionysius Longinus, and also for herself, while she was alive.

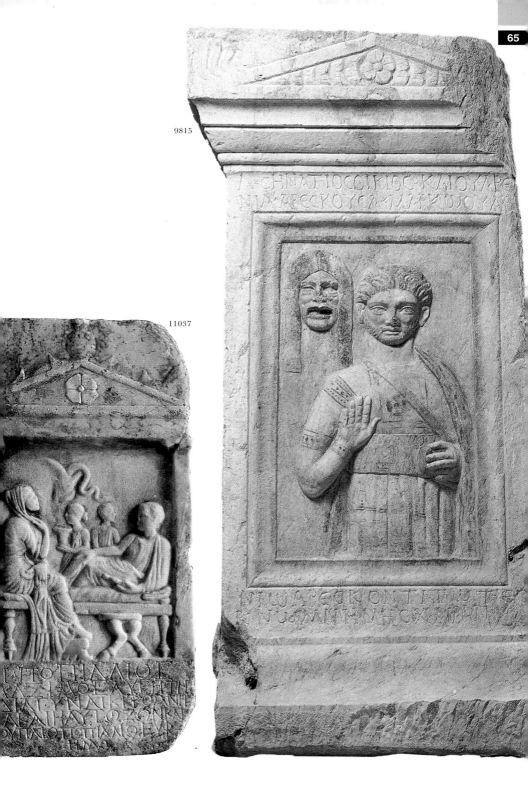

9815

11037

AREA D Religious Cults in Thessalonike

It is clear from inscriptions that many gods were worshipped in Thessalonike, an outstanding place being occupied by Dionysos, Asclepius, Pythian Apollo and Cabirus, patron god of fertility and the vintage. To date, however, only one sanctuary, the Sarapeion, has been excavated in 1920 and 1939, and this was reburied beneath the buildings in Diikitiriou Street. A plaster model gives us some idea of the lost building, with its secret underground corridor leading to a crypt with a cult niche, in which a small herm (1074) was found *in situ*.

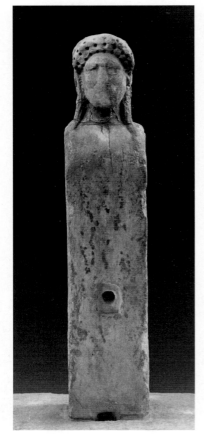

1074

The Sarapeion was a large sanctuary, with porticoes and a small temple dating from the 3rd century BC. The cult of Sarapis, wife of Isis, came to Greece from Egypt, together with that of her son Harpokrates, and Osiris. They were 'listening' gods (ἐπήκοοι), who listened favourably to the prayers of their followers, and were worshipped mainly for their healing powers.

A vast number of votive statues, reliefs and inscriptions was found in the Sarapeion, attesting to the enormous popularity of the cult of the Egyptian gods. A selection of these finds is on display:

Votive stele 997, from the end of the 2nd century BC. Demetrios dedicated this stele to Osiris on behalf of his parents, Alexandros and Nikoa, who are depicted making an offering on an altar, watched by a young man, who is probably their son, the dedicator.

Relief 841. The engraved footprints (βήματα) were dedicated to Sarapis and Isis, after a divine command (κατ᾽ ἐπιταγήν), as evidence of the visit to the shrine of the believer Caecilia Paulla.

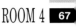

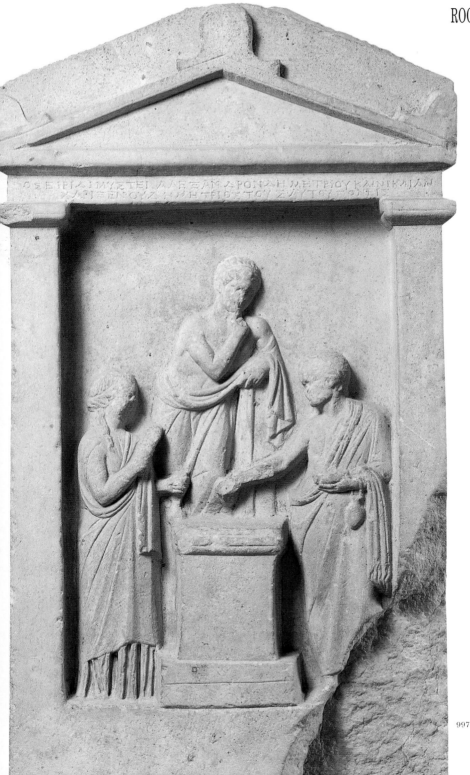

997

843

844

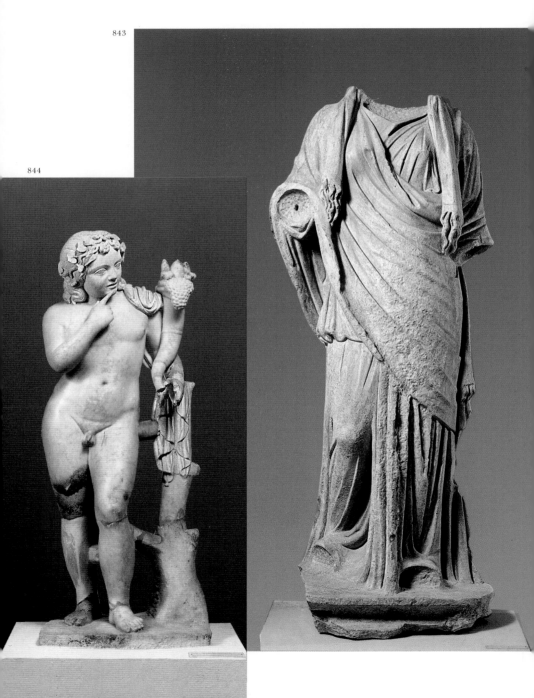

Reliefs 827, 828, 995. All three have relief carvings of ears, proof that the believer's request was heard by the 'listening' Isis. 827 bears the inscription Πώλλα Αυία Ἴσιδι ἐπηκόῳ χαριστήριον (Paulla Avia, to Isis Epekoos in thanksgiving).

Stele 1254 was discovered in the west cemetery and depicts the Egyptian god Anubis, patron of the dead, in the form of a dog.

The statue of Harpokrates 844 is from the Sarapeion. Crowned with an ivy branch, he has a cornucopia and is hold-

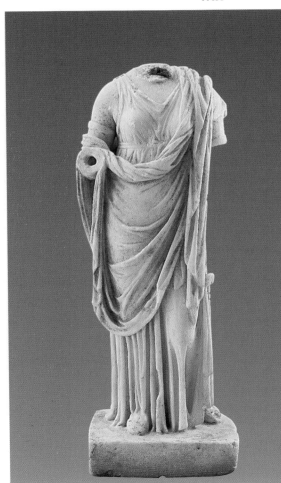

11450

ing the index finger of his right hand to his mouth, to silence the initiates into the mysteries of the Egyptian gods. Harpokrates himself, as son of Sarapis and Isis, was patron god of children (2nd century AD).

Sphinx 4922, an Egyptian work of black basalt, is connected with the cult of the Egyptian gods.

Circular altar 986 was dedicated to Isis Orgia, an epithet indicating the orgiastic nature of the cult of this goddess, and dates from the end of the 1st century BC. Near to it stands the statue of the priestess of Isis 843 of the Roman period, dressed in an archaizing Dorian peplos, a himation and a head-cover with a fringe.

Opposite is the sacred couple Sarapis and Isis. Only the heads are preserved of their larger than lifesize statues. 897 is a Roman copy of the original created by the sculptor Bryaxis in the 4th century BC. The female head 2490 was found in the area of the Sarapeion and is probably a portrait of Isis. The hole at the back of the ribbon in her hair was used to attach the goddesses

897

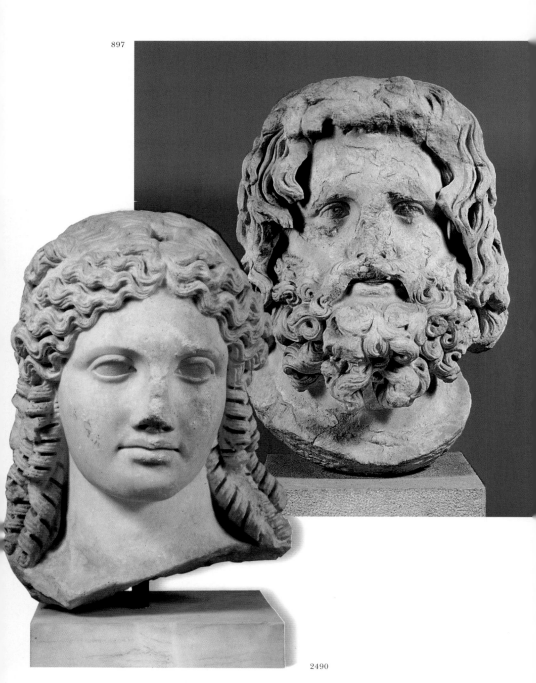

2490

emblem, a crescent moon, perhaps of metal. Next to this head, inscription 1683 preserves part of the 'Aretology of Isis', a hymn composed in the first person, praising the goddess's good works towards mankind (1st century AD).

Against the opposite wall are fragments of statuettes of deities found in various parts of Thessalonike and dating from the Roman period. On the wall itself is a head of Dionysos (11600) from the Roman Agora, and above it a torso of Athena (833) from the Sarapeion.

The rectangular pedestal supports, from the left, a statuette of Demeter enthroned (896), a statuette of Hygeia (7502), a female statuette (11450), three-bodied Hecate (228) from the Sarapeion and an inscribed statuette (996), also from the Sara-

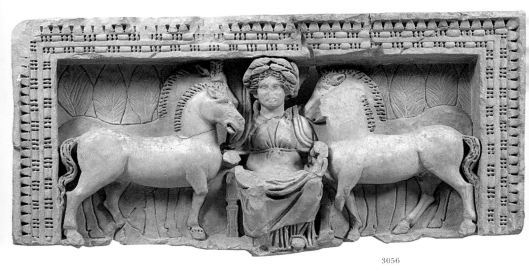

3056

peion, dedicated to Aphrodite Homonoia by the priest Pontianos, which is dated by the inscription to the year 182 AD.

Relief 3056, high up on the wall, depicts the Celtic goddess Epona, seated on a throne between four horses, as goddess of the earth and patron of the animal kingdom. Her cult came to Thessalonike under Galerius at the beginning of the 4th century AD, at the end of the ancient world.

AREA E Public Life in Thessalonike

Our evidence for public life in Thessalonike comes from ancient authors, coins, and mainly from public and private inscriptions.

824

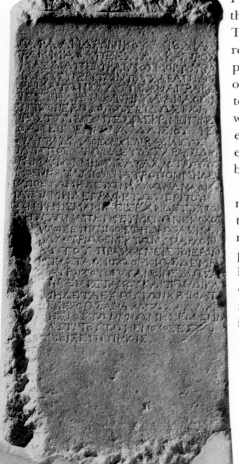

Inscription 824 from the Sarapeion records a royal edict of Philip V issued in the 35th year of his reign, that is 187 BC, and sent to the Sarapeion in Thessalonike by Andronikos, the king's representative. Philip gives strict instructions to protect the landed and other property owned by the Sarapeion, forbidding the city to issue any decrees concerning it. Those who contravened the edict were to be considered sacrilegious, and it is ordained that the edict should be inscribed on a stone stele to be erected in the sanctuary for all to see.

Base of a dedication (859) from the Sarapeion. This supported a statue made at the expense of five politarchs of Thessalonike. This is the earliest mention of the politarchs (first half of the 2nd century BC), who were the most important officials of the city, were eponymous (gave their name to the year), and had many administrative duties, including convening the Council and presiding over meetings of the Popular Assembly.

On the wall above the inscriptions is part of a mosaic floor, 6723, from a 3rd century AD bath: a coloured guilloche frames a square panel with busts of Dionysos (right) and women (left).

Altar 1698 was found together with twenty more in Kassandrou Street. Eighteen of them were dedicated to Fulvus,

the deified son of the emperor Marcus Aurelius. The altar was erected in 219 AD by the *patris* – that is, the city of Thessalonike – in honour of the priest and agonothetes (organizer of games) Marinianus Philippus the younger, who was son of the *Macedoniarch* of the same name and his wife, Flaviane Nepotiane, the *Macedoniarchissa*. The *Macedoniarch* was possibly the supreme official of the Macedonian League. *Macedoniarchissa* was also an office, and not simply a title held by Flaviane.

1698

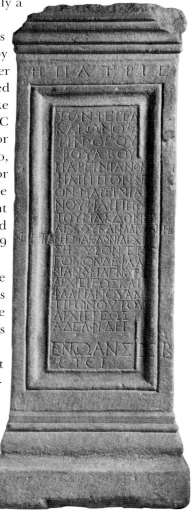

Case 21 contains coins struck by the mints of Thessalonike. At the top are coins issued by the founder of Thessalonike, king Cassander (nos. 1-3), from 305-297 BC. They are followed by the first issues of the mint of Thessalonike under Philip V, which date from after 187 BC (nos. 4-17). The obverse depicts Dionysos or Zeus, Hermes, Artemis, Herakles, and Apollo, while the reverse has either the emblem of, or the animal sacred to the god. After the battle of Pydna in 168 BC, the Thessalonike mint ceased production, apart from some isolated cases, such as the coins issued by Pompey in 49 BC, just before the battle of Pharsala.

After the battle of Philippoi in 42 BC, the triumvirate of Octavian, Antony and Lepidus proclaimed Thessalonike *civitas libera* (free city), and a series was issued celebrating this event (nos. 18-21).

The Thessalonike mint operated almost without interruption from the time of Augustus to Gallienus (31 BC - AD 268). Two categories of coins may be distinguished: those with a bust of the emperor on the obverse (nos. 52-161) and the 'pseudo-autonomous' coins, depicting the symbols of the 'autonomy' of the city: the bust of the 'Fortune' of Thessalonike, Cabirus, Nike, Pan etc.

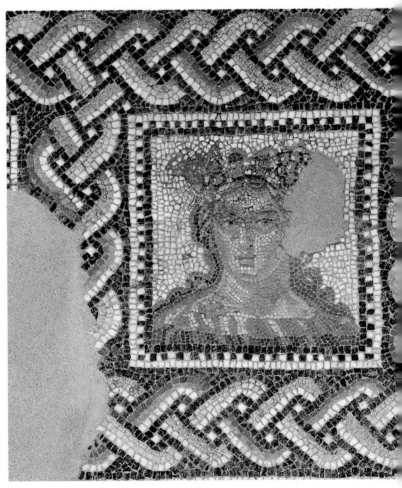

(nos. 22-51). The mint ceased production under Gallienus (AD 259-268) and began operations again in AD 292, though not as an independent mint, but as one of the many state mints that operated in the empire.

Altar 1712 was erected in honour of Domitius Statilius Dionysios, a priest of Fulvus, in the year of Augustus 285 – that is, AD 253. The starting point for the dating is the first year of the rule of Augustus, in 32/31 BC (battle of Actium). The titles used by Thessalonike are of some interest. The city

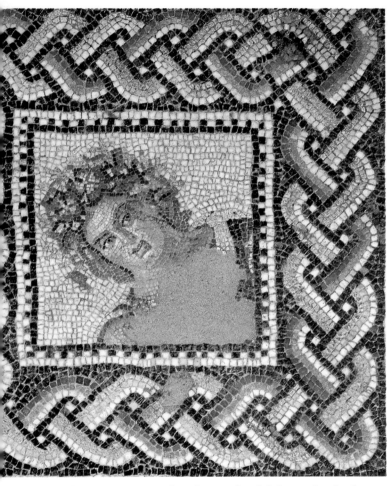

6723

is referred to as 'Metropolis of Macedonia' from the 2nd century AD. It was a *colonia* after the middle of the 3rd century AD, when it received Roman settlers. The title *neokoros* occurs in the first half of this same century and granted by Rome on account of the temples dedicated by Thessalonike to the imperial cult.

The female statue 1255 from Pylaea is probably a funerary statue of the 3rd century AD, in the type of the 'Large Herculaneum Goddess'.

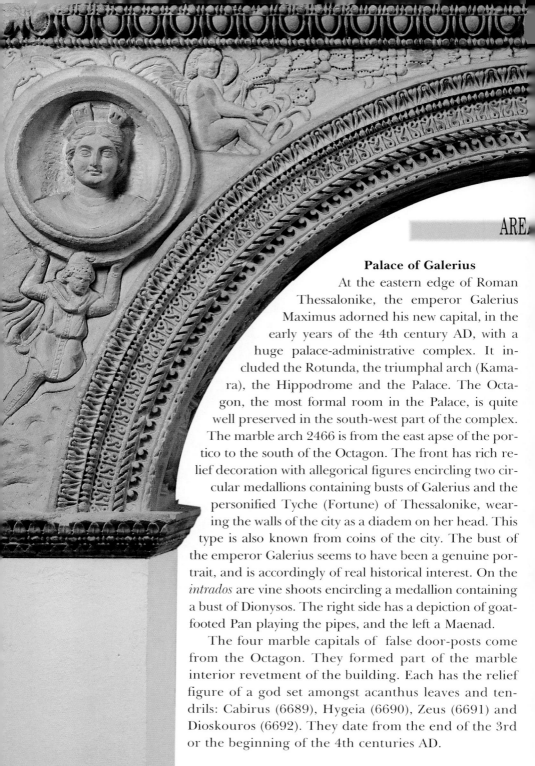

Palace of Galerius

At the eastern edge of Roman Thessalonike, the emperor Galerius Maximus adorned his new capital, in the early years of the 4th century AD, with a huge palace-administrative complex. It included the Rotunda, the triumphal arch (Kamara), the Hippodrome and the Palace. The Octagon, the most formal room in the Palace, is quite well preserved in the south-west part of the complex. The marble arch 2466 is from the east apse of the portico to the south of the Octagon. The front has rich relief decoration with allegorical figures encircling two circular medallions containing busts of Galerius and the personified Tyche (Fortune) of Thessalonike, wearing the walls of the city as a diadem on her head. This type is also known from coins of the city. The bust of the emperor Galerius seems to have been a genuine portrait, and is accordingly of real historical interest. On the *intrados* are vine shoots encircling a medallion containing a bust of Dionysos. The right side has a depiction of goat-footed Pan playing the pipes, and the left a Maenad.

The four marble capitals of false door-posts come from the Octagon. They formed part of the marble interior revetment of the building. Each has the relief figure of a god set amongst acanthus leaves and tendrils: Cabirus (6689), Hygeia (6690), Zeus (6691) and Dioskouros (6692). They date from the end of the 3rd or the beginning of the 4th centuries AD.

2466

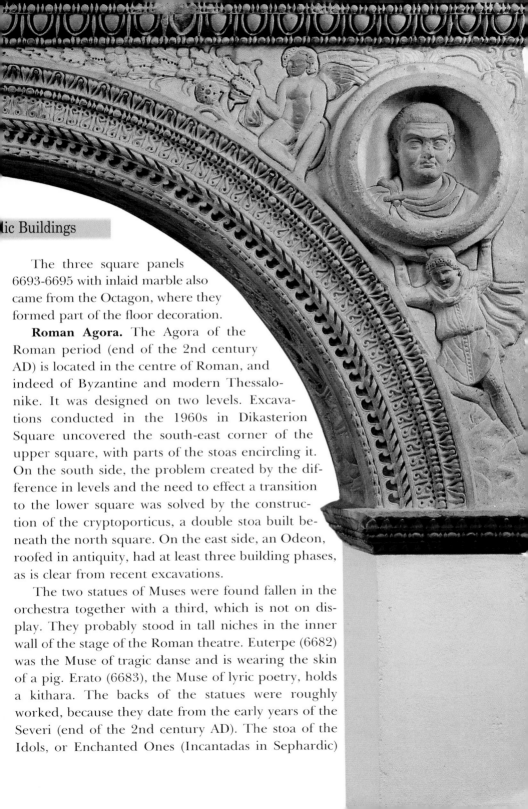

The three square panels 6693-6695 with inlaid marble also came from the Octagon, where they formed part of the floor decoration.

Roman Agora. The Agora of the Roman period (end of the 2nd century AD) is located in the centre of Roman, and indeed of Byzantine and modern Thessalonike. It was designed on two levels. Excavations conducted in the 1960s in Dikasterion Square uncovered the south-east corner of the upper square, with parts of the stoas encircling it. On the south side, the problem created by the difference in levels and the need to effect a transition to the lower square was solved by the construction of the cryptoporticus, a double stoa built beneath the north square. On the east side, an Odeon, roofed in antiquity, had at least three building phases, as is clear from recent excavations.

The two statues of Muses were found fallen in the orchestra together with a third, which is not on display. They probably stood in tall niches in the inner wall of the stage of the Roman theatre. Euterpe (6682) was the Muse of tragic danse and is wearing the skin of a pig. Erato (6683), the Muse of lyric poetry, holds a kithara. The backs of the statues were roughly worked, because they date from the early years of the Severi (end of the 2nd century AD). The stoa of the Idols, or Enchanted Ones (Incantadas in Sephardic)

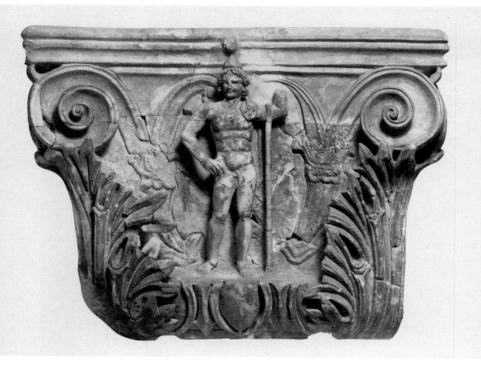

6692

stood in the south square of the Agora. It was a double stoa, consisting of two colonnades, one above the other; the four-sided pillars of the upper one had relief figures of goddesses (beginning of the 3rd century AD). Four pillars were preserved *in situ* until 1865, when they were taken off to Paris and are now on display in the Louvre Museum. Popular tradition connects these 'figures turned to marble' with a legend relating to Alexander the Great's love for the wife of a king of Thrace.

The torso of Atlas 10301 was found beneath the surface of the Roman Agora. It was an architectural member of a building from an earlier phase of the Agora.

The statue of the hydrophoros (water-carrier) 895 was found to the north-west of the Agora and probably comes from a public fountain. The neck of the vase acted as a water-spout (2nd century AD).

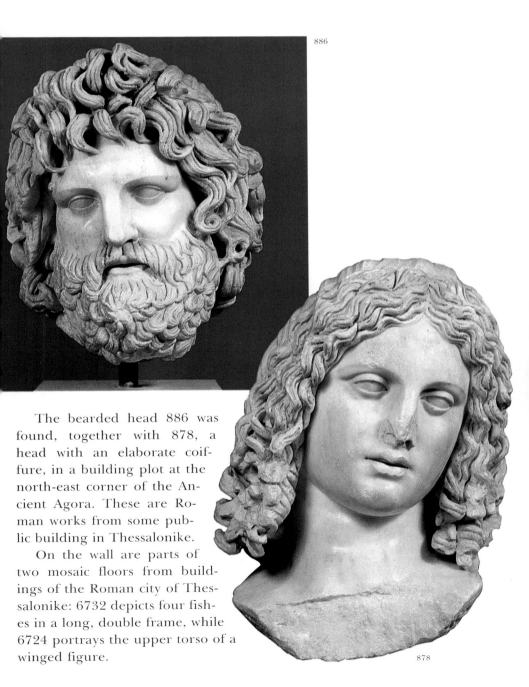

886

The bearded head 886 was found, together with 878, a head with an elaborate coiffure, in a building plot at the north-east corner of the Ancient Agora. These are Roman works from some public building in Thessalonike.

On the wall are parts of two mosaic floors from buildings of the Roman city of Thessalonike: 6732 depicts four fishes in a long, double frame, while 6724 portrays the upper torso of a winged figure.

878

AREA G Private Residences

Private residences dating from the Roman period have been excavated here and there beneath modern Thessalonike. Wall-paintings, marble revetments and mosaic floors adorned the richer houses. In one of these, in Sokratous Street, was found the large mosaic floor 6733, the main subject on which was a scene of Ariadne on Naxos. The heroine sleeps obliviously; Theseus is abandoning her, but her new companion, Dionysos, is arriving with his followers, a youth, a mature Satyr, and a Maenad. The two smaller panels in the border depict the abduction of Ganymede by Zeus, and

6724

6722

Apollo pursuing Daphne. The floor dates from the beginning of the 3rd century AD.

Mosaic 6722 depicts a four-horse chariot, of the type known as a *synoris*, as attested by the inscription *ΑΡΜΑ ΣΥΝΩΡΙΣ*. It will have formed part of a mosaic depicting the events at the hippodrome, which were popular subjects with the people of Thessalonike (3rd century AD).

The Satyr 6680, in a drinken sleep, comes from a public or private fountain in Thessalonike. He is still holding the wine-jar, from the mouth of which issued the fountain water.

Statuettes-table supports are on display near the Ariadne mosaic. Figures, carved almost in the round, of Eros (3025, end of the 2nd century AD), Ganymede with an eagle (3024, middle of the 3rd century AD), and Herakles with two Erotes (846,

6733

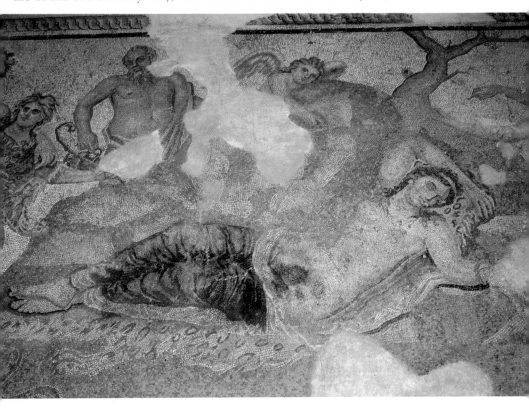

middle of the 3rd century AD) lean against pillars that formed the legs of marble tables.

Cases 22 and 23 contain objects discovered during the excavation of Roman houses.

Case 22. Alongside the undecorated pots designed for everyday use are displayed imported vases from other countries in the Roman world; the amphoriskos 3571, with relief decoration, dating from the 3rd century AD, comes from North Africa, possibly Tunisia, as do the fragments of red plates with relief decoration, at the top right: 9891 has the head of a sea deity wearing a crown of lobster claws, set amongst curling tendrils. On 9894 is a representation of a four-horse chariot (3rd century AD), on 9895 a lion, and on 9893 a woman seated on a rock (4th century AD).

The undecorated amphoriskos 7218 possibly comes from Asia Minor, and on both sides has a relief Maenad dancing amongst vine shoots (3rd century AD).

At the bottom right are plates of different sizes, and a fragment of an Arretine plate 9890, which came from Italy at the end of the 1st century BC.

6680

Case 23. Lamps bearing clear traces of use from the lighting of the wick at the end of the nozzle are frequently found during the excavation of houses. A selection of clay lamps is displayed from different provenances and dating from the 1st to the

5th centuries AD, together with a mould for making them (7127). There were also bronze lamps, like 9875.

The tile 9878 had lines scratched on it, for some kind of game. We are brought even closer to the people of that period by the bone spoons, a fragment of a bone pyxis 9986, combs and brooches, bronze bow fibulae, and an iron knife with a bone handle. The delicate bronze instrument 11544 is a pen; the sharp end was used to scratch the waxed surface of a tablet, and the broad end for erasing the letters by smoothing the soft wax.

3571

9891

9890

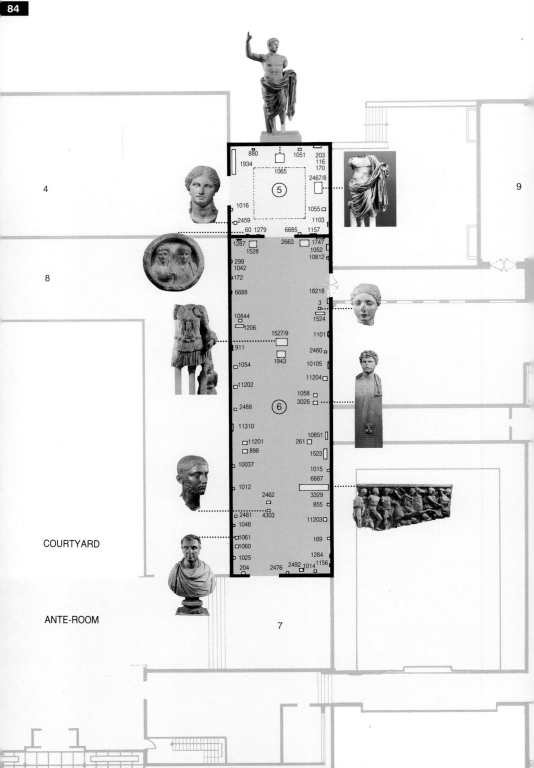

4

9

8

880 1051 203
1934 116
170
1065 2467/8
⑤
1016 1055
2459 1103
60 1279 6685 1157
1287 2663 1747
1528 1052
10812
299
1042
172
6688 18218
3
10844 1524
1206
1527/9 1101
911 2460
1943
1054 10105
11204
11202
1058
2488 ⑥ 3026
11310
11201 10851
898 261
1523
10037
1015
1012 6687
2462
3329
855
2461 4303
1046 11203
1061 169
1060
1025 1284
204 2476 2492 1014 1156

COURTYARD

ANTE-ROOM

7

ROOM 5 Sculpture Exhibition

Room 5 contains exhibits from the Augustian period (1st century BC - 1st century AD). In the centre is the dominating statue of Octavius Augustus (1065), which was found to the north of the Sarapeion. The emperor is depicted semi-naked, as a heroized ruler; his right hand was resting on a spear, and he held a short sword in his left. This statue follows a bronze original, as does the famous Augustus found at Prima Porta near Rome. It was possibly made in Thessalonike in the time of Tiberius. It is one of the best examples of the imperial prop-aganda statues –and is, indeed, one of the first of the series – that the Romans erected in various nerve-centres of their boundless empire. To this same category belongs the headless statue of the emperor Claudius (2467, 2468, c. 50 AD), which was found in the same area as the statue of Augustus. The head 1055 next to it has been identified with some certainty as that of Vespasian (AD 69-79).

This was the period in which the realistic portrait still flour-ished, as is clear from the private portraits in this room. A num-ber of these, like 203+116+170, 1103, 1157, 60, belong to cir-cular funerary reliefs of the type called *imago clipeata*. The last (60) depicts a dead couple in a circular frame, the outer border of which takes the form of a relief wreath (middle of the 1st cen-tury AD). These portraits are amazingly realistic. The male por-trait from Veroia 1279 is an exceptional work, rather marred by the break in the area of the nose (AD 50-100).

The three relief slabs 1934 come from Lete (cf. room 3), and formed the funerary monument of Antigonos, son of Eu-landros, dating from about 30 BC. Five full-length figures are depicted almost frontally, with horses and young servants carved in lower relief in the background. They recall the slightly earlier monument of Dionysophon, also from Lete, which is signed by the sculptor Euandros from Veroia (room 3, no. 1935). The relief slabs from both these monuments

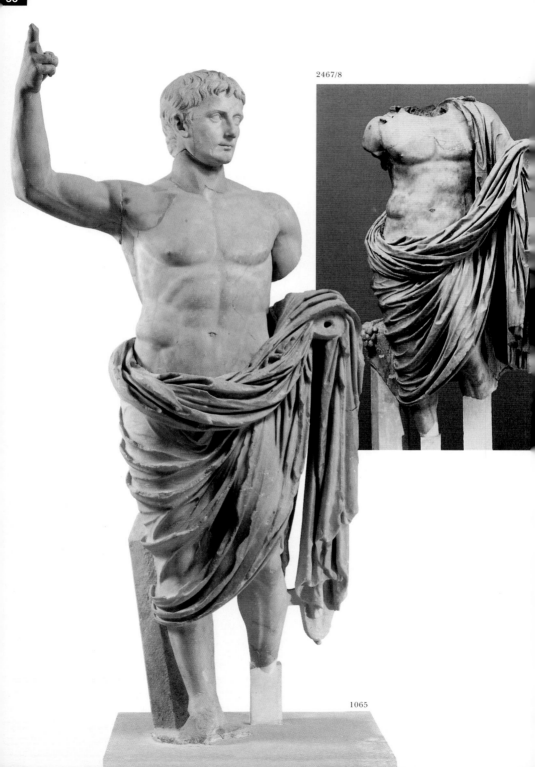

2467/8

1065

had been reused in the walls of an Early Christian tomb. The Lete reliefs are particularly interesting and furnish evidence for Macedonian portraiture of the 1st century BC, since it is certain that they are works by local artists.

60

The head 880 is probably a portrait of the Augustian period. The groove below the diadem was used to attach a wreath made of a different material.

The reworking of earlier pieces was not rare in the Roman period. Later sculptors would modernize them or turn them into portraits, as in the case of head 2459, a Hellenistic goddess that was converted into a portrait in the second quarter of the 1st century BC.

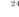

2459

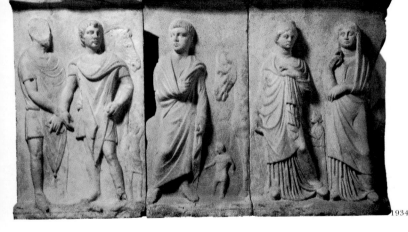

1934

ROOM 6 Sculpture Exhibition

Room 6 contains groups of Roman Imperial sculpture, most of it from Thessalonike; they date from the 2nd to the 5th centuries AD and are arranged in chronological sequence.

1527/9

A number of 2nd century AD works are displayed at the beginning of the room, centred on the torso of Hadrian (1527/9). The identification of this torso with Hadrian is based on the type of the breastplate (Archaistic Victories are setting up a trophy) which is also found in other statues of the emperor. Below his left hand is depicted a kneeling barbarian.

The portrait of a young girl (3), with her coiffure in the type of Sabina – Hadrian's wife – is one of the masterpieces of the 2nd century AD. The flesh is modelled with incomparable sensitivity, and reveals a knowledge of Athenian sculpture. On the wall are parts of a gold-embroidered cloth (18218) from a 4th century AD burial in a lead coffin.

Opposite the statue of Hadrian, the togatus 1528 is also an exceptionally fine work of the 2nd century AD; this depicts a man of letters, as is clear from the scrinium, or papyrus case, to his left. The statue of a soldier 2663 is another fine work.

According to the inscription on the bust 10844, this depicts L. Titonius, a high priest of Isis. He is depicted in the type of the philosopher; some other inter-

18218

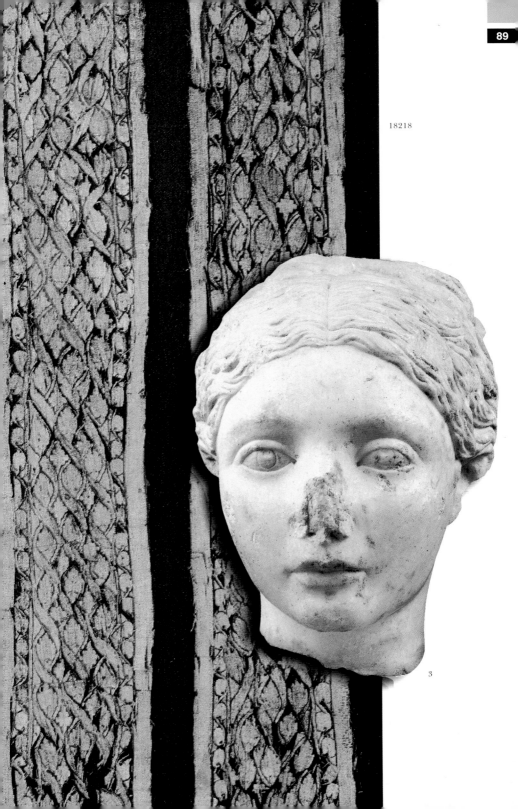

3

esting portraits of the second half of the 2nd century AD belong to the same category, amongst them nos. 2460, 11201, 11204, 1058 and the herm 3026 with the noble figure of a bearded youth. It is apparent that the representational type of the philosopher emperor Marcus Aurelius influenced the portraiture of his time and of the beginning of the 3rd century AD.

The larger than lifesize female statue 1943, in the 4th century AD type known as the 'Small Harculaneum Goddess', is a portrait from the early period of the Severi. It was discovered in the area of the Odeon in the Ancient Agora, from where it was removed by force during the Second World War to Vienna, and concealed in the salt-quarries of Salzburg, until it was returned to the Museum in Thessalonike. It dates from about AD 200.

The popular grave reliefs of this period (3rd-4th centuries AD) are multi-figural and attest to a flourishing realistic and intensively expressive art (11310, 1101). The grave stone carved in the round 10851, dating from the 4th century AD, is from the west cemetery of Thessalonike. It has three busts, together with a fourth, smaller one (a child?) on each side, and was used twice. The busts are often combined with small reliefs of funerary banquets (1523, 1524). The relief of a funerary banquet (10105) was dedi-

1058

3026

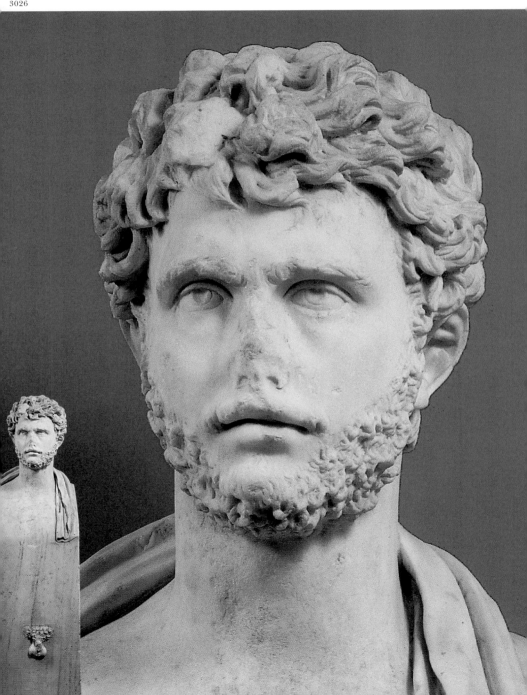

cated by the brothers Paramonos and Serapas to the memory of their father Serapanos. The blue paint on the background is well preserved. The entire family is gathered around the bed of the father for the banquet; a boy sitting at the front reads from a papyrus. The scene conveys with great immediacy the emotion of a spontaneous popular work (4th century AD).

The wealthier classes ordered portrait busts (like 11201, 11204, a girl 1052, a young woman 10812) or Attic sarcophagi (6687 with Erotes and 3329 with the hunt for the Calydonian boar). The small marble ossuary 261 from Redestos in east Thrace is a model of a sarcophagus with relief garlands and goat's heads at the corners, and was designed to hold the ashes of some dead person (beginning of the 3rd century AD).

The sculpture of the period of the Severi (end of the 2nd-beginning of the 3rd centuries AD) is also of some note. The larger than lifesize head of Septimius Severus (898) is one of the early portraits of the emperor, from the end of the 2nd century AD. The head (4303) of a bronze statue of Alexander Severus (AD 222-235) is a masterpiece, found at Ryakia in Pieria. The short-cropped hair is typical of the fashion of this period, from which date the bust 2462, from Kassandra, depicting a man with a naked chest, with his head turned to the left, and the intensely re-

1943

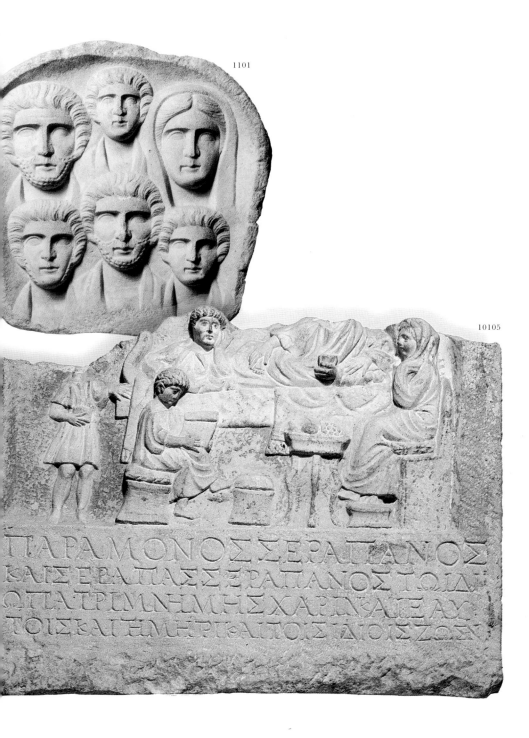

1101

10105

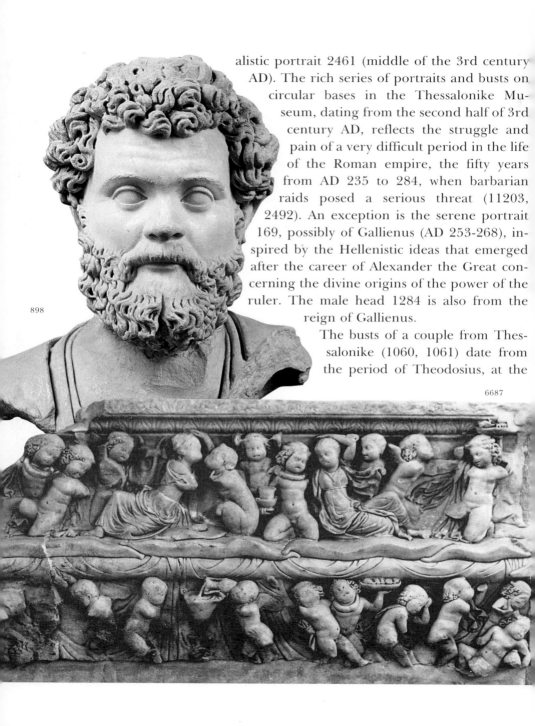

alistic portrait 2461 (middle of the 3rd century AD). The rich series of portraits and busts on circular bases in the Thessalonike Museum, dating from the second half of 3rd century AD, reflects the struggle and pain of a very difficult period in the life of the Roman empire, the fifty years from AD 235 to 284, when barbarian raids posed a serious threat (11203, 2492). An exception is the serene portrait 169, possibly of Gallienus (AD 253-268), inspired by the Hellenistic ideas that emerged after the career of Alexander the Great concerning the divine origins of the power of the ruler. The male head 1284 is also from the reign of Gallienus.

The busts of a couple from Thessalonike (1060, 1061) date from the period of Theodosius, at the

898

6687

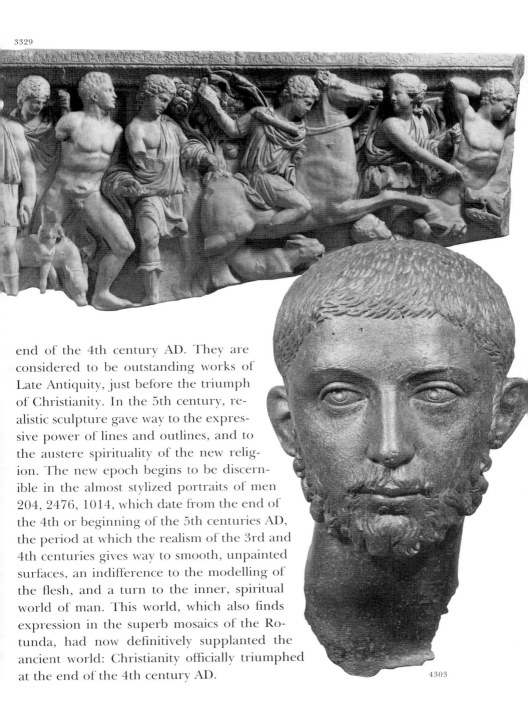

3329

4303

end of the 4th century AD. They are considered to be outstanding works of Late Antiquity, just before the triumph of Christianity. In the 5th century, realistic sculpture gave way to the expressive power of lines and outlines, and to the austere spirituality of the new religion. The new epoch begins to be discernible in the almost stylized portraits of men 204, 2476, 1014, which date from the end of the 4th or beginning of the 5th centuries AD, the period at which the realism of the 3rd and 4th centuries gives way to smooth, unpainted surfaces, an indifference to the modelling of the flesh, and a turn to the inner, spiritual world of man. This world, which also finds expression in the superb mosaics of the Rotunda, had now definitively supplanted the ancient world: Christianity officially triumphed at the end of the 4th century AD.

4

5

9

8

6

COURTYARD

ANTE-ROOM

9231

(7)

9747

9748

PORTICO

ROOM 7 The Macedonian Tombs

The Macedonian tombs received their final architectural form after a long period of experimentation in the middle of the 4th century BC. These subterranean monuments were the family tombs of the upper classes, and were covered by a tumulus above the ground that took the form of a man-made conical mound of earth. The vaulted roof of these single- or double-chambered tombs was an architectural device imposed by the enormous weight of the tumuli, to prevent the roof from collapsing. Constructed of dressed poros stones, they usually had the façade of a temple, of which there were a large number of variations, often with painted decoration. Marble, stone or wooden doors

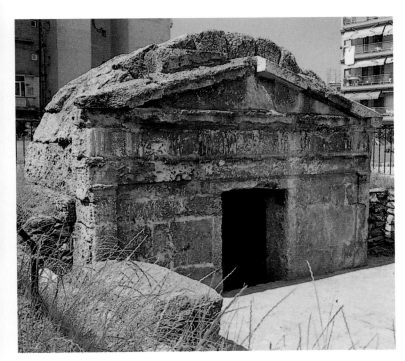

Macedonian tomb in Papanastasiou Street, Thessalonike. 3rd c. BC.

led to the interior of the tomb, where the dead were placed on built, or marble or wooden couches; in cases of cremation, the cinerary urn was placed on a special pedestal, or in a container.

A typical example of a Macedonian tomb is that at Ayia Paraskevi in Thessalonike, a 1:100 model of which is displayed. The façade of the tomb was painted lifesize, and the monumental marble door (9231) that led to the antechamber of the tomb has been placed at the door opening. The door is 2.48 m high, and is unique for its technical perfection and the superb state of preservation of its bronze attachments: the studs, the superb handle, and the lock. The very heavy leaves of the door open easily, thanks to wheels that ran in lead runners on the floor.

The tomb of Ayia Paraskevi, like most of the Macedonian tombs, had been plundered when it was discovered. Two clay figurines (9233, 9234) that had fallen behind the bench in the main chamber, escaped the pillage, and a lamp, part of a gilded bronze wreath (9236), two pieces of gold sheet (9241) and leaves from gold wreath (9237) were all that remained of the grave offerings. The glass beads and small plaques 9243 adorned a wooden bed. The tomb dates from the end of the 4th century BC.

The small tomb at Potidaea, with its uncluttered façade and simple stone door (9748), was robbed a few days before it was found, in 1984. The only objects left by the antiquities-dealers are displayed in the small show-case against the wall, near the couches: a gilded bronze wreath (9749) with gilded clay insects and myrtle berries, two figurines (9757a-b), two alabastra (9750, 9751) and fragments from the bone ornamentation of a box (9752). The top shelf of this case has clay figurines from later cist graves in the same tomb.

Despite their attempts, the robbers were unable to remove the marble couches from the tomb at Potidaea. These are important monuments of ancient painting (9747). The subject depicted on the upper cross-piece is an open-air shrine, with a spring, tree, deer, and an archaizing statue, where gods and goddesses are relaxing: Aphrodite with the goose, the young Dionysos, a Silenus with red shoes, *embades*, and a silver rhyton

9231

9747

in his hand, and a young Herakles. The lower cross-piece has a series of individual decorative motifs: bulls, kraters, and a feline. On the panel between the two cross-pieces are three heraldic compositions with polychrome griffins, and there is a rectangular painted foot-rest beneath them. The legs of the couch are decorated in red paint, and the empty circular depressions were for oval glass eyes, which were removed by the robbers.

The competent painter of the couches of Potidaea used the

9747

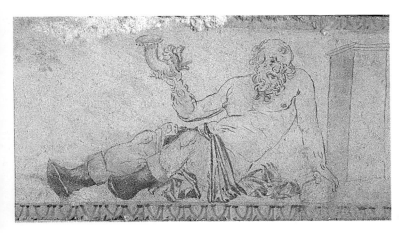

9747

technique of xerography on a fine earth-coloured slip that covered the entire surface of the marble. The decoration is an imitation of the inlaid ivory decoration of wooden couches, remains of which have been found in the royal tombs at Vergina and in many other tombs.

The couches from the tomb at Potidaea are important for our knowledge of ancient Greek painting at the end of the 4th century BC.

9747

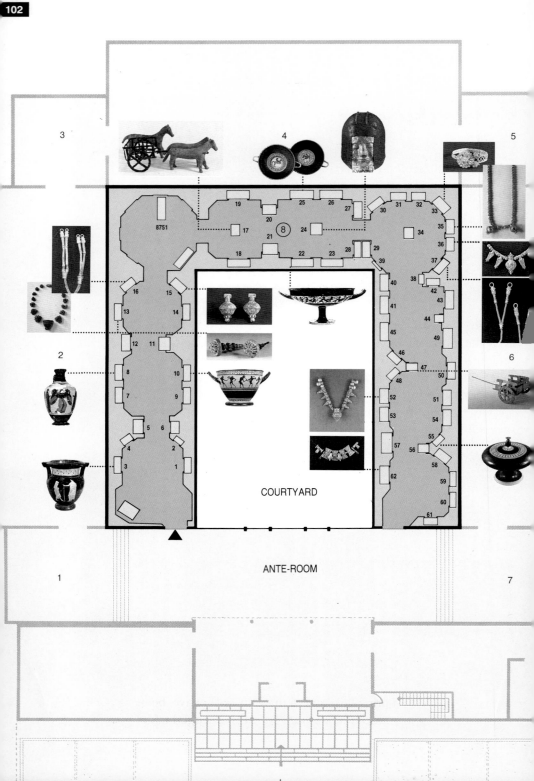

3

4

5

8751

19
25 26
20 27 30 31 32
17 24 33
21 8 34 35
18 22 23 28 29 36
39 37

2

16 15
13 14
40
38
41
42
43
12 11
44
8 10
45
49
7 9
46
47
50
48
5 6
52 51
53 54
4 2
55
57 56 58
3 1
62 59
60
61

COURTYARD

6

7

ANTE-ROOM

1

ROOM 8 Sindos Exhibition

An ancient settlement surrounded by cemeteries has been found near modern Sindos; that was either ancient Chalastra, or ancient Sindos itself. In 1980-1982, 121 graves were excavated, covering a single period in the long life of the city, from the middle of the 6th to the middle of the 5th centuries BC. Though these were simply constructed rock-cut or cist graves made of poros, they contained large numbers of frequently very valuable grave offerings (the objects placed in a tomb), which furnish important information concerning trade, the arts and society in a small Macedonian city in the Archaic and Early Classical periods.

The presence in the graves of so much gold jewellery is very striking, as are the items of gold sheet also destined for the dead, such as the lozenge-shaped mouthpieces used to stop up the mouth of the dead, the five gold masks and the vast number of gold strips used to adorn the clothing. Quite apart from the custom that ordained this usage, it could not have been carried out if there had not been an abundant supply of the raw material, gold, in the sand of the nearby river Gallikos, the ancient name of which was Echeidoros: 'gift-bearing'. Thanks to these two circumstances the Sindos graves have revealed the high level of development of gold-working and of metallurgy in general in ancient Macedonia, and have demonstrated that the 4th century acme was not due to influences and workshops from southern Greece, but was the result of a long local tradition in the arts. In the 6th century BC, the goldsmiths of Chalastra were masters of two difficult techniques: filigree and granulation.

The clay vases and figurines found at Sindos indicate that there was a lively trade with Ionia, Attica and Corinth. Another category of grave offerings is of special interest: in several tombs, containing both male and female burials, have been found miniature iron models of a waggon, a three-legged table,

a chair, and spits with supports for roasting meat, which convey to us a despairing belief in a shadowy continuation after death of the daily needs of life.

Finds from 36 of the Sindos graves are displayed in 62 cases, organized by grave groups.

Case 1. Grave offerings from the male grave 40, dating from the decade 460-450 BC. The depositing of a large number of identical objects in a single grave is the exception rather than the rule in the cemetery at Sindos. Seven figurines, of which five are displayed, all made from the same mould were found in this tomb, representing a standing woman wearing a himation, along with ten identical small Corinthian kotylai (7762 ff.), five glass globular aryballoi and two glass amphoriskoi of Phoenician type (7773-7779), and two malformed Boeotian male figurines (8192, 8193), which were probably from the same mould and may be caricatures of mythical heroes.

The Attic red-figure lekythos 7758 with a depiction of Victory in front of an altar has been attributed to the 'Bowdoin painter' and dates from the 2nd quarter of the 5th century BC. The iron sword 8602 was found in the same grave, with the remains of a cloth material clinging to it.

Case 2. The female grave 26, which had been robbed, contained two Attic black-glaze vases: column-krater 7892 and kylix 7889, which date from the decade 450-440 BC.

Case 3. The male grave 55, from the decade 460-450 BC, produced two figurines, of which 8196, depicting a girl at rest, is preserved intact, and also five vases made in Attica. The best of these is the column-krater 7786 with a scene depicting a youth with a staff talking to a child who is covered by his himation.

Case 4. The young girl in grave 68, which dates from the decade 470-460 BC, was an infant. The gold bracelets (7993) with snake's head finials are only 3.5 cm in diameter. The girl's jewellery also includes a pair of gold earrings (7995), a gold trefoil pendant (7994) and a silver tubular pendant (8676). Her tender years are also suggested by the two clay toys, a model of a dove and a pig (8202, 8203). Two Attic lekythoi with black-figure palmettes on a white ground (7808, 7809), and a glass

7786

aryballos (7807) were also placed in the grave, together with a small wooden box, of which only the inlaid bone decoration – quadruple palmettes, and stars with five points – has survived.

Case 5. The female grave 117, from about 500 BC, contained jewellery, most of it silver, though there were a few items of gold. The pieces of gold sheet 8433 and 8434 were used in place of a single gold mask over the eyes the former and mouth the latter of the dead woman. This is an unusual find at Sindos; a total of five masks have been discovered here, and a large number of lozenge-shaped mouthpieces, but this is the only example of this particular combination.

The gold pieces 8414 were imitations of earrings designed

for burial, and the gold spherical pendant 8435 will have hung from a fine cord around the neck.

Of the silver jewellery we may note a silver necklace consisting of a quadruple chain with snake's head finials (8579). The chain was fastened to the shoulder with the aid of the pins 8581 that passed through the holes in the mouths of the snakes. Two silver fibulae with an iron pin (8582), two bracelets (8580) and a double pin also accompanied the dead woman.

Two objects of everyday use, the iron knife 8613 and the bronze basin 8567, were accompanied by four clay vases connected with cosmetics and ritual: two tiny kotylai (8338, 8339), an Attic plemochoe (8336) and a small local exaleiptron (8337). The last two probably contained aromatic oil.

Case 6. Grave 4 (450-440 BC) is poor in comparison with the others. It contained a pitcher (8322) from a north-east Aegean workshop, two Attic vases – a black-glaze cup (8320) and a lekythos with palmettes (8319) – a bronze bowl with a boss (8537), two silver pins (8578) and two silver earrings (8577).

Cases 7, 8, 12. The rich contents of the male grave 65 (530-520 BC) are displayed in cases 7, 8 and 12.

Case 7. Corinthian, Attic and Ionian vases were found together in grave 65. The kylix 7747 is Ionian, the four small kotylai 7753-7756, the kotyle 7751 and the exaleiptra 7749, 7750 (the latter with a frieze of panthers at the top) are all Corinthian, and the black-glaze oinochoe 7748 with heraldic lions on the body is from Attica, or possibly Eretria.

The long gold strips found in the grave will in some cases have adorned the hems of clothing, while others will have decorated the scabbard or the straps of the two iron swords. The gold rosette 7930 adorned the pommel of the sword, while the gold ring 7933 was wrapped around a wooden core.

Case 8. The Attic kylix 7746 at the back is one of the miniature ribbon kylikes of the third quarter of the 6th century BC. The zone at the handles has an identical miniature scene on both sides, with three horsemen between two pairs of standing men wearing himatia. Contemporary with this

is another Attic kylix (7745), with an undecorated rim and a nonsense inscription between the handles. The Attic black-figure lekythos 7757 (550-540 BC) has a depiction of a boar between two horses on the shoulder, while the body has a winged female figure – Iris or Victory – between two pairs of men wearing himatia.

The three-sided piece of gold sheet 7929 has *repoussé* decoration consisting of simple and complex rosettes. The technique involves hammering the gold sheet on a mould, after which it was cut to the desired shape, with the result that often the outline does not fully take account of the design.

Large four- or three-sided pieces of gold sheet were found only in male graves and were probably sewed onto the clothing, in the middle of the chest.

The bronze bowl with a boss 8733 was used for offering libations. Two iron swords and a pair of spears formed part of the offensive equipment of the warrior.

Case 12. The bronze helmet 8680 was the main piece of defensive equipment at Sindos used by warriors in battle. It belongs to the so-called 'Illyrian' type. This was created in the 8th century in the Peloponnese, and has no connection with Illyria; it was very popular in Macedonia and the south Balkans in the 6th and 5th centuries BC.

7757

The rectangular piece of gold sheet 7926 is 18.5 cm long; it is decorated with rosettes and palmettes, and was probably used to cover the face of the dead man.

Two more bowls with bosses from tomb 65. The presence of

these ritual, usually, vessels in great quantities in the graves at Sindos has not been satisfactorily explained.

The iron models of a three-legged table, a chair, and a group of spits and their supports formed the equipment required for the banquets of the deceased. In the rest of Greece, this same belief was given expression by grave reliefs depicting scenes of such banquets.

Case 9. The male tomb 111 (430 BC) contained the basic weapons of the dead warrior: bronze helmet 8563, iron sword 8607 with the fused remains of its wooden scabbard and two iron spearheads.

A lozenge-shaped gold mouthpiece (8416) sealed the mouth

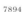

of the dead man, and the pieces 8417-8421 adorned the reinforced end of the scabbard. The gold finger-ring 8415, which has the inscription *Δῶρον* (gift) in the Ionian alphabet, is an important find. Rings explicitly stating that they are gifts have been found elsewhere – e.g. *Κλείτα δῶρον* (a gift for Kleita) on a

ring at Derveni (see below, room 9, case 39); the custom was perhaps intended to lend special importance to the occasion of an engagement.

Two Attic black-glaze vases, cup 8300 and the stemless kylix 8301, are accompanied by the unique iron exaleiptron 8614 with a bronze swinging handle.

Case 10. The female grave 22 (about 500 BC) was not one of the richer tombs. An Attic plemochoe (7893) and a large black-figure Attic cup (7894), with a scene of men dancing in high spirits to the accompaniment of a flute-player, were the only clay vases placed in it; the dead woman was also accompanied by two clay figurines of an enthroned goddess (8229, 8230). The gold lozenge-shaped mouth-piece 8076, the finger-ring 8078, the substitute earrings 8072 of thin gold sheet, and the 43 cm strip 8075, which was probably a diadem, were all designed for funerary use. The only genuine piece of gold jewellery is the pyramid-shaped pendant 8071 with granulated decoration. The pairs of silver pins (8675) and fibulae (8688) were also genuine items of jewellery.

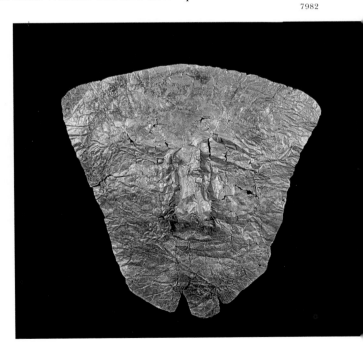

7982

Cases 11, 13-16 contain the grave offerings from female tomb 20, dating from the end of the 6th century BC (510-500 BC), one of the richest tombs at Sindos.

Case 11. The mask of fine gold sheet 7982 covered the face of the dead woman, as in four other graves at Sindos. The four

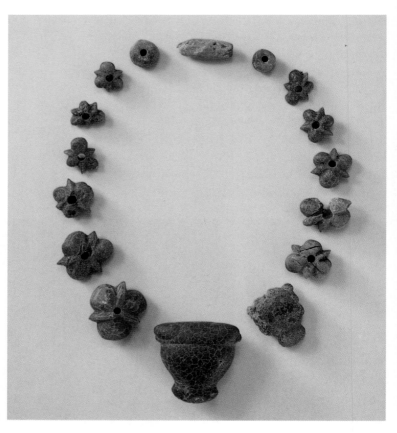

8399-8401

holes at the ends of this pentagonal piece were for a cord that was tied at the back of the head. The nose was covered by a separate piece.

The 32 cm strip 7949 was a funerary diadem sewn onto thick material. It has *repoussé* decoration consisting of two rows of guilloches.

Case 13. The six gold strips with *repoussé* guilloches (7947) were sewn on the hems of clothing, as was the triangular piece 7948. Two exquisite silver pins (7935) with gold heads in the form of stylized open flowers were used to fasten the front and back pieces of the chiton or peplos on the shoulders. Two plainer silver pins (8572) and a double pin (8573) served a similar

purpose, as did the pair of silver fibulae 8570, 8571. Two plain silver bracelets (8569) end in stylized snake's heads.

On the pedestal at the left of the case is a rare find from the cemetery, the silver kantharos 8568. Next to it is another rare find, the amber necklace 8399-8401. Most of the beads are in the form of a three-petalled flower, while the central bead and the one next to it are stylized ox-heads (bucrania).

Amber travelled to Greece from the Baltic from as early as the Bronze Age; the great distance is reflected in the myth of the Hyperborean Maidens.

Case 14. The basin 8531 on an iron tripod (8687), the oino-

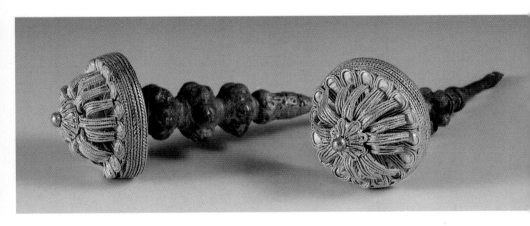

7935

choe 8549 and the tripod bowl 8548 are all bronze vessels designed for everyday use. The custom of placing such commonplace objects in the tomb along with the precious offerings certainly continued down to the 4th century BC, as is clear from the finds in the royal tombs at Vergina. The belief that after death the deceased would continue to have the same needs as in his earthly life also accounts for the models of a table and chair (8673 and 8674), which are found in several tombs, both male and female.

The bone rosette 8402 was an inlay for a wooden box, which has not survived. A faience bead and four others of glass paste belonged to a necklace. The kylix 7780 came from Attica.

Case 15 contains gold jewellery belonging to the dead woman of grave 20. The two biconical pendants 7944, 6 cm high, were made of gold sheet with applied filigree and granulated decoration. They perhaps both belonged to a single piece of jewellery, together with the much smaller parts of a necklace (7939-7943), which consisted of beads of various sizes and small pendants: two shaped like axes, six in the shape of vases, entirely covered with tiny granules of gold, four ring-shaped beads and a large, biconical pendant.

The finger-ring 7937 is solid, not an imitation in gold sheet

7944

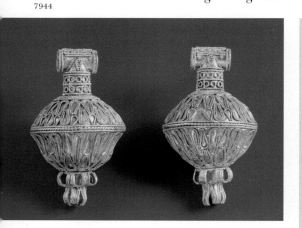

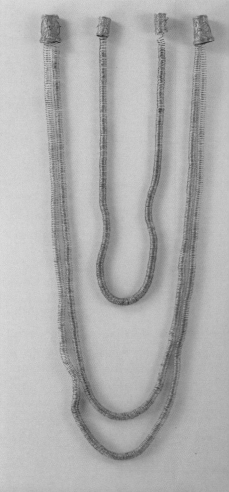

of the type found elsewhere. The two earrings 7936 are a typical piece of Macedonian jewellery of the Late Archaic period. Behind the flower that adorned the ear was a small hook which passed through the ear and fastened in the eyelet at the other end of the earring, which rested against the back of the lobe.

Case 16. The gold and silver necklace 8042 is a masterpiece of the goldsmith's art in terms of both design and technique. The silver chain, which is square in section, is made of eight intertwined braids. The ends are covered by fluted cylinders, from which project two pairs of chains ending in tubular gold finials in the form of snakes. Through the rings in the mouths of the snakes passed the pin-tongs of silver fibulae like those in case 13 (8570, 8571), which were used to fasten the necklace to the woman's shoulders.

The two necklaces (7945 a-b), made of coiled gold wire, are rare and striking pieces. The cylinders covering the ends of the wires have hooks by which they were attached, according to the excavation data, to a head-band or ribbon at the temples. This allowed the gold spirals to hang free at the front, below the middle of the body.

The two gold spirals of larger diameter (7946) are hair-clasps that adorned plaits or long tresses of hair.

The clay larnax (casket) 8751 contained the female burial 43, dating from the middle of the 5th century BC. The larnax itself, possibly of Ionian origins, had a pedimental lid in two pieces and is one of three clay sarcophagi discovered in the cemetery. It contained two Attic kylikes, a Co-

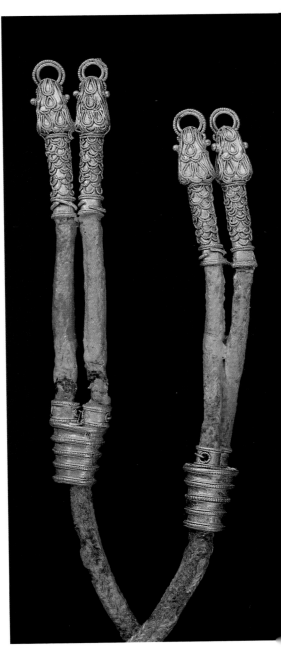

8042

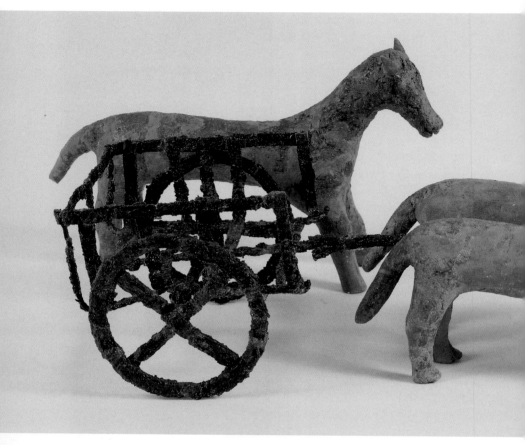

8651

rinthian exaleiptron, two double iron pins, two silver pins, two bronze bow fibulae, two silver earrings shaped like the Greek letter omega (Ω), and a silver finger-ring.

Cases 17-19, 21. Finds from grave 59, dating from the decade 530-520 BC, in which was buried a young boy.

Case 17. The iron model of a waggon (8651), and three figurines of mules were found next to grave 59. Two of the mules were yoked to the pole, and the third was walking alongside the waggon. They are made of unfired clay, and traces of paint are preserved on them. The waggon is a two-

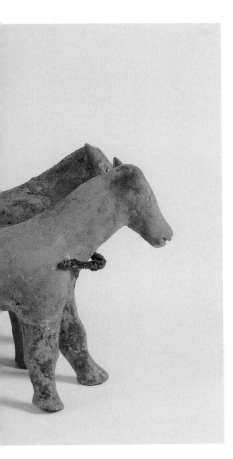

wheeled, rural type. Models of waggons, in slightly different shapes, have been found in other graves at Sindos, and also at Vergina and Pydna. They belong to the category of vessels that were thought to be needed by the deceased in the after-life, though they may also be models of the waggon on which the body of the deceased was transported.

Case 18. The graves at Sindos contained many bronze vases, notably bowls; in general these were found in a poor state of preservation, and only those that could be restored are on display. The bronze exaleiptron 8533 consists of two hammered halves, and stands on a cast three-legged base. The beaked jug 8527 is an imitation of a Corinthian model, and the trefoil oinochoe 8528 and the bowls with bosses 8534, 8536, 8542,

8527

8659 are vessels for everyday use. The bowls are decorated in low relief with linear designs.

The ribbon kylix 7802, with a black-figure scene of a horseman and standing male figures, is Attic, the clay aryballos 7796 with quatrefoil ornament is Corinthian, and the faience aryballos 7801, which is also a perfume vase, was made at Naucratis in Egypt or on Rhodes.

7800

Case 19. The same grave contained another faience aryballos (7799) which is certainly from Naucratis in Egypt, and is earlier than the other objects in the grave (590-550 BC), and also two clay Corinthian aryballoi from 550-525 BC (7797, 7798). The amphoriskos 7795, decorated with swans and panthers in two zones, is another Corinthian vase, dating from the first quarter of the 6th century BC. The small, high-footed plate 7800 is an Attic work dating from the beginning of the last quarter of the 6th century BC.

The three enthroned goddesses 8198-8200 are the products of an Ionian workshop. The bronze basin 8529 belongs to the category of semi-globular dinoi. The usual models of a three-legged table and a chair (8652, 8653) were accompanied by the iron knife 8655 and the model of a group of spits 8654.

Case 21. The custom of including personal objects appropriate to a mature man amongst the offerings deposited in a child burial is also found in other regions, such as Epiros. Here, in the child burial 59, was placed the equipment the boy would have worn when he grew up: the bronze 'Illyrian' helmet 8577 with applied gilded strips around the face-opening, the iron sword 8591 with fused wooden scabbard, and the two iron spearheads 8662.

8562

8577

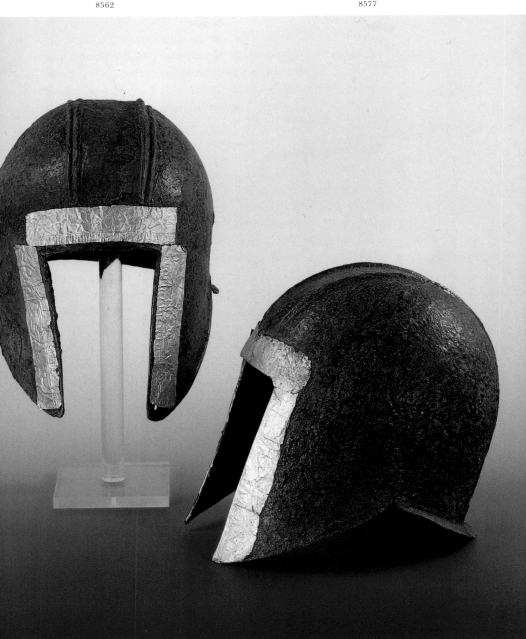

The solid gold ring 8486 was a finger-ring, and the silver pin with gold band 8487 was used to fasten the clothing of the dead boy. The gold strips of various sizes adorned his clothing or the straps on his scabbard, while the large triangular piece with *repoussé* triple rosette (8483) was probably attached to the breast of the chiton as an ornament.

Cases 20, 25, 26. The rich male grave 25 dates from about 540 BC; the finds from it are exhibited in cases 20, 25, 26.

Case 20. The bronze 'Illyrian' helmet 8562 has applied gilded strips around the face-opening with relief scenes: the eight-petalled rosette in the centre of the horizontal strip at the top is flanked by lions and boars, while the side strips have a variety of animals and birds.

The large rectangular piece of gold sheet 8020 is decorated with various animals and birds set in three horizontal zones; amongst the animals are a small rosette in the centre and two palmettes. The piece was found next to the dead man's skull, and since there was no mouthpiece, it

8020

8022

was probably used instead of a mask. Another large, perforated piece of gold sheet (8022), ending in four triangles was found on the dead man's breast, where it will have adorned his clothing. It is decorated with a *repoussé* rosette at the top, and has relief animals (a lion, a boar, an eagle and another lion) in the triangles at the ends.

Eight strips with a relief frieze of animals were sewn onto clothing; the finer strip 8027 possibly adorned the straps of the scabbard, while the small triangular pieces were perhaps attached to various parts of the scabbard itself. The finger-ring 8026 is solid gold, and 8029 is of gold sheet over a wooden core.

The model of a die (8018), of gold sheeted wrapped around a wooden core, is of some interest. The holes on the faces are conventional, and the model is not a completely faithful imitation of a genuine die.

Case 25. Grave 25 contained two fine Attic high-footed miniature kylikes with undecorated rims. The medallion, *tondo*, in the interior of 7840, dating from 550-540 BC, has a black-figure scene of a Siren, while that in 7839, of similar date, has a depiction of Pegasus. The two exaleiptra-perfume vases 7845 and 7846, and the two large and two small aryballoi

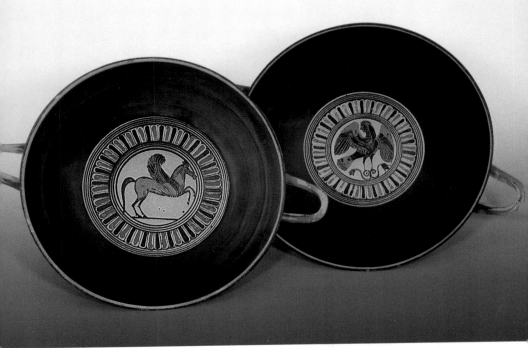

7839 7840

8215

7841-7844 came from Corinth.

The three small bowls with bosses have radiate decoration. The vase in the centre (8216), in the form of a dwarf, and the vase 8214, in the form of a girl, came from Ionian workshops in Asia Minor, as did the clay figurine of a clothed kouros (8222). The superb vase in the shape of a cock (8215), with painted black and red feathers, is of the same provenance.

Of the four Ionian figurines of enthroned goddesses (8218-8221), two are wearing the high head-dress called the polos. Two couples of seated deities from the same mould (8732, 8201), in which the male figure is larger than the female, also come from Ionia.

Case 26. Two bowls with bosses and two clay oinochoai, from Lesbos, Samos or Rhodes, all four of grey clay with a black glaze, are examples of Greek *bucchero* ware; the relationship of this style to Italian *bucchero* ware is the subject of much scholarly debate. The ware dates from the second quarter of the 6th century BC.

With the exception of the faience aryballos 7847, which hangs from a hook, all the other objects from tomb 25 are of iron. Models of household equipment designed for use in the after-life are represented by a bundle of fused spits for roasting meat, sitting on the supports (8640, 8641), a chair and a three-legged table, with two knives on it (8638, 8639), an iron knife (8668) and a two-wheeled waggon (8637), all of which are in a fairly good state of preservation.

The offensive equipment of the dead man includes the two

iron spearheads 8665, 8666 – to one of which a circular wood-en object has fused – the two swords 8595, 8663 and the single-edged knife 8664 with a handle in the form of a bird, which was originally sheathed in ivory. This type of dagger-sword made its appearance in the 8th century BC; the handle in the form of an animal is first found in the 6th century BC, and continued until Roman times. Both swords are also in a very good state of preservation; 8595 has the pommel pre-served, which is in the form of a cylinder sheathed with gold sheet. A gold sheet was also attached to the heart-shaped fin-ial of the scabbard. The other sword (8663) has a blade that widens at the bottom half; the pieces of gold sheet that bound the ends of the wooden scabbard are preserved on the hilt and the tip of the sword.

The two iron double pins (8028 and 8642) were used to fas-ten the clothing.

8632

Cases 22, 24. Finds from the male tomb 115, c. 520 BC.

Case 22. The pho-tographs next to this case show the inter-ior of the tomb after the covering slabs had been removed. Bones and objects were found moved by flood-water from the river. A cir-cular bronze shield which covered the legs of the dead warrior was found in a very rusty condition. Only one of the bronze bowls is exhibited, since it proved im-

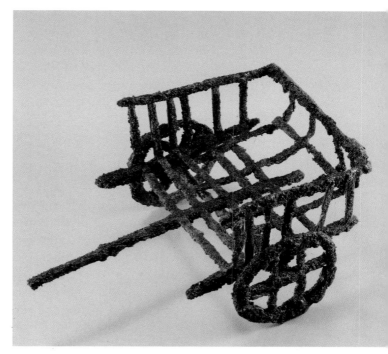

8017

possible to restore the others to their original form, because of their badly corroded condition.

The tomb contained three clay vases, the Corinthian exaleiptron 7837, the black-glaze kylix 7836 and the large Attic black-figure ribbon kylix 7835; this has a miniature scene depicting the battle of the Amazons in the decorative zone at the level of the handles (535-525 BC).

The trapezoidal gold sheet 8017 with a *repoussé* design of a radiate rosette adorned the centre of the deceased man's breast, and the gold pieces with triangular ends (8014) were attached to other parts of his clothing. A gold finger-ring (8013), a silver pin (8045) and an iron pin (8635) were the other pieces of jewellery accompanying the deceased. In this tomb, too, there were iron models of a table, chair, spits and a waggon (8632), the last-named of rural type. On the wall to the right are two iron spearheads (8643, 8644).

Case 24. The centre of this case is dominated by the tranquil figure of the dead man, as portrayed in the gold mask at the face-opening of the bronze helmet (7983, 8559). The scarcely perceptible smile recalls contemporary marble statues of kouroi. The closed eyes indicate death in Archaic art.

The facial features were probably worked by pressing the gold sheet on the dead man's face, or on a mould. To achieve a better fit around the nose, the sheet was cut open vertically and the resulting gap filled with a separate piece, attached to the back of the mask. The helmet is very well preserved. The parallel ribs on the crown, and the small hole on the forehead were for attaching the crest, which is now missing.

The warrior buried in tomb 115 had two very fine iron

7983 8559

swords, 63 cm long. A few traces of the ivory sheathing are pre-
served on the handle of sword 8593, and considerably more on
the wooden scabbard and the horseshoe-shaped finial, which
had an inlaid ivory plaque.

The handle of sword 8594 is in a better state of preservation,
with the gold sheathing of the conical pommel surviving. The
wooden scabbard is also in good condition, as is the trapezoid-
al finial with its bone plaques; these were decorated with *inta-
glio* rosettes, the depressions of which were filled with coloured
material. These swords are similar in all details to those depict-
ed on Late Archaic Attic vases.

Cases 23, 27, 28. These cases contain finds from the female
tomb 56, c. 510 BC.

Case 27. In this tomb, too, the face of the occupant was cov-

7835

ered by a gold mask (7981). The prominent cheekbones, narrow lips and deep hollows around them give the impression that the woman's face was already sunken from illness when the mask was formed by pressing the sheet of gold on it. The separate piece used for the nose was cut from a larger, decorated sheet of gold and attached to the outside of the mask.

Case 28. Two lekythoi are displayed in this case alongside the gold jewellery accompanying the dead woman in tomb 56. The Attic lekythos 7790 has a scene of standing men wearing himatia, and that from Euboea (7789) a depiction of a lion; both are from minor workshops. The jewellery, too, is not of the highest quality, and seems to be a simplified version of the superb pieces found, e.g. in tomb 20 (case 15). The pendants of the necklace 7956, which are in the shape of axes and amphorae, have no granulated decoration, while the disc-shaped heads of the silver pins (7957) are covered with a *repoussé* gold sheet, in contrast with the exquisite heads of the pins in tomb 20 (case 13). The gold strips 7951-7955 that decorated the clothing are just like those in the other tombs. The earrings 7958 are also a simplified imitation of those in tomb 20.

Case 23. The silver chain 8576 in the centre has deteriorated as a result of rusting; it is similar in type to that in tomb 20 (case 16), though simpler in form with only a single snake's head at each end of the chain. The bronze basins 8545, 8546 are vessels for everyday use. The Attic 'Droop'

7981

7980

kylix 7788, with floral decoration (535-520 BC), the plainer Attic kylix 7792 and the Corinthian jug with cut-away neck (7791) complete the list of grave offerings found with female burial 56.

Case 23 also contains four objects from the male tomb 37, dating from the beginning of the 5th century BC: the bronze strainer 8541, a vessel essential for filtering wine, the bronze basin 8538 and the ladle 8532 formed a set for serving wine, similar to the vessels associated with symposia found in 4th century BC tombs. The basin may have been used instead of a krater to contain wine, which will have been transferred, through the strainer, to the drinking cups or kylikes by means of the ladle. The fourth object from tomb 37 is the small iron tripod 8660.

Cases 29-37, 39. These ten showcases contain the grave offerings from the richest tomb in the Sindos cemetery, female burial 67, dating from around 510 BC. In contrast with what one might expect, this tomb consisted of a simple pit, and the dead woman was a very young, no doubt much-loved girl of twenty years.

Case 34. The central case has the large gold death mask, which is oval in shape and 22.2 cm in diameter. This mask dif-

fers from the ones described above in that the eyes are open, and the ears are indicated. The stylized ears and the fine lines of the eyes strongly suggest that the mask was made by being pressed on a mould. The nose was formed of a separate triangular piece.

Case 29. The black-figure hydria 7810 is probably from a Euboean workshop, around 525-510 BC. The shoulders of the vase are decorated with palmettes and lotus flowers. The panel below the flowers depicts two couples between a man wearing a himation at the left and a standing woman at the right.

The complete group of iron models for the deceased woman's use in the after-life was represented in tomb 67: the waggon is again the four-wheeled rural type (8646); a seat (8690), a small three-legged table (8689), iron spits and their supports (8647, 8691); a bronze bowl with a boss (8552).

Apart from the jewellery and the weapons, no distinction

7810

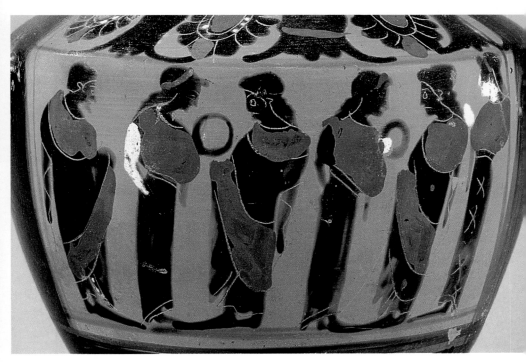

7974

was made between the sexes in the offerings placed in the tombs at Sindos.

Case 30. The Attic 'Droop' kylix 7811, with floral decoration, dates from around 525-510 BC. The basin 8554 and the jug 8555 are everyday vessels used for cooking, while it seems likely from their frequent presence in the tombs of Sindos that the bowls with bosses probably served as plates or drinking glasses.

Case 31. In the centre are two glass amphoriskoi-perfume vases (7812, 7813), a pair of silver bracelets (8407), a silver pin (7984) and a ring (8696). At the left a silver bowl with a boss (8574) and one of bronze

7972

(8553). At the right is a bronze exaleiptron-perfume vase (8695) and an Attic black-figure kylix of 'Cracovia' type (8287).

Case 32. Long dentilated gold strips were sewn to the clothing of the dead woman. At the left are a pair of earrings with drops of rock-crystal suspended from two concentric silver rings (7974). They will have been fixed to the lobe of the ear by means of a hook which has not survived. Alternatively, they may have been part of a pectoral ornament.

The gold horizontal piece of jewellery 7972 probably adorned the woman's breast.

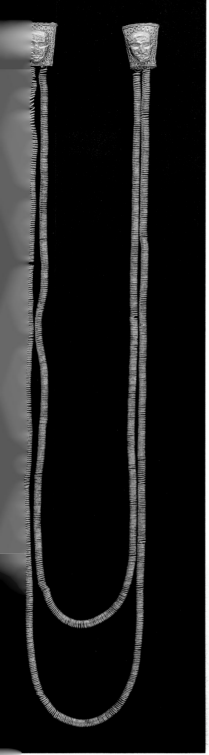

Case 33. The piece of jewellery 7968, 7969, consisting of two rows of coiled gold wire, is similar to that in tomb 20 (case 16), with the difference that the truncated cone at the ends has a relief gorgoneion. These tubular cones were fastened with hooks to the headband or the wreath at the temples, while the free spiral swung to and fro in front of the woman's body as she walked.

The pair of earrings 7975 is the largest and best finished in the entire cemetery at Sindos (diam. 5.5 cm). The complex flower that sat in front of the lobe of the ear is worked in granulated and filigree techniques, and was accompanied by two

7975

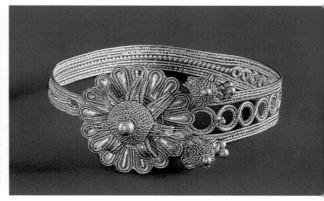

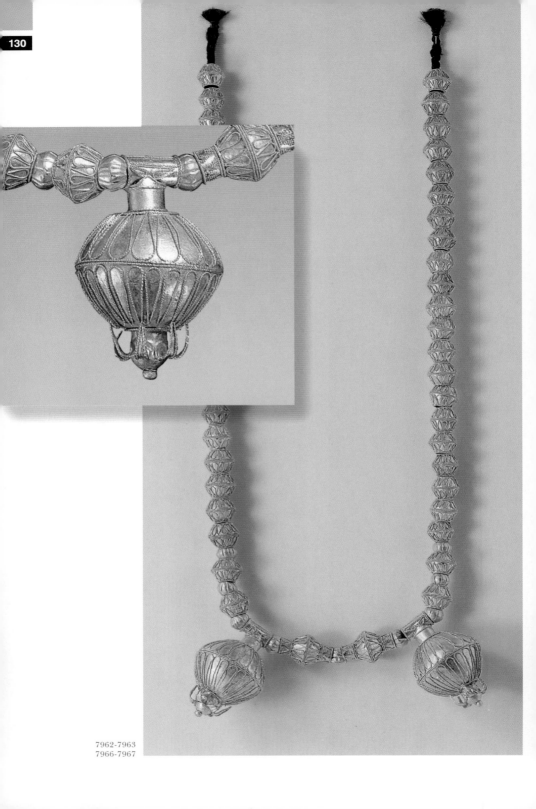

7962-7963
7966-7967

smaller flowers. For the way in which they were worn, see the similar earrings in cases 15 and 62.

Case 35. This case contains the most precious necklace found in the tombs at Sindos (7962-7963, 7966-7967). It consists of two pendants in the forms of pomegranates and 58 beads, of which 46 are biconical. They are made of sheets of gold decorated with filigree foliate designs. The shapes of the beads of this necklace are not new: they occur in bronze, with smooth surfaces, in central Macedonian tombs from the 7th to the 5th centuries BC. At Sindos precious metal was used and the technique was unsurpassed. The gold ring 7973 is solid, with a convex outer face and a straight inner one.

Case 36. The pendants of the necklace 7964, in the shape of flames and pomegranates, are incomparable masterpieces of granulated decoration. This technique requires each microscopic granule of gold to be applied very swiftly, and at the correct high temperature, to the gold surface of the object to be decorated, in this case the pendant.

Case 37. The gold chain 7970, which is similar in design to that found in tomb 20 (case 16), is made entirely of gold and is perfectly preserved. This chain was fixed on the woman's breast at the level of the shoulders, by means of the gold fibulae 7976,

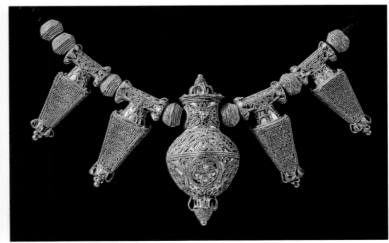

7964

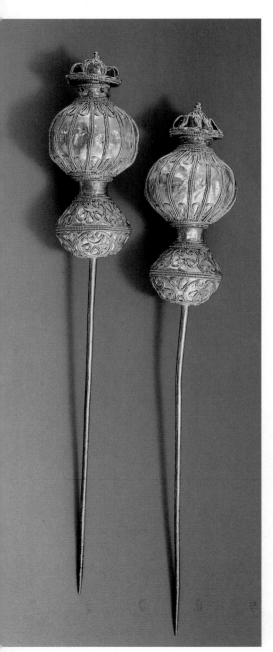

7971

the pins of which were passed through the rings in the mouths of the snake's heads on the necklace.

Case 39. The two gold pins 7971 from tomb 67 (c. 510 BC) are the largest (26 cm long) and finest discovered at Sindos. The double heads are concave and contained resin to prevent them from being squashed together and losing their biconical or spherical shape. They end in flowers, and have filigree decoration.

Case 38. The Attic red-figure bell-krater 7859 (440 BC) is from male tomb 14. The front has a depiction of a young traveller wearing a chlamys and petasos (kind of hat), chasing a young girl holding a hydria. It is probably a scene from mythology (Peleus and Thetis?).

Case 40. This case contains the grave offerings from tomb 76. They are dated to around 410 BC on the basis of the Attic aryballoid lekythos 8311, which is later than the rest of the pottery in the tomb and dates from 415-405 BC. The other vases are Attic black-glaze ware: the cup 8313 dates from the first half of the 5th century BC, the kylix 8310 with impressed decoration in the interior to 450-430 BC, and the piriform amphoriskos 8312 with impressed circles and palmettes to about 435-420 BC.

The bronze helmet 8565 is of 'Illyrian' type, from the hand of a good craftsman. Two large iron spearheads (8608, 8609) formed part of the dead

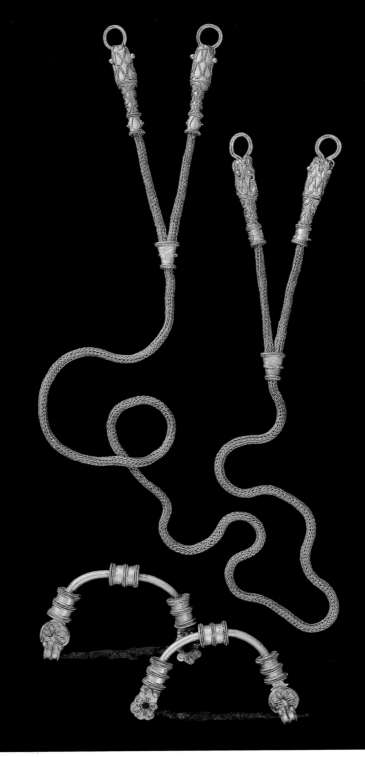

7976 7970

man's equipment, and his mouth was covered by a gold, lozenge-shaped mouthpiece (8432).

Silver double pins with case, like the pin 8458, were normally used by men to fasten the chlamys.

Cases 41, 45-47. The rich male tomb 52, dating from the last decade of the 6th century BC, contained a larger number of pieces of gold sheet than any other male tomb at Sindos.

Case 41. Two glass amphoriskoi-perfume vases (7821, 7823a) of rippled white and brown glass, with ribbed bodies. From an Aegean workshop.

Of the large number of pieces of gold sheet in this case, the rectangular ones and the three-sided piece (7996-8000, 8002) were probably sewn onto the garment or leather breastplate that covered the deceased man's breast, and the long narrow ones onto the hems of his clothing. The two with triangular finials (8012, 8499) probably adorned his shoes.

8575

Case 45. The Attic blackfigure kylix 7820 has two large eyes on each side, to ward off evil ('apotropaic eyes'). Between them is depicted Dionysos, seated, holding a rhyton, with a Satyr dancing in front of him; in the background is a vine shoot. The circular emblem inside has a painted Silenus (about 510-500 BC). The silver bowl 8575 with gilded boss is a precious vase that was used for making liquid offerings (libations) to the gods, heroes and the dead. The embassed decoration consists of a lotus flower.

The bronze jug 8526 is a vessel for everyday use that nonetheless had its place in sacred ritual. The silver double pin 8004

had a gold head and was used to fasten clothing. A long iron sword (8596), with traces surviving of the bone sheathing on the handle and of the wooden scabbard, formed part of the dead man's equipment, as did two iron spearheads 8585.

Case 46. Two more glass amphoriskoi (7822, 7823b), similar to the ones in case 41, also come from tomb 52. A large number of pieces of gold sheet, which were sewn to the clothing and attached to the shoes and the sword, together with the large lozenge-shaped gold mouthpiece 8498, help us to form a picture of the dead man, who was completely surrounded by gold when he was placed in the tomb to face eternity.

Case 47. This is the only example in the Sindos cemetery where the models of a waggon (8648), chair (8650) and table

7820

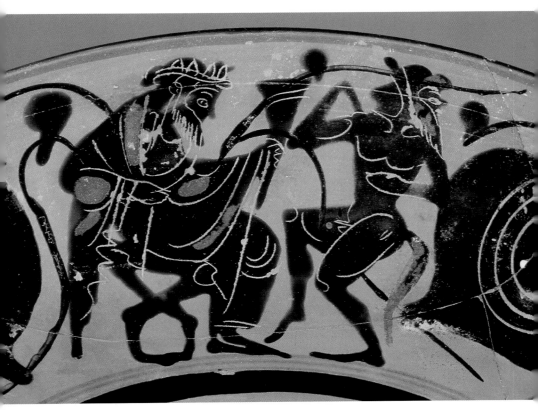

(8649) were made of bronze sheet, instead of iron. Particular interest attaches to the details of the model of a rural waggon (8648), which has a rectangular box at the back.

Case 42. This case contains the finds from two female tombs (96 and 75).

In tomb 96 (450-440 BC) were found the Attic red-figure cup 8368 with a scene of a woman sitting on a rock wrapped in her himation; the lozenge-shaped piece of gold sheet 8509 with a *repoussé* multi-petalled rosette in the centre; the gold pendant 8752 with granulated decoration; the bronze tweezers 8717; the pair of silver earrings 8718, which were suspended from the ears with the help of a fine open ring, which has not survived; and the silver chain 8719, which was fastened to the dead woman's shoulders by the four silver fibulae 8720. Three other variations of this piece of jewellery have been found (in solid gold, and in silver and gold, see cases 5, 16, 23, 37).

Tomb 75 (470-450 BC) contained the Attic black-glaze cup 7740, the Corinthian exaleiptron 7741, the lozenge-shaped piece of gold sheet 7923 with a multi-petalled rosette between two palmettes, and the two silver pins 7924, 7925.

8648

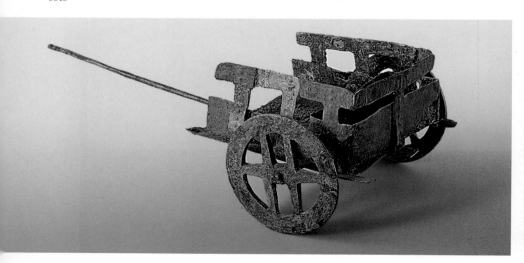

Cases 43-44. Grave offerings from the male tomb 66 (about 540 BC).

The clay vases from this tomb reveal the wide range of provenances of the objects found at Sindos, and also the extent to which a 6th century Macedonian township was acquainted with the various regions of Greece and the Mediterranean.

The Attic black-figure krater 8327 (case 44) has been attributed to the 'Louvre F6 painter'. The main face has a scene of a warrior's farewell, showing a hoplite with a circular shield amidst five men wearing himatia. The back has two panthers in a standard heraldic composition, with an aquatic bird between them.

8327

7923

8424

In *case 43* the orange jug with cut-away neck (8329), of about 550 BC, was made in a Macedonian pottery work-shop, in which this shape, and the technique of burnishing the belly of the vase with a scraper, had a long tradition. The exaleiptron 8328 is a local Corinthian vase, and the small kotyle 8330 was probably made in Boeotia: the male figure between the two aquatic birds is perhaps an echo of a theme from mythology.

In the same tomb was found the lozenge-shaped piece of gold sheet (8424), the model of a gold finger-ring (8425), and pieces of gold sheet in a variety of shapes, used to decorate the leather strap and scabbard of the iron sword 8597. A short iron sickle-shaped knife had stuck to the wooden scabbard as a re-sult of the effects of rusting. The two iron spearheads (8615) are also rusted together.

Case 49. This case contains finds from two contemporary tombs, the female burial 102 and the male burial 87, dating from about 530-510 BC.

In the female tomb 102 were found three clay vases. The At-tic black-figure cup 7870 has a main decorative zone between the handles depicting a runner between two men wearing hima-tia, and on the other side a sphinx between men wearing hima-tia (about 530-510 BC). The exaleiptron 7871 is an imitation of a Corinthian model, and the kantharos 7869 is of Ionian origin.

8234 8236

In the male tomb 87 was found a genuine Corinthian exaleiptron (8377) with a decorative foliate band on the upper surface (about 530-510 BC). The lozenge-shaped piece of gold sheet 8511 covered the mouth of the dead man, and the piece of gold sheet in the shape of a ring (8510) possibly encased a wooden finger-ring.

The two iron spearheads 8606, rusted together, the iron sword 8598, and the bronze helmet 8564 were the basic weapons in the defensive and offensive equipment of the dead warrior.

Case 50 contains finds from tombs 53 and 119.

In the male tomb 53 (550-525 BC) was found the Attic kylix 7850, which is an imitation of a Corinthian 'Sianna'

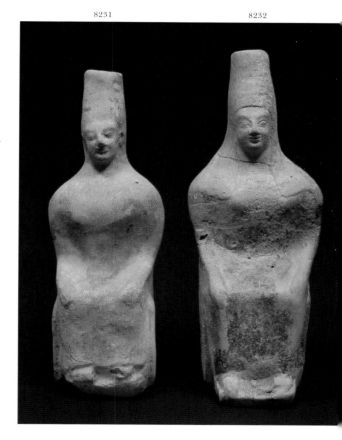

8231 8232

kylix, a type predominant in the 2nd quarter of the 6th century BC. It dates from the decade 560-550 BC. The Corinthian exaleiptron 7851 was also found in this tomb, in a very poor state of preservation, along with a seated figure (8224) and a perfume vase worked in the shape of an Ionian kore holding a bird in front of her breast with her left hand (8223). This vase was produced in an Ionian workshop, as was the enthroned goddess 8224.

The finds exhibited from the female tomb 119 (560-550 BC) are a small Ionian kylix (7879), an Ionian kotyle (7880), and two lozenge-shaped mouthpieces with *repoussé* rosettes in the centre (8060, 8061).

Cases 48, 51-54. These five showcases contain the finds from the female tomb 28, one of the earliest in the cemetery, from about 560 BC.

Case 48. The case is dominated by the plastically worked perfume vases: 8233 in the form of a Siren, and five in the form of birds, which are similar though of differing dimensions (8234-8238). These were made in an Ionian workshop in Asia Minor; the stylized birds' wings are in black and red paint.

Also from an Ionian workshop are the two figurines (8231, 8232) of an enthroned goddess wearing the ritual tall headcover called a polos. Similar figurines were found in tomb 25 (case 25).

8082-8092

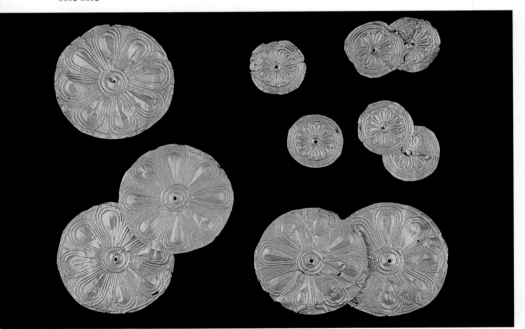

Case 51. The clay vases from burial 28 are also from a variety of different origins. The piriform amphoriskos 7895, which was used as a perfume vase and the kylix of Ionian type (7896) are both Attic products dating from about 575-565 BC. The annular aryballos 7900 is from Corinth, as are the three globular aryballoi: 7897 is decorated with a panther and a bird, and

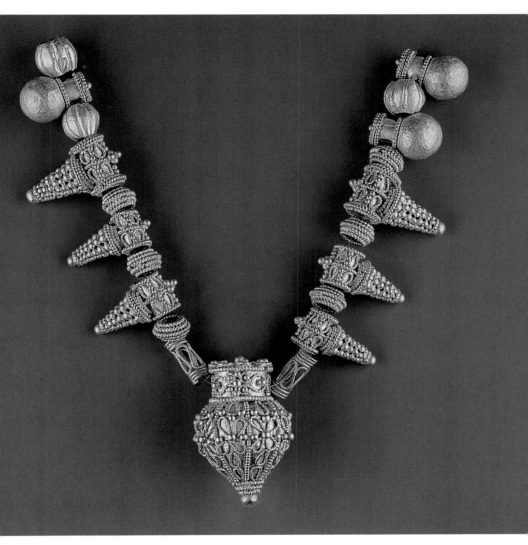

8091

7898, 7899 with a quatrefoil ornament. The five black alabastra 7901-7904, 7911 belong to the category of Ionian *bucchero* ware, and were probably made on Rhodes.

Case 52. In cases 52 and 53 are displayed the dead woman's jewellery. For the second time at Sindos we have a necklace

8079 8080

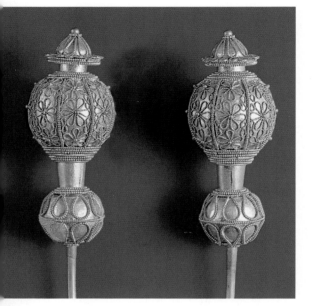

made of amber (8090); it consists of 24 biconical (actually polyhedral) beads. When buried in the earth, amber loses its familiar translucent honey colour and becomes a brownish-red.

The gold necklace 8091 consists of 20 beads of assorted shapes and a central pendant in the shape of a piriform vase; the combination of filigree and granulated decoration and the contrast with the smooth surfaces of the spherical beads lends a special charm to this masterpiece of the Macedonian goldsmith's art.

Instead of the usual strips of gold sheet, tomb 28 contained gold disc-shaped pieces (8082-8022), decorated with rosettes, in three groups with different diameters; there were two cut-out rosettes (8086, 8087), curving towards the bottom edge so that a rosette in a different material could be attached to them. The other rosettes were probably attached to cloth.

Case 53. The two gold pins 8079, 8080, 21 cm long, are 5 cm shorter than the longest pins in tomb 67 at Sindos, which are on display in case 39. They are made with the same technique and possibly in the same workshop, and consist of a spherical and an ovoid head, crowned with a stylized flower. The gold sheeting of the heads is decorated with filigree rosettes and leaves.

The gold earrings 8094 are of the type familiar at Sindos, though they are smaller than the others. The gold finger-ring 8089 is solid, though it is doubtful whether so large a ring (2.5 cm in diameter) would have been worn on a woman's finger. Six small bone spheres with iron shafts (8711-8714) are pins of a type not known in the other tombs at Sindos.

The lozenge-shaped mouthpiece 8093 has a unique subject

8093

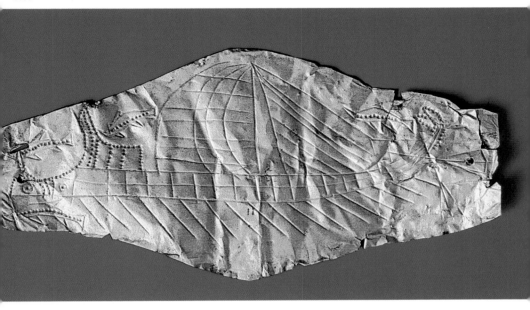

depicted on it: a ship with 18 oars and two rudders at the stern and its sail swollen by the wind moves over the ocean, indicated by four lively dolphins. The details are faithfully reproduced in a manner that suggests that the inhabitants of the ancient township of Sindos had a clear knowledge of ships and the world of the sea. The portrayal of a ship on the piece of gold that sealed the mouth of the deceased will not have been related to the person's profession, for this is a female burial; the decoration on these mouthpieces was probably of no particular significance, as is clear from the frequently random cutting of the decorative motifs.

Case 54. With the exception of the iron pins 8706 and the two knives 8610, all the objects in this case, from tomb 28 (about 560 BC), are miniature models of objects relating to the belief that the daily routine of the dead person continued after death, as saw in the case of offerings deposited in other graves.

The long narrow waggon 8636 had a curved cover – parts of the frame and the arch at the bottom right – and a long pole with a yoke for the beasts that pulled it. The seat 8656 is not in

a good state of preservation, and the table 8707 is, for the first time, round rather than rectangular. There is also the usual group of spits and two supports (8657, 8658).

Cases 55, 56, 58. These cases contain the grave offerings from the male tomb 62 (about 520 BC).

Case 55. The plemochoe 7806 and C-type kylix 7805 are two masterpieces of Attic pottery, with their impressive harmonious proportions and technical perfection. The kylix dates from the last quarter of the 6th century BC, and the plemochoe is slightly earlier (540-510 BC). The handle on the lid had broken off, and the ancient holes around it attest to attempts to repair it with lead clamps in antiquity.

Case 56. In the face-opening of the bronze 'Illyrian' helmet 8661 that accompanied the dead man in tomb 62 were found the remains of a gilded iron mask, of which parts of the eyes and mouth are preserved. The eyes are open and the mouth has thin lips turned up at the corners in the restrained, Archaic smile. The nose is covered by a separate piece of gold sheet. If this were better preserved, it would be the finest mask at Sindos.

Case 58. The man interred in tomb 62 had the longest iron sword in the cemetery – 68.5 cm long. The handle had an ivory sheathing attached by a cruciform piece of iron. At the end of the handle, the pommel consists of an ivory disc with gold sheathing and inlaid decoration, forming an iron eight-petalled rosette. The wooden scabbard is preserved in several places.

The two iron spearheads 8724 were found rusted together, as usual, with traces of both thick and fine cloth on them.

The few gold strips found in the tomb perhaps adorned the sword. The gold finger-ring 8044 is of gold sheet, and therefore a model of a real ring. The silver double pin 8035 has applied gold sheet at the head.

The bronze beaked jug 8525 is restored in several places; the attachment discs at the tops of the handles have incised rosettes. The bronze basin 8530 belongs to the category of circular trays which were frequently used to serve wine.

Case 57. The dead warrior in the male tomb 105 (510-490 BC) wore the bronze Corinthian helmet 8566, decorated with a narrow band of incised running spiral pattern around the face-opening. The iron sword 8599 was sheathed in a wooden scabbard, of which all that survive are a few traces of the wood and part of the iron pommel, and the horseshoe-shaped finial that protected the point. The equipment is completed by the iron spearheads (8619, 8620) and a curved dagger (8721).

The lozenge-shaped piece of gold sheet 8442 is decorated with three *repoussé* rosettes amongst scattered rosette-leaves; the ring of gold sheet 8443 was perhaps the sheathing for a wooden ring.

Three plain clay vases were found in the same tomb: the grey cauldron 8371 and the exaleiptron 8372 from local workshops and the kotyliske 8373 from Corinth.

Case 59. The female tomb 38 dates from the period of the Early Classical style (480-460 BC), to which belongs the clay protome 8210: the young goddess is wearing a Doric peplos and her hair, apart from a few curls above the temples, is hidden beneath the headcover. A Corinthian exaleiptron (7829) and two clay models of fruit, a pomegranate (8211) and a fig (8212), were also deposited in the tomb.

In the female tomb 101, which is one generation earlier (510-480 BC), were found the Corinthian exaleiptron 7868, the kantharos 7867, which represents the local tradition, though with several Ionian features, the gold mouthpiece 8063, the 'Sindos' band earrings 8064, 8065, the gold axe 8059, and the three gold roundels 8066. The last named were found on the

7806

dead woman's skull, and were probably attached to a cloth ribbon to form a simple diadem.

Case 60. Finds from two female tombs. Tomb 113, about 450 BC, contained a clay vase, the Attic black-glaze kotyle 8340, the gold mouthpiece 8436 with a *repoussé* rosette in the centre and palmettes on volutes in the narrow angles, and also several pieces of jewellery: the piriform gold pendant 8437, two pairs of silver bow fibulae (8468, 8469), two silver bracelets (8467) with large snake's heads at the open ends, two silver earrings (8466) in the shape of the Greek letter omega (Ω) which were fastened to the lobe of the ear with the aid of an open wire ring, and the gold band 8438, which was found on the dead woman's skull, suggesting that it was used as a diadem.

The female tomb 49, of the second quarter of the 5th century BC, contained similar silver jewellery and two clay vases: the black-glaze cup 7818 from Attica and the Corinthian exaleiptron 7819. The lozenge-shaped gold mouthpiece 7991 is decorated with palmettes and lotus flowers. The silver jewellery consists of a pair of earrings in the shape of the Greek letter omega (8701), a silver pin (8700), two pairs of bow fibulae

8047

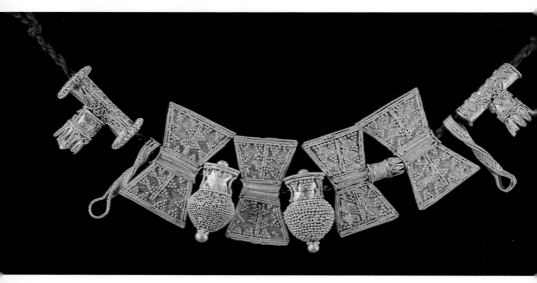

(8697, 8698), two bracelets with snake's heads (8702), and a finger-ring of silver sheet (8699). A small bronze bow fibula (8703) was also found in the tomb.

Case 61 contains finds from the male tomb 57, about 520 BC. The dead warrior was placed in the tomb accompanied by his weapons: the bronze 'Illyrian' helmet 8558, the iron sword 8727, and the two iron spearheads 8728, 8229. He was wearing a silver double pin (7912) with a head in the shape of a poppy, enclosed in gold sheet. The ivory finger-ring 7916 was also covered with a piece of gold sheet. The many gold strips and triangles adorned the dead man's clothing, as in the other tombs at Sindos.

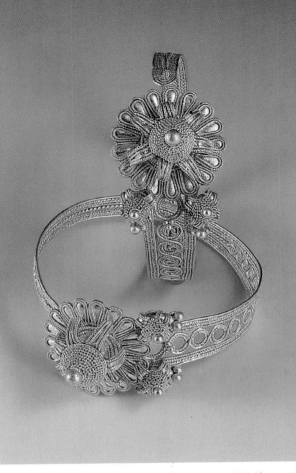

8045-46

Case 62. The female tomb 48 (525-500 BC) contained a Corinthian exaleiptron (7853) and gold and silver jewellery. The necklace 8047 with attachments in the form of axes, amphorae and other shapes, is one of the finest examples of the goldsmith's art at Sindos, with flawless granulated decoration. Filigree technique was used in the earrings (8045, 8046), which have the familiar perforated band, with a superb flower on the free end at the front. This part of the earring adorned the lobe of the ear; at the back of it there was a hook that passed through the pierced lobe and fastened into the eyelet at the free end of the band.

The pieces of gold sheet 8048, 8051 belonged to a ribbon diadem that adorned the skull. Two silver pins with disc-shaped heads (8726) and two bow fibulae completed the dead woman's jewellery (8725).

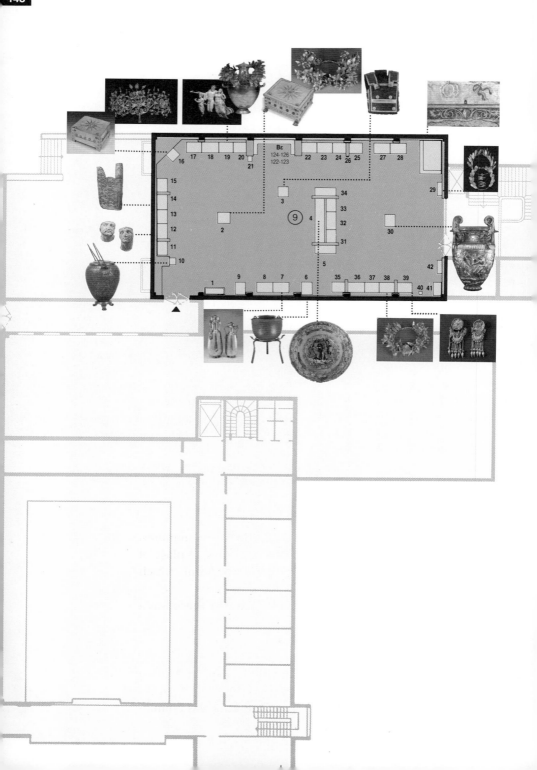

Bε
124-126
122-123

ROOM 9 Vergina and Derveni Exhibition

Vergina is near Veroia, on the site of ancient Aegae, the first sacred capital of the Macedonians.

On 8th November 1977, the lengthy investigations of Professor Manolis Andronikos at Vergina reached their climax with the opening of an unplundered royal tomb, followed a few months later, in 1978, by a second tomb, also unplundered.

The initial suspicion that the first larger tomb belonged to Philip II, the father of Alexander the Great, became certainty a few years later, with the completion of the study of the bones by J. Musgrave. The observation that there was a healed wound in the bone above the right eye accords with the statements in the ancient historians that Philip was wounded in the right eye at the battle of Methone in 355/4 BC, causing him to lose the sight in it. The dates of the objects found in the tomb are also completely consistent with the known date of the death of Philip II, who was murdered in the year 336 BC while entering the theatre of Aegae in a procession for the wedding of his daughter Cleopatra.

Both these unplundered tombs were well protected from robbers beneath Megali Toumba (Great Tumulus) at Vergina, an artificial hill of earth 110 m long and 12 m high. The tomb of Philip II is one of the largest Macedonian tombs known, being 9.50 m long and having two chambers. Between the Doric columns of the façade a double door opened onto the antechamber, from which a second door led to the main chamber. Above the Doric epistyle and the triglyphs there was, in place of the pediment, a painted frieze depicting a hunting scene, which is a landmark in the history of ancient Greek painting.

In both the antechamber and the main chamber there was a marble chest, which concealed a gold casket (larnax) containing the bones. Each chest was surrounded by an assemblage of truly regal grave goods, leaning against the walls or fallen from shelves and tables: gold, silver, bronze and iron accompanied the deceased to their final residence.

The excavation data suggest that the dead king was cremat-

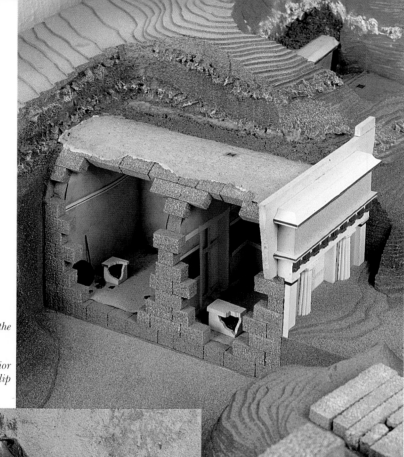

Vergina. Model of the tomb of Philip II.

Vergina. The interior of the tomb of Philip II, detail.

ed on an imposing pyre, lying on a precious bier and wearing on his head the valuable gold oak wreath that was found inside the larnax. The pyre was probably extinguished before the body was completely incinerated, so that the bones could be collected, washed in wine, wrapped in the purple, gold-embroidered cloth, and deposited in the casket. The bones were deformed and crumbling, fragmented as a result of the fire. The small size of the skeleton is striking; it is undoubtedly due in part to the fact that Philip must have been a short man, though partly also to contraction of the bones as a result of the cremation.

Bε 8

After the pyre had been extinguished and the bones of the dead king collected, the charred remains of wood and objects thrown into the pyre along with the body, and parts of brick structure probably built to support the bier, were taken and deposited on the vault of the tomb. The same custom has been observed during the excavation of smaller cist graves in various parts of Macedonia.

Case 1. Model of the Great Tumulus with the two unplundered royal tombs. Scale 1:300. The model was made in 1978 for the exhibition 'Treasures of Ancient Macedonia', before the façades of the tombs had been completely uncovered.

Cases 2-12 contain objects from the burial chamber of Philip II.

Case 2. In the centre of the room is displayed the gold casket (larnax) that contained the bones of Philip II, wrapped in purple cloth, of which only a few traces have survived.

The gold casket has the shape of a rectangular box, meas-
uring 41 x 34 x 20.5 cm (Bε 8). Made of hammered solid gold
sheet, it weighs 7.82 kilos. In the centre of the lid are two ro-
settes, one set inside the other within a relief circle, with in-
laid blue glass paste in the petals of the inner rosette,
and surrounded by sixteen *repoussé* rays. This is
probably a primeval symbol of the sun, and is
quite common in Macedonia from the 6th cen-
tury onwards, and not only in royal tombs.
From as early as the time of Philip II,
however, this star-symbol probably
had an official character, since it is
clear, both from surviving shields,
and from depictions of them on
coins, that a few decades later it
formed the basic decoration of the
Macedonian shield. The vertical
sides of the casket have three zones
of decoration. The narrow central
zone has five *appliqué* rosettes inlaid
with blue glass paste. The top zone
is decorated with relief palmettes
and lotus flowers, hammered from
the inside in the *repoussé* technique,
and the broader zone at the bottom
has a complex floral motif: tendrils
with small flowers and leaves spring
from a central calyx with leaves and acanthus flowers and
wind to the left and right. The vertical posts at the corners
are decorated with double rosettes and end in lion's paws
that supported the larnax. The four round studs on the lid
and the front may have been part of a system to fasten the
larnax from the outside.

The harmonious proportions, flawless workmanship and
the precious metal used all make this large royal larnax from
Vergina a unique work of art. It was probably used during
Philip's lifetime to hold jewellery, as indicated by the depiction

Bε 8

Βε 17

of a gold or bronze larnax in the wall-painting in a cist grave at Aineia (in the north-east corner of the Vergina room).

The gold wreath with oak leaves and acorns (Bε 17) is the heaviest and most impressive wreath surviving from Greek antiquity. It has 313 leaves and 68 acorns, and weighs 714 gr; it will originally have been heavier than this, since several of the leaves are missing.

The central section is deformed and a number of gold acorns were found amongst the remains of the funeral pyre, which were placed on the vault of the tomb (see p. 151), demonstrating that the dead king was wearing the wreath when the pyre was lit, though it was removed before it was destroyed, so that it could be preserved with the bones in the larnax. Of unique size and beauty, the wreath is as worthy of a king as is the superb larnax.

The ancient Greeks wore wreaths on a variety of different occasions: at banquets, at sacred ceremonies in honour of the gods, and at weddings. Wreaths were also placed on the bodies of the deceased when they were buried. Gold funerary wreaths are usually imitations of shoots of myrtle, laurel, olive or oak.

Case 3. The warrior king's cuirass is the

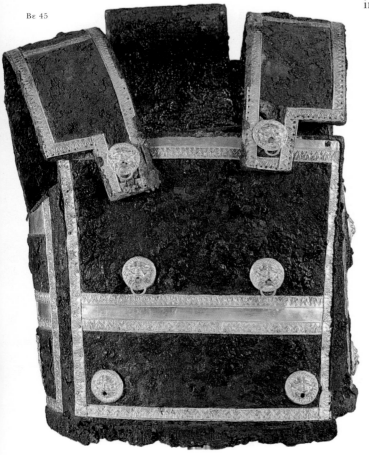

Bε 45

only iron cuirass surviving from Classical times (Bε 45). It is composed of nine sections, fitted together in such a way that they open out completely to form a flat surface. The chest piece consisted of two sheets of iron, one above the other, and the back piece had a rectangular projection at the top to protect the back of the neck. The inside was lined with leather and cloth. The bottom edge had a piece of leather fastened to it, to which were attached leather flaps to protect the belly; of these, only the decoration has survived, which consisted of a double row of gold strips. Gold strips with relief egg and dart pattern adorned the edges

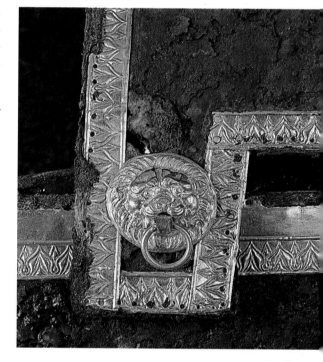

Bε 45

and the middle of the cuirass, and there were eight gold lion's heads holding rings, through which were passed the leather cords by which the front plate was attached to the side and the shoulder pieces to the front. All these details are also found in the cuirass worn by Alexander in the Naples mosaic, depicting the battle of Issus. A rectangular plaque with a small relief figure of the goddess Athena, the patron goddess of warriors in battle, was sewn to the leather at the right side of the cuirass.

Case 4. In the centre is Philip II's gold and ivory shield (Bε 121); at the left are the attachments from the inside of the shield; the small bronze bowl (Bε 22) at the right appears to have been used as a makeshift cover for the shield in the tomb.

This is the only gold and ivory ceremonial shield to have survived from antiquity. A piece of leather with a curving surface was stretched over a wooden frame, and on this was spread a thin layer of gilded white plaster, that acted as the

background for the main composition – the ivory emblem which has been preserved in a poor condition: a young woman kneels in front of a naked young man with his himation blowing behind him in the wind. It is possible, though not sure, that this is a representation of Achilles vanquishing the Amazon Penthesileia. The perimeter of the shield has two zones of running spiral pattern framing a broader band with an ivory maeander in which are set square glass plaques and four gold plaques with the relief radiate sun.

On the inner face of the shield are two strips of gold intersecting at right angles, decorated with relief Victories and ending in palmettes that project outside the circular strip around the rim. At the centre is a series of rectangular and trapezoidal pieces of gold decorated with relief lions; to this was attached a broad leather strap, through which the warrior passed his forearm before grasping the semi-circular handle, next to one of the palmettes. The ivy leaves and studs scattered over the surface had strips of leather attached to them.

Case 5. This contains the iron defensive and offensive equipment of the dead king, and also a cylindrical bronze torch (Βε 1) with an iron shaft that was attached to a wooden pole.

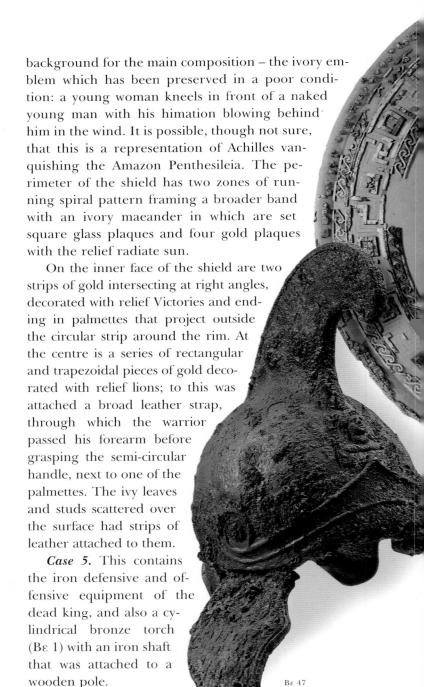

Βε 47

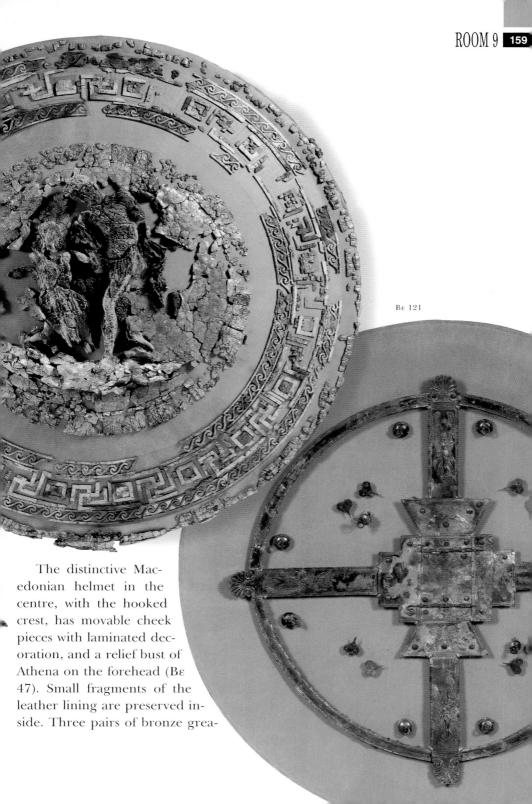

Βε 121

The distinctive Macedonian helmet in the centre, with the hooked crest, has movable cheek pieces with laminated decoration, and a relief bust of Athena on the forehead (Βε 47). Small fragments of the leather lining are preserved inside. Three pairs of bronze grea-

ves and an iron pectoral (Bε 48) complete the defensive equipment, which also included a shield with a bronze sheathing that could not be restored.

Six iron spearheads were found in the tomb, and also a pointed iron spike from the butt of a spear (Bε 31). The largest spearhead possibly came from a *sarissa*, the spear carried by Macedonian hoplites (Bε 33). All these items exhibit great technical and artistic ability, indicating a high level of competence in iron-working. Further evidence for this is furnished by the two iron swords, especially the larger one (Bε 49), which was deposited in the tomb in its scabbard, of which the ivory reinforcements for the top and bottom edges of the scabbard survive, along with several pieces of wood. The arms of the hilt are of gold, and there is a gold palmette in the middle of each side. The pommel, of bone or wood, was adorned by two gold rings, and the end of the iron shaft is concealed by a tiny 'Chalkidian' helmet, 1.5 cm high, with a sphinx in place of the crest and a relief lion on the cheekpiece.

Bε 42-43

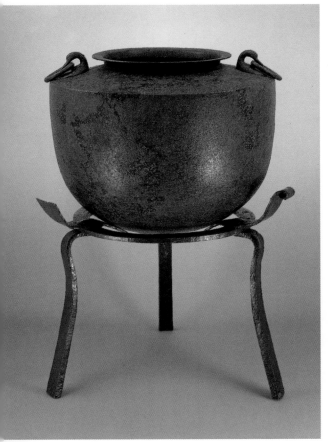

Case 6. Next to the bowl used as a cover for the shield, in the south-west corner of the tomb, was deposited a variety of bronze everyday vessels. The large basin found overturned on its iron tripod (Bε 42-43) is particularly striking, with its harmonious proportions and cast handles. The majority of these bronze vases in the south-west corner

of the tomb form a group of vessels used for bathing: the bowl, shield-cover, could be used as a bathing-tub. Indeed, a large sponge was found on the floor of the tomb, in front of the lid of the situla with the semi-circular handle (case 11).

Cases 7-8 contain the symposium vessels, which were discovered on the north side of the chamber, fallen from a wooden table. Most of these vases – 20 – are silver, and there are six clay and two bronze ones. Most of the silver vases are in pairs, especially the various types of drinking cups, such as kylikes, kan-

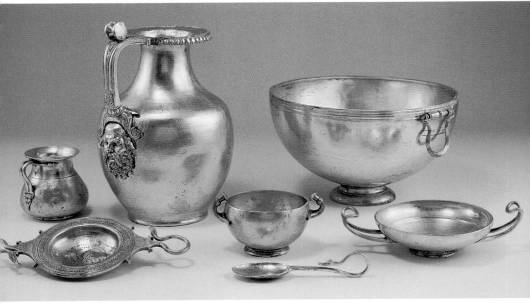

Βε 59 Βε 67 Βε 57 Βε 58 Βε 66 Βε 50 Βε 60

tharoi, kalykes and oinochoai. It is clear from the *repoussé* decoration of the shapes, and the relief figures adorning the handles, that all of them, large and small vessels alike, are the products of outstanding workshops, which were undoubtedly Macedonian. This is supported by Herodotus' testimony (*Histories* VII, 119) that local workshops producing gold and silver table vessels were active at the time of the Persian Wars.

Βε 7 Βε 55

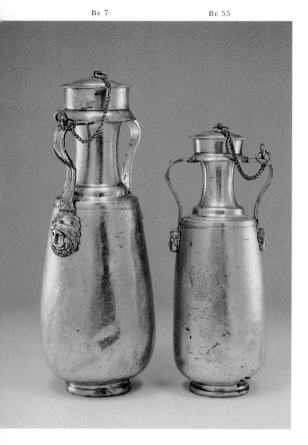

Case 7. The silver oinochoe (Βε 57) at the left has a relief head of Silenus below the handle. Of the Archaic animal's face, only the fallen ears have survived; the noble face could easily be a portrait of a philosopher, a unique study of a male bearded head. On the pedestal at the back are, from the left, a deep bowl with two swinging handles (Βε 50) and two lekythoid amphoriskoi with lids (Βε 7, Βε 55); the lids are attached by a chain to one of the handles to prevent their being lost. The face of Herakles, portrayed frontally, projects from the mouth of a lion at each of the lower handle attachments of Βε 7, and the corresponding positions in Βε 55 are occupied by heads of Pan.

The amphoriskoi in the shape of lekythoi were designed to hold either a rare aromatic drink or, more probably, myrrh. It was the custom to offer lekythoi containing myrrh to the guests at banquets.

The strainer (Βε 67) at the front left retained the sediment of the wine, when this was poured from the oinochoe into the drinking cups (cups, kylikes and kalykes). The handles have finials in the form of aquatic birds, and the guilloche around the rim is gilded. The name *Μαχάτα* (Machata= 'Warrior') is inscribed in dots below the rim, along with a number that indicates the weight or value of the strainer. *Μαχάτα* was the name of a brother of Philip's wife, and the connection drawn between the strainer and this man may be well founded. A small spoon (Βε 66) with a curving handle ending in the head of an aquatic bird, two kylikes with no base, Βε 60-61, and a simple cup (Βε

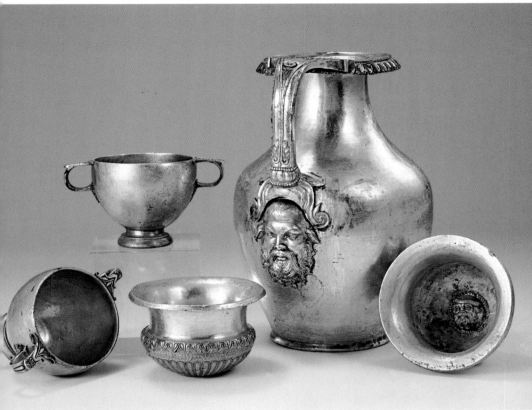

58) have a charming harmony of line. The black-glaze Attic oi-
nochoe and the three 'salt-cellars' are amongst the few clay
vases found in the tomb.

Case 8. The silver situla (Βε 54) at the back, with swinging
handles and spout in the form of a lion's head is a vessel that
could have been used instead of the usually much larger krater
for carrying wine to the participants in the symposium. The
cupbearer used the elegant silver ladle (Βε 56) to serve the wine
into the drinking cups (kylikes, cups etc.), or perhaps poured it
directly from the situla while holding the strainer above the
drinking cup to filter the sediment. There is another silver oi-
nochoe (Βε 6) at the right; although this forms a pair with Βε

57 in case 7, the head of Silenus and many of the decorative details are different. The bronze oinochoe Βε 24 at the left has a handle with the spine decorated with a superb palmette and spirals; the body of the vase, which is mended, has a relief female mask, probably of a Maenad.

There are three pairs of drinking cups at the front: two kantharoi (Βε 63-64), two kylikes (Βε 52-53), and two exquisite kalykes (Βε 62, Βε 5), decorated on the inside as well as the outside, to delight the gaze of the participant in the symposium while he was drinking the divine gift of Dionysos; a miniature head of Silenus is attached to the middle of the inside. His half-closed eyes and blissful expression indicate the state of euphoria by which this devotee of Dionysos is possessed. The details are emphasized by the use of gilding.

At the left end of the case is another black-glaze 'salt-cellar' (Βε 27). No satisfactory interpretation has been advanced of the purpose of this vessel.

Βε 44

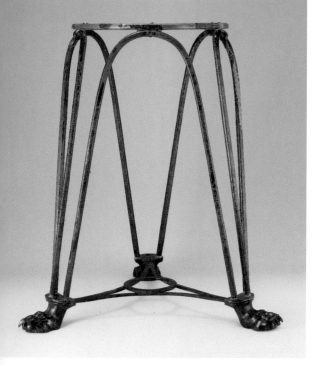

Case 9. The bronze tripod (Βε 44), standing solidly on its lion's paws, is at least one century earlier than the other objects in the tomb, and dates from the third quarter of the 5th century BC. One of the three straight rods terminating in the head of an aquatic bird is missing; these rods, together with the curved supports, were attached to the lion's paws and surmounted by the circular rim. The fact that this ancient broken object was placed in the royal tomb indicates that special significance was attached to it, and probably that it was an important heirloom. An inscription punched

Bε 9

on the upper surface confirmed the view expressed by Manolis Andronikos: *Παρ' Ήρας Άργείας ἐμὶ τῶν ἀϝέθλων* (I am a prize from the games (in honour) of Argive Hera). The tripod, that is, was a prize offered at games held at the famous Heraion at Argos in the Peloponnese. One of Philip's ancestors will have taken part in these games, and the tripod was kept by the family as an heirloom. The Vergina tripod, taken in conjunction with the fact that the Macedonian royal family, the Argeadai, were descended from the Temenids of Argos, was evidence that the tomb belonged to a king, even before it was conclusively demonstrated that the dead man was Philip II.

The three plain bronze bowls (Bε 39-41) were found with the much larger one Bε 19 (case 11) and formed a group used for bathing.

Case 10. The bronze lantern Bε 9 is a rare vessel – only the second known from Classical antiquity. The first was discovered in tomb A at Derveni (case 36); its purpose had remained unexplained until the discovery of this one at Vergina. Inside the vase is a clay lamp supported on an iron base. Manolis Andro-

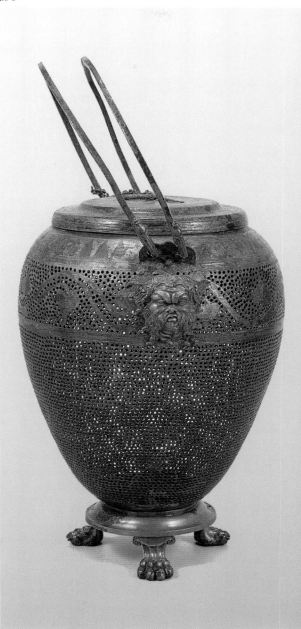

nikos's identification of this object with the lanterns referred to by ancient writers is undoubtedly correct. The pierced body of the vase allowed the lamp to stay alight, and not be extinguished by draughts of air while it was being carried about at night outdoors, by means of the large semi-circular handles.

The vase itself is a masterpiece of metal-working. A cast tripod base with lion's paws for feet supports the ovoid vase, which has a round hole at the top, closed by a lid. The attachments for the swinging handles are in the form of the face of a mature Pan, with goat's horns and ears and bestial features. The ivy wreath between the horns and the low forehead indicate the figure's connection with Dionysos. On the shoulder of the vase is a zone of silver-plated triangles, and lower down, at the level of the mask of Pan, there is a silver-plated tendril and ivy leaves, set between horizontal bands. Apart from these zones of triangles and ivy, the entire body of the vessel is perforated with holes, 2 mm in diameter, in closely set rows.

Case 11 contains bronze and clay vases for everyday use. The three at the back, the deep bowl Βε 19, jug Βε 18 and deep situla Βε 38 with cast semi-circular handle with a suspension ring in the middle formed part of the equipment used in bathing (see above cases 6 and 9). The situla could be used for heating water by suspending it over a fire. The name Σίκωνος (Sikon) can be made out punched on one of the handle attachments.

The vessel in the middle of the case shaped like a frying pan (Βε 37) is called a patera. It has a small swinging handle and a fixed handle in the form of a fluted rod with a ram's head finial. This type of vase is common in the 4th century BC, and is usually interpreted as a dish for serving food.

The two alabastra (Βε 127-128) are representative of a group of several like them found in the tomb, while the red-figure askos (Βε 25) and the local imitation of a Cypriot amphoriskos (Βε 51) – possibly made in Chalkidike – are amongst the few clay vases found in the royal tomb. Cypriot amphoriskoi are often found in 4th century tombs in Macedonia, and are probably directly related to the funerary customs.

Βε 4

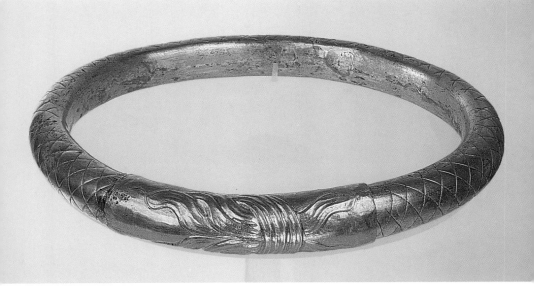

Case 12. The centre of the case is dominated by a unique find from the main chamber of the tomb of Philip II: the gold and silver diadem (Βε 10), which has an inner diameter of 21 cm and an outer diameter of 24-27 cm. It is made of a hollow silver cylinder with open ends, which are concealed by a second cylinder, of slightly larger diameter than the rest of the diadem. This made it possible to adjust the diameter of the wreath. The cylinder has a plano-convex section, so that the flat face would fit more easily against the head. The curved surface is decorated with lozenges formed by two sets of intersecting lines. The cylinder with the larger diameter is adorned with a gilded sacred knot in relief; similar knots are found on sacred and royal diadems. The king of the Macedonians is known to have been the high-priest of his people.

The cylindrical structure of the diadem is similar to the woven cylindrical wreath at the bottom of the Macedonian headcover, the *kausia*, which was made of soft leather or thickly woven woollen material. Small pieces of leather and cloth were found sticking to the flat inner face of the Vergina diadem, and

Βε 10

Bε 119 Bε 131 Bε 11 Bε 130 Bε 12 Bε 118 Bε 129

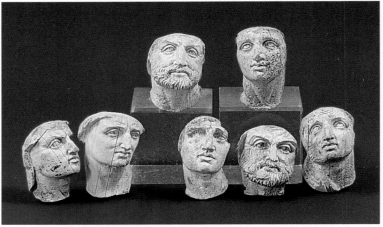

Bε 133

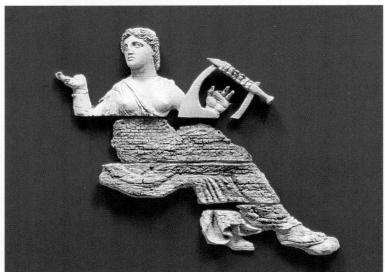

Bε

it therefore seems likely that the royal diadem of Vergina
was related to the Macedonian national headcover, the *kausia*,
for which the term 'diadem-bearing *kausia*' also survives. In
Philip's case, the diadem of the *kausia* was no ordinary one but
made of precious metals, and bore a sacred emblem: it was a
truly royal diadem.

The gold roundels with *repoussé* rosettes, beneath the diadem, are perhaps from the decoration of a chest (Bε 4).

The ivory heads and reliefs on the sloping shelf in this case belong to the decoration of a wooden couch that was placed in the main chamber. The cross-pieces on the long sides of the couch, connecting the legs, were decorated with friezes, as in the marble couches at Potidaea (room 7). The small heads from the Vergina couch come from a frieze worked in high relief, in which the naked parts of the moving figures were of ivory, while the clothed parts are rendered in gilded plaster. Of the heads, the two in the centre are believed to be portraits of Philip himself (Bε 11 on the left) and Alexander (Bε 12 on the right).

Bε 134

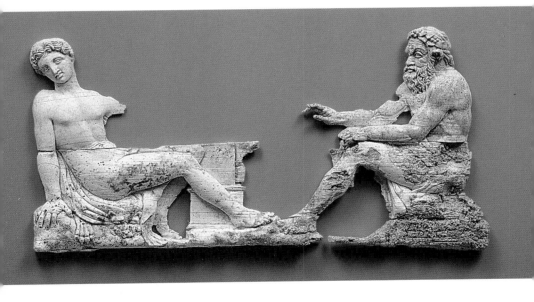

ferent theme, from the Dionysiac cycle, and probably come from a different frieze: at the left a Muse plays a lyre, and in the centre the young Dionysos sits on a rock next to a small altar, while opposite him a Silenus crowned with ivory addresses him (Bε 134). The rectangular plaque at the right depicts a herm with an archaizing bust of Hermes (Bε 133).

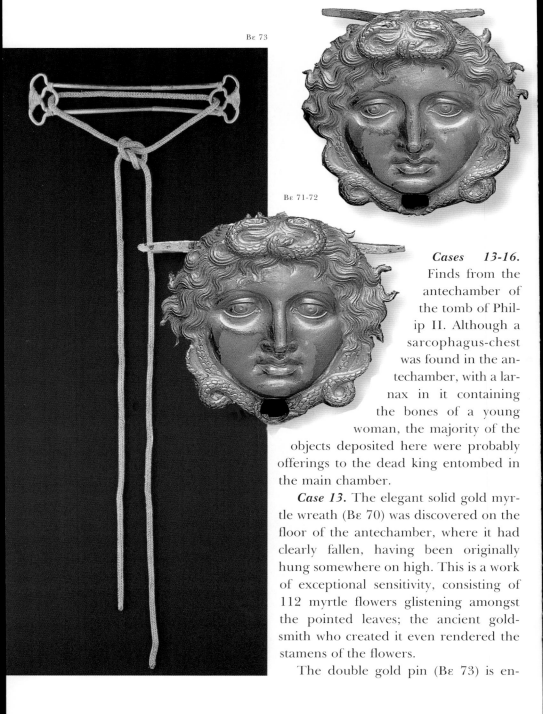

Bε 73

Bε 71-72

Cases 13-16.
Finds from the antechamber of the tomb of Philip II. Although a sarcophagus-chest was found in the antechamber, with a larnax in it containing the bones of a young woman, the majority of the objects deposited here were probably offerings to the dead king entombed in the main chamber.

Case 13. The elegant solid gold myrtle wreath (Bε 70) was discovered on the floor of the antechamber, where it had clearly fallen, having been originally hung somewhere on high. This is a work of exceptional sensitivity, consisting of 112 myrtle flowers glistening amongst the pointed leaves; the ancient goldsmith who created it even rendered the stamens of the flowers.

The double gold pin (Bε 73) is en-

Bε 70

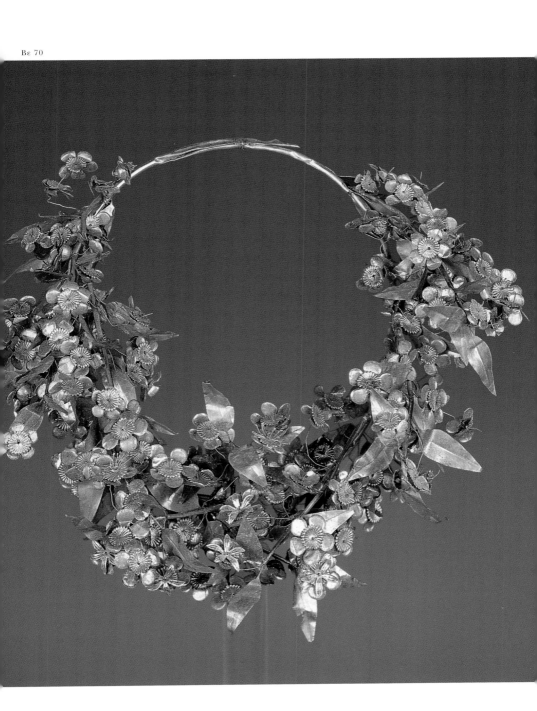

closed in a double case like it; a braided chain connected the eyelets of the pin and the case, fastening them together and helping them withstand the pulling of the free ends of the chlamys, which they were designed to hold together.

The gold roundels probably come from small chests. The two gold gorgoneia (Bε 71-72) are exceptional works of art, which were perhaps also nailed to a chest. They are the earliest examples of the 'Belle Méduse' type that was to become predominant in the Hellenistic period.

Case 14. At the back of this case are gold roundels bearing the radiate star-symbol. The traces surviving on the backs of these suggest that they were sewn to a purple cloth, perhaps a peplos, or to a curtain hanging in the antechamber.

Three of the most important pieces of the ceremonial equipment of Philip II were deposited in the antechamber – a circumstance accounted for by the hasty burial in the half-finished tomb.

At the left is the gilded silver gorytos (Bε 3), or more accurately, sheath for a leather gorytos, a Scythian type of bow and arrow case, which has a compartment for the bow as well as the arrows. A group of iron arrows with bronze heads, rusted together, were found next to it, along with three wide rings (Bε 77) that encircled the wooden bow.

The decoration of the gorytos is unique: on the rectangular projecting section is depicted a young hoplite in a relaxed posture, standing in a rocky landscape. Below him is a vertical zone with a complex guilloche, and a narrower zone with an egg and dart pattern. These two together form the lower border to two friezes with multi-figural scenes of the capture of a city. The upper border consists of birds in flight. The scene of the capture of the city is full of movement: there are groups of naked warriors, and three altars at different points, at which wounded heroes and young women, either alone or holding children in their arms, are taking refuge. The scene appears to be inspired by the Fall of Troy, but this interpretation is not certain.

The gorytos was part of the equipment of a Scythian archer, and similar items have been found in Scythian tombs in the

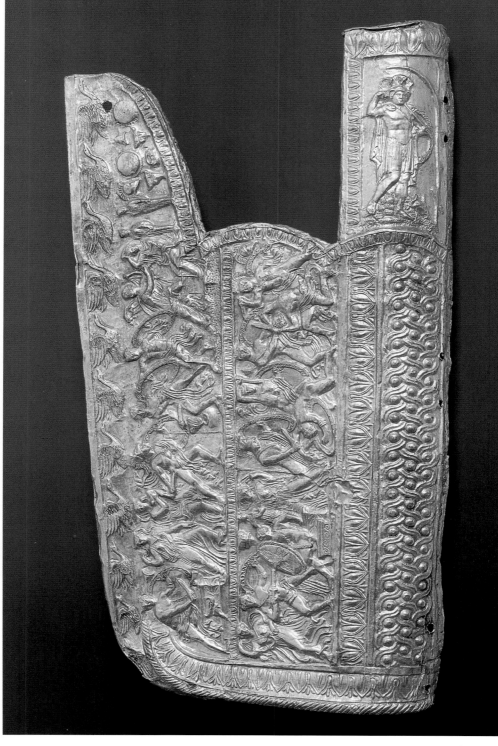

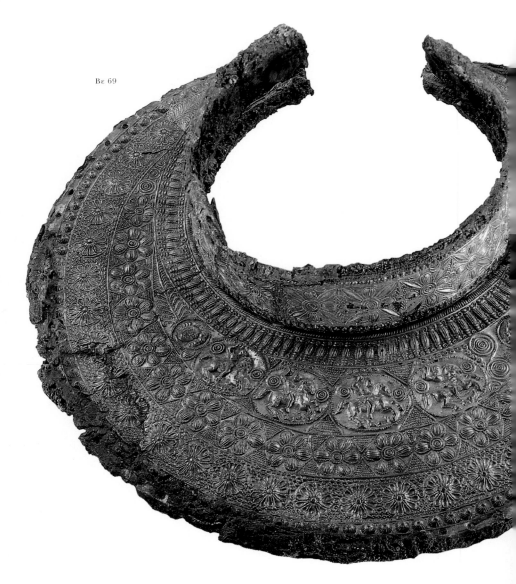

Bε 69

Ukraine. Its presence in Philip's tomb may perhaps be account-
ed for by its being a spoil from Philip's campaign against the
Scythians of the Danube (Ister) in 339 BC.

The gilded pectoral (Bε 69) in the middle consists of a
crescent-shaped piece of iron, the underside of which is
sheathed with material and the top with a gilded piece of silver.
This last has relief decoration in concentric circles. The broad-

er zone has four medallions with Scythian horsemen. On the other zones and the upright collar, the predominant motif consists of rosettes. Like the gorytos, the pectoral in the antechamber was probably a spoil from a war against Thracians or Scythians.

The pair of gilded greaves (Bε 2) has been the subject of much debate, since they are of unequal height and width. Philip is known to have been lame as a result of a wound to the thigh, but this would not account for the difference in size of the greaves. The maker of them is perhaps to blame, since other pairs of unequal greaves are also known.

Case 15. Of the gilded purple cloth in which the bones of the dead man were wrapped before being placed in the gold chest in the antechamber (case 16) two decorated em-

Case 15

blems have been restored to a sat-
isfactory degree. They possibly
come from the ends of a long nar-
row peplos. The gold ground was
woven of very fine gold thread,
while the purple cloth, which was
reduced to ashes, was probably
made of wool. A floral motif is
set within a border consisting of
a running spiral: large acanthus
leaves spring from a central calyx,
along with tendrils and shoots
that twine around, filling the en-
tire space and ending in flowers

Βε 74

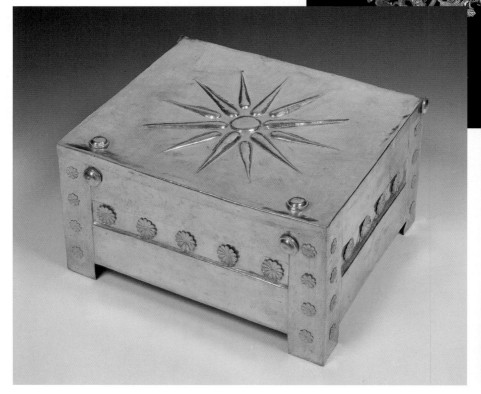

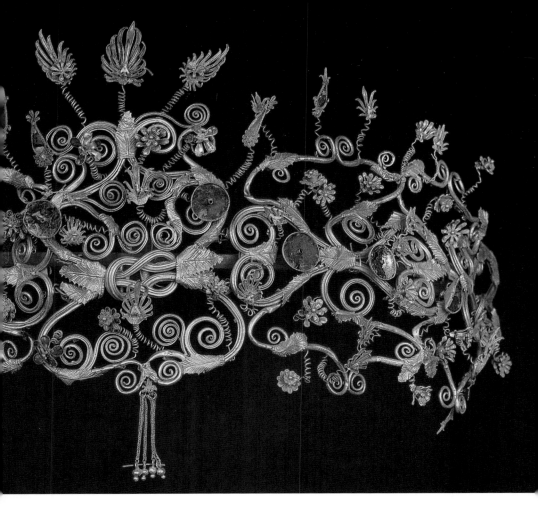

and leaves. Two small birds sit facing each other on tendrils. The rarity with which cloth is preserved from Classical times, and the importance of this find for our knowledge of the weaving of precious garments need no emphasizing.

Case 16. Inside the marble chest in the antechamber was a smaller, less richly decorated gold larnax (Βε 74) containing the bones of a young woman wrapped in the gilded purple cloth in case 16. Next to the bones was a superb woman's diadem (Βε 75).

This gold larnax measures 32 x 37.7 x 20 cm, and has a relief star on the lid, with twelve rays. Each of the sides has a recessed zone to which cut-out rosettes are attached. Smaller rosettes, set vertically, adorn the legs of the larnax, which weighs 5.55 kilos.

The woman's diadem is a unique masterpiece of the ancient goldsmith's art. Fluted tendrils of a climbing plant intertwine in

Vergina. The interior of the tomb of the Prince, details.

the middle in a loose 'Knot of Herakles', and then spread outwards. On minute stalks of wire sit leaves and flowers, on which tiny bees and a bird can easily be detected by the naked eye. Blue glass paste, inlaid in roundels and leaves, lends a charming contrast of colour to this truly royal diadem.

We do not know who the young queen was. It may have been Cleopatra, Philip's last wife, who was murdered shortly after his death.

Cases 17-21. The second unplundered tomb of the Great Tumulus is known as the 'Tomb of the Prince'. In it was buried a youth of 13-16 years. Here, too, the grave offerings are of exceptionally high quality, though not unique. A number of theories have been propounded as to the identity of the dead youth, the most generally accepted being that it was Alexander IV, son of Alexander the Great and Roxane, who was executed in 311/10 BC along with his mother, on the orders of Cassander.

Case 17 contains 14 of the 27 silver vases deposited in the tomb. They are vessels for use at symposia, with a greater variety of shapes than those in Philip's tomb. In the top row, from the left, is a deep bowl with handle (Βε 88), a situla with a gilded engraved palmette (Βε 13) and an oinochoe of Italian type (Βε 14). The middle row has three handleless cups (Βε 91, 92, 85) and a kantharos (Βε 15), and at the bottom are four small cups or bowls (Βε 84, 86, 93, 94), and a strainer in the middle (Βε 108). The askos with the circular handle at the left (Βε 89) and the piriform vase at the right (Βε 87) were perfume vases.

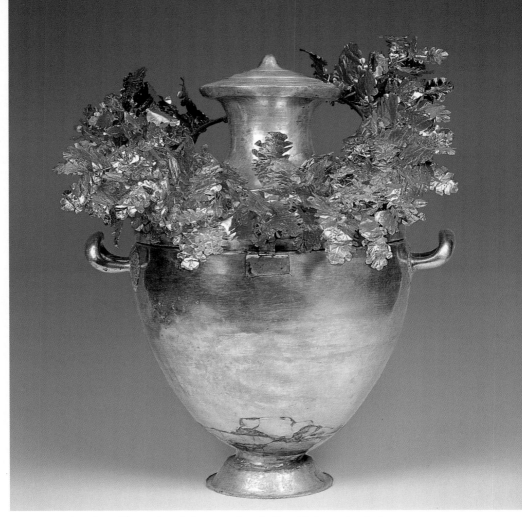

Case 18. The silver-plated bronze bowl (Bε 138) at the left was a vessel connected with bathing. Next to it was found a bronze basin, which is not on display, since it was badly damaged by the marble door, which collapsed on it. The large gilded bronze wreath (Bε 98) in the middle was an offering to the dead man. The pair of gilded bronze greaves (Bε 83) have traces of the leather straps by which they were tied to the shins. A plain iron pectoral (Bε 137) and two iron spearheads (Bε 99, 102) were similarly part of the dead man's military equipment. Five bronze strigils (Bε 78-82) attest to his performance in the palaestra: these instruments were used after wrestling to scrape off the sand that adhered to the oiled skin.

Case 19. The silver hydria (Bε 96) that contained the bones of the dead youth was placed in a hollow in the top of a built

pedestal, covered with lime plaster. A solid gold oak wreath (Βε 97) was found placed around the neck of the vase.

The hydria was made solely for funerary use. It is cut in two horizontally above the handles, and hinges were added so that it could be opened to place the bones inside. The gold wreath with oak leaves is smaller than Philip's wreath, and has fewer acorns, though it is still one of the largest and finest funerary wreaths from Classical times.

The Tomb of the Prince also contained a wooden couch with ivory decoration, some fragments of which are preserved in excellent condition: the group of the drunken Silenus and a Maenad (Βε 139), walking with some difficulty, accompanied by goat-footed Pan, who plays the pipes as he leads the way, was a revelation for the achievements of Greek ivory-carvers in the Late Classical period. The same quality of workmanship can be seen in the eastern god Sabazios (Βε 140), who stretches out his arms as he appears amidst acanthus leaves.

Βε 140

Βε 110

Βε 139

Case 20 contains another thirteen table vessels from the Tomb of the Prince. A ladle (Βε 95), used for serving wine, hangs at the left of the top row. Next to it is a low kylix (Βε 106), a typical situla for wine (Βε 111), and a unique patera (Βε 110), in which the ribbed horizontal handle ends in a powerful ram's head. The pupils of the eyes and the hair are gilded.

The middle row has another kylix (Βε 107), which formed a pair with the previous one – in this tomb, too, the drinking cups were found in pairs – a kantharos (Βε 109) similar to that in case 17, and a kalyx with a relief head of Pan in the interior (Βε 113). A second kalyx also has a head of Pan (Βε 112); it is displayed in the bottom row, along with two 'salt-cellars' (Βε 114, 115) and three plates (Βε 116, 117, Βε 90). The largest of these, at the

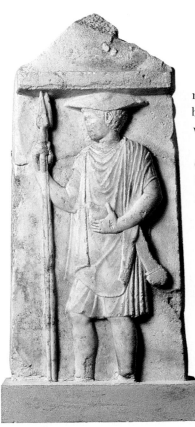

Bε 126

right end, has a depression in the centre and belongs to the type known as 'fish-plates', which were called 'ichthya' in antiquity.

Case 21. The silver-plated iron lamp-holder (Bε 104) was placed upright in the main chamber of the tomb. It is 1.31 m high and ended in a disc at the top, on which was placed a large lamp with two nozzles. The equipment needed for lighting the lamp (tweezers etc.) was suspended from the two hooks below the disc. The hooks may also have been used to have the ladle and strainer during the symposium, as is clear from scenes painted on vases.

The funerary stelai of Vergina were discovered in the earth deposits of Megali Toumba (Great Tumulus), that is, the deposits of the tumulus that covered the royal tomb of Philip II. They were broken into many fragments, and it is clear that they were destroyed before being used as waste material. Their destruction was associated by Manolis Andronikos with a historical event: the capture of Aegae by Pyrrhos, king of Epiros, in 274/3 BC, when his Galatian mercenaries destroyed the cemetery at Aegae nearby; this association was made at the very beginning of the investigation into Megali Toumba, before the discovery of the royal tombs which confirmed the identification of the site with Aegae. The broken material from the royal and other tombs was probably used after the expulsion of the Galatians to increase the height of the mound of Philip II. This work was carried out under Antigonos Gonatas. A total of 47 stelai have been mended from the fragments, dating from the middle of the 4th to the beginning of the 3rd century BC, with the exception of the relief stele Bε 126, which is earlier and dates from the end of the 5th century.

The five best-preserved stelai are displayed in the Vergina room. The stele of Harpalos (Bε 124) has painted decoration

124 Βε 122

on the pedimental crowning member. The broad red ribbon in
the middle is an imitation of the real ribbons which, as we know
from Attic 5th century BC lekythoi, it was customary to dedi-
cate to the dead by tying them around grave stones. Below the
pediment is engraved the inscription: *Ἅρπαλος Κύτας. Ἀδελφή με
ἀνέθηκε Παγκάστα* (Harpalos, son of Kyta. I was dedicated by his
sister Pankasta). About 350-325 BC.

The stele of Kleonymos (Βε 125) has four painted figures: at
the left is a young standing hoplite, at the right a seated man
with a standing woman behind him, and a young child at the
front right. The inscription carved below the pediment, which
has painted decoration of tendrils and a chthonic goddess,
gives the names of four dead (?) people from the same family:
*Κλεώνυμος Ἀκύλου - Ἄδυμος Κλεωνύμου - Πευκόλαος Ἀδύμου - Κρι-
νώ Ἀδύμου* (Kleonymos son of Akylos; Adymos son of Kleonymos;
Peukolaos son of Adymos; and Krino daughter of Adymos). The
stele dates from about 330-325 BC.

The relief stele (Bε 126) of the hoplite wearing a petasos (kind of hat) was found at the centre of the tumulus. The young man wears a short chiton and chlamys. In his right hand he holds two spears, and in his left a dove, and the scabbard for his sword projects from beneath the chlamys. The work of a local craftsman with Ionic and Attic influence, dating from the decade 430-420 BC.

The stele of Xenokrates (Bε 122) is decorated with a painted red ribbon and has two incised and painted inscriptions:

Ξενοκράτης Πιερίωνος - Δρύκαλος Πιερίωνος
(Xenokrates son of Pierion - Drykalos son of Pierion).

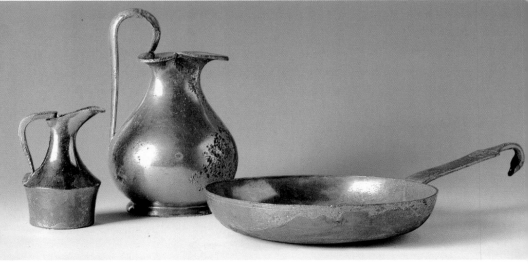

5126 5125 5127

It dates from about the end of the 4th- beginning of the 3rd centuries BC.

The stele of Berenno (Bε 123) has a painted picture of the young dead girl, and an inscription with her name: Βερεννώ Φιλίστου (Berenno daughter of Philistos). It dates from the middle of the 4th century BC.

The inscribed stelai of Vergina yielded 70 proper names, some of which, together with the patronymic, can be assigned to the end of the 5th century BC. These are Greek names, with Greek roots. Some, like Berenno, Drykalos (from drys=oak and

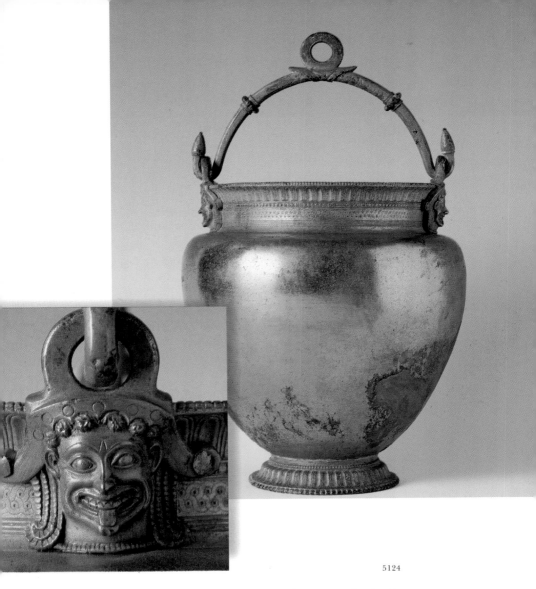

5124

kalon=wood), Peukolaos and others, are local to Macedonia. It is significant that these are the names of ordinary Macedonians and not members of the royal house. The evidence afforded by the Vergina stelai thus confirms the conclusion suggested by study of writers earlier than the 4th century, that the ancient Macedonians were Greeks.

The rest of the room is devoted to finds from tombs from the area around Thessalonike, most of them contemporary with the Vergina tombs. Gold, silver and clay objects, and

colourful frescoes attest the striking flowering of arts in the second half of the 4th century BC.

Case 22 contains finds from a cist grave in Dangli Street, Stavroupolis, to the west of Thessalonike. The tomb contained a male burial dated to the end of the 5th century BC on the basis of a small Attic red-figure lekythos.

The bronze krater 5124, with the handle of a situla, is earlier than the other finds from the tomb. The gorgoneia on the handle attachments and the profile of the vase suggest that the krater was perhaps made at the end of the 6th century BC. Bronze vessels last much longer, and were frequently deposited as precious family heirlooms in much later tombs.

The small oinochoe 5126 with a piriform body belongs to the 5th century, and the oinochoe 5125 with trefoil mouth dates from the end of this century. The patera 5127 has a strap handle ending in a swan's head. In the 6th century BC the handles of these vessels were in the form of a kouros, while in the 4th century their shape changed completely, as we have seen in the examples from Vergina, and became a cylindrical shaft ending in a ram's head. This vessel is found in tombs together with other vases associated with symposia, and is thought to have been used either for offering food or for washing hands.

In this same tomb was found the gold double pin and case 5128, similar to that from Vergina (case 13), a small gold strip with a *repoussé* guilloche (5132), and some tiny cut-out gold palmettes (5133), which were perhaps part of the decoration of a box. The two rectangular pieces of gold sheet with *repoussé* lions crouching to pounce, and a third with a lion (5129-5131), were attached to the flat surface of some object.

Case 23. A number of well-built cist graves were excavated in 1938 in the area of the military airfield at Sedes (Therme), near Thessalonike. Tomb C, which dates from the lst quarter of the 4th century BC, was unplundered. The exhibits in case 23 come from this tomb, apart from the gold wreath with olive leaves (5408), which was discovered in the small tomb A.

Above the wreath are two clay models of ivy berries (5535) and below it a gold necklace (5411), the ends of which take the

form of lion's heads with a 'Knot of Herakles' between them.

On the column at the right are gilded clay roundels with relief decoration: a star with eight rays, a gorgoneion, a protome of Athena Parthenos. These roundels are very common in the tombs of Macedonia; they usually have bronze eyelets at the back so that they can be sewn onto dresses, though occasionally they are flat, in which case they were stuck onto funerary garments or objects. They are thought to be substitutes for gold roundels, like those found in the royal tombs at Vergina.

On the bottom of the case at the left is a silver kalyx (5425) and six gold bow fibulae, with a pendant (5412-5417, 5419). In the centre are a necklace (5440), with gilded clay beads, clay models of grapes (5539), perhaps from a wreath, a gold finger-ring (5420) with an engraved scene of a woman feeding a baby, and a gold earring (5418). The gold ornament 5410 is unique. It is interpreted as a wreath or diadem in the publication of this tomb and its similarities with the female diadem found at Vergina (case 16) support this view. The predominant idea in the composition is similar to that in the Vergina diadem: two plant tendrils twist and turn to form the lyre-shaped parts of a large chain, from which spring wire stalks with leaves and flowers on them. At the centre of the chain is a small naked Eros, on a 'Knot of Herakles'. The free ends of the ornament end in lion's heads, through which passed the ribbon by which the wreath was tied at the back of the head.

Two finely made clay vases were discovered in the same tomb: the black-glaze cup 3732 and the pyxis 5233; the body of the latter is decorated

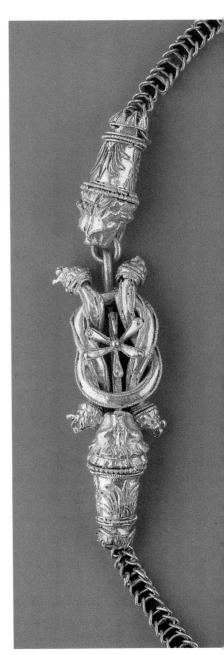

5411

with an ivy shoot, and the lid with necklaces. The decoration was executed with diluted clay, in the style known as 'West Slope' decoration, since many vases of this type were discovered on the west slope of the Athenian Acropolis. Pyxides contained objects and material connected with the toilette.

Tomb C also contained a wooden couch, of which a few pieces and the inlaid decoration survive. The eight rectangular pieces of gold sheet decorated with groups of three deities (5421 ff), amongst which can be seen Apollo with Demeter and Kore, or three nymphs, adorned the tops of the legs of the couch, where they were placed beneath glass plaques of a similar shape. The figure of Demeter or Hekate carrying a torch, executed in gild-

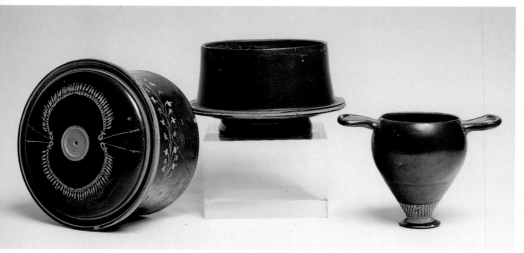

5233

3732

ed bone, is the only character surviving from a frieze adorning the long side of the couch. The heads of griffins (5511), colonnettes (5509, 5510) and rosettes (5508), and a fragment of an ivory plaque incised with the figure of a youth (5530) also belong to the decoration of the couch, or to that of a small wooden box.

In this same tomb was found 1/8 of a gold stater of Philip II (5424) and the bronze mirror 5506.

Cases 24-25 contain finds from a cist grave in Oreokastrou Street, Stavroupolis, near Thessalonike. This tomb is 50 metres away from the 5th century tomb (see case 22) and is dated to

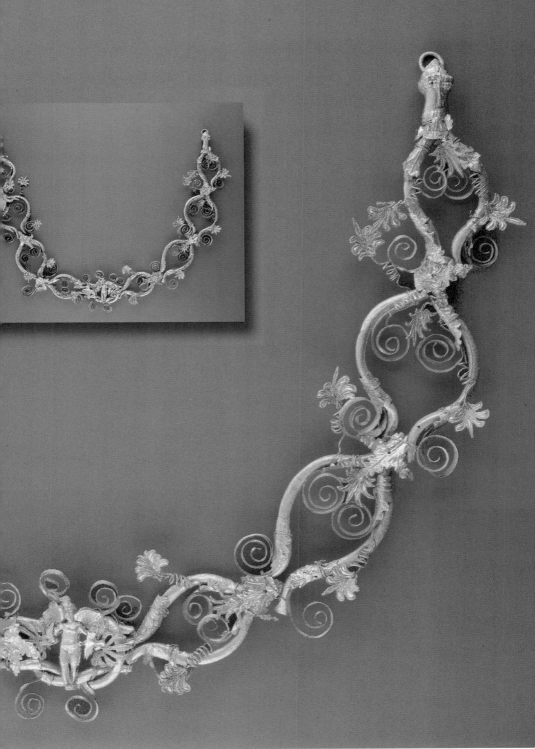

7418

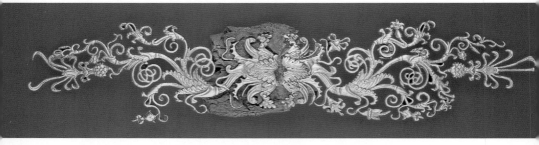

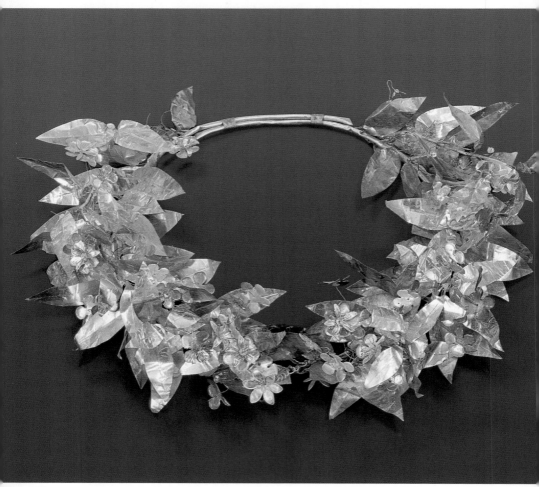

7417

the end of the 4th century BC. It contained a male burial with more than 35 grave offerings.

Case 24. The gold myrtle wreath 7417 is in the type of the one like it at Vergina. Four of the seven silver vases found in the tomb are on display: the cylindrical pyxis 7429, the kalyx 7427 with a very fine relief head of a woman or a Maenad in the inside, the kantharos 7430 and the lekythos 7432. At the back of the case are gilded clay groups of warriors and Amazons; these bear traces of fire, and probably adorned the bier, which was usually cremated along with the corpse.

7437

The gold floral ornament 7418, with intricate delicate tendrils and palmettes is attached to a part of an ivory object, the nature of which cannot be determined. The 77 cm long gold strip 7420 and the five smaller pieces have small holes at intervals by which they were attached, possibly to a leather cuirass. The 27 roundels-rosettes 7421 have eyelets at the back so that they could be sewn to cloth or leather. The cast ring 7419 with palmettes round the central rosette probably adorned the pommel of an iron sword.

Another unique find is the folding bronze cylindrical case 7437, which has a holder for an ink-pot in one half-cylinder and a case for the pens in the other.

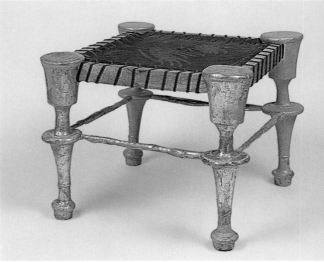

7440

4304

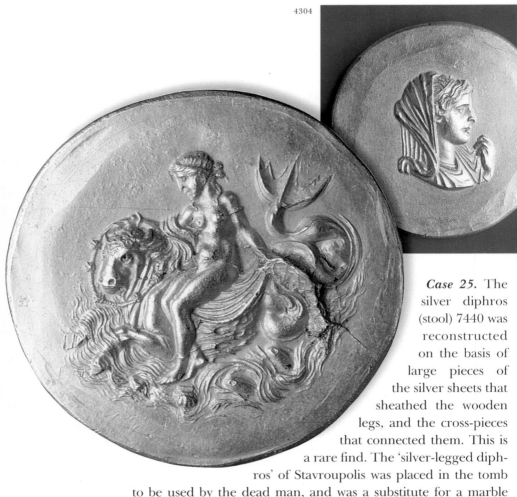

Case 25. The
silver diphros
(stool) 7440 was
reconstructed
on the basis of
large pieces of
the silver sheets that
sheathed the wooden
legs, and the cross-pieces
that connected them. This is
a rare find. The 'silver-legged diph-
ros' of Stavroupolis was placed in the tomb
to be used by the dead man, and was a substitute for a marble
throne like the ones found in the Macedonian tombs at Vergina.

One of the cases displaying finds from Stavroupolis, the
small case 26, contains a gold medallion (4304) from the games
held at Veroia in AD 225-250 in honour of Alexander the
Great. From the other medallions, such as 4304, found at Abu-
kir in Egypt, we know that the obverse had a portrait of the
family of Philip II. The female bust on the Thessalonike medal-
lion is therefore thought to be a portrait of Philip's wife, Olym-

pias. The reverse depicts a Nereid on an imaginary sea-beast, with a bust of a bull.

Cases 27-28 contain the finds from the cist graves and the funerary pyre of three tumuli at Nea Michaniona, which were part of the cemetery of ancient Aineia. They are dated to the third quarter of the 4th century BC.

Case 27 contains objects from Tomb III. The bronze cinerary hydria 7552 was another family heirloom. It was an Attic work, produced about 430 BC. On the lower attachment of the vertical handle is a young Victory, landing lightly on acanthus leaves. The bones of the dead woman were wrapped in linen and placed inside the hydria. With them was found the gold finger-ring 7579, the stone of which has a scene of a chariot pulled by swans, a gold ring and three of the five gold bow fibulae 7580-7584. Two of these were fastened around the handles of the hydria, and its neck was encircled by a gilded bronze wreath.

Amongst the precious grave offerings in the tomb were the bronze folding mirror 7553. The cover of the disk of the mirror is adorned with a relief figure of Eros drawing his bow, with a cock, one of his symbols, next to him. This is probably the product of an Attic workshop in the middle of the 4th century BC.

Twenty-two stone alabastra, two glass ones and one of faience formed the rich collection of perfume vases deposited with the dead woman. Some of the alabastra, like the Attic kotyle 7550, have gold leaf stuck to them (7525, 7526), and two other vases, which are imitations of metal wares, the jug 7548 and the patera 7547, are coated with a yellowish slip in an effort to imitate the colour of bronze or gold. It seems that those who were unable to offer vases made of precious metals to their dead provided close imitations of them.

7579

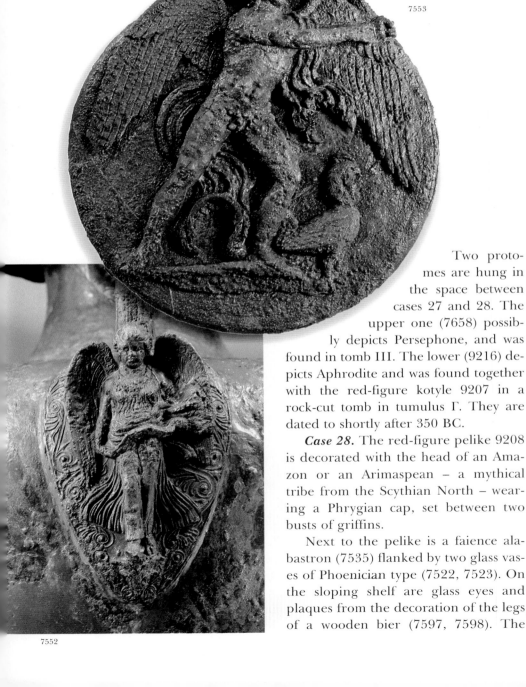

7553

7552

Two proto-
mes are hung in
the space between
cases 27 and 28. The
upper one (7658) possib-
ly depicts Persephone, and was
found in tomb III. The lower (9216) de-
picts Aphrodite and was found together
with the red-figure kotyle 9207 in a
rock-cut tomb in tumulus Γ. They are
dated to shortly after 350 BC.

Case 28. The red-figure pelike 9208
is decorated with the head of an Ama-
zon or an Arimaspean – a mythical
tribe from the Scythian North – wear-
ing a Phrygian cap, set between two
busts of griffins.

Next to the pelike is a faience ala-
bastron (7535) flanked by two glass vas-
es of Phoenician type (7522, 7523). On
the sloping shelf are glass eyes and
plaques from the decoration of the legs
of a wooden bier (7597, 7598). The

gilded clay rosettes and cut-out plaques in the form of figures of Eros and Muses (7593, 7594) are attachments from a funerary wreath.

The upright column supports two gilded bronze wreaths (7570) and gilded clay roundels or buttons with protomes of Athena Parthenos (7507). Three Attic black-glaze small bowls (7540, 7541, 7543) and a fish-plate (7545) flank a rare glass vase, the kalyx 7551, which is the earliest glass vase in this shape.

At the far right are two more alabastra (7521, 7527), a black-figure askos-perfume vase (7546), and a necklace of gilded clay beads (7708), which was found together with the glass decorative elements from the couch and the gilded roundels in the funerary pyre in tumulus B.

In the south-east corner of this room are displayed the

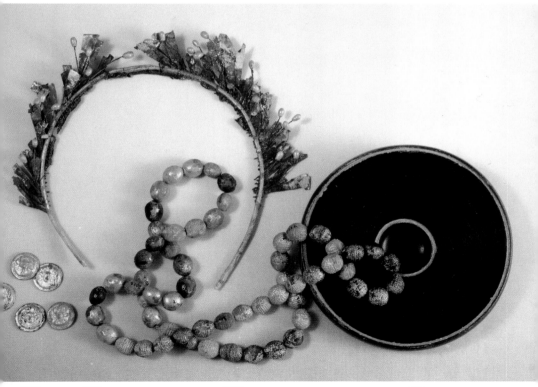

7707 7570 7708 7545

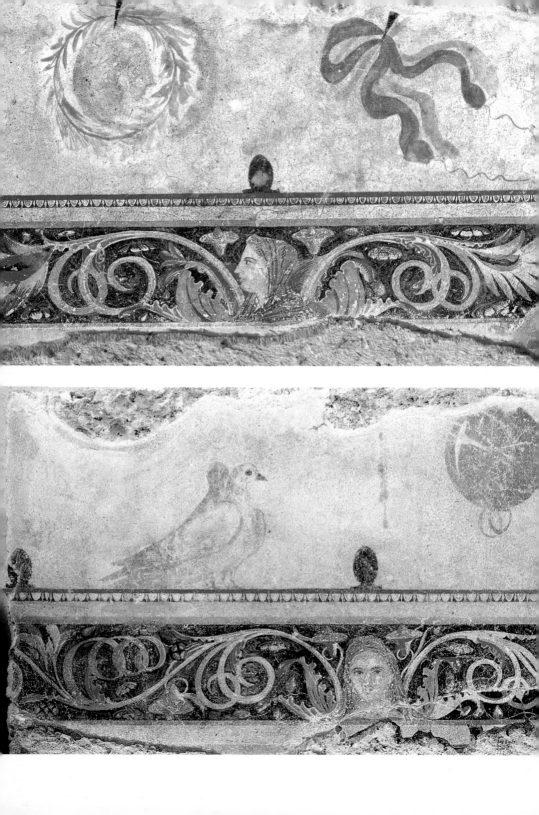

Aeneia. Tumulus A, tomb II.

finds from tomb II of Tumulus A at Aeneia (Nea Michaniona), 350-325 BC. The few grave offerings in the tomb had been deposited around the built block on which was placed a wooden box containing the bones of a young woman and her newly-born infant. The offerings consist of a Cypriot-type amphoriskos, four glass alabastra, ten alabastra made of high quality gypsum-plaster, of which two were gilded, and a gilded bronze wreath.

Despite this paucity of objects, tomb II is of great value for the painted decoration of the inner walls, which imitated the archi-

tectural features of the walls of a woman's room, with objects associated with the women's apartments hanging from nails or resting on shelves.

The base of the wall, the toichobates, is indicated in black paint, and the marble revetment in white and pink; the latter is surmounted by a zone painted in vivid colours, the volute-frieze, in which curling tendrils and flowers wind amongst busts of chthonic deities. Above the frieze is a representation of a stylized geison (cornice), on which stands a superb white dove and a gold jewellery box. The other objects in the top zone hang from nails: a head-cover of woven material, a disk-shaped mirror, painted ribbons, wreaths, a wooden box and a protome of Aphrodite. The colours are in an excellent state of preservation. The shadow is depicted of all the objects, even the under surfaces of the volutes in the frieze. The Aeneia painter uses decorative motifs known from the mosaics of Macedonia, and also from the large vases of Apulia, and he is at the same time aware of the achievements of painting at the major centres in Attica and the Peloponnese.

Case 29. This case contains finds from the last quarter of the 4th century BC from tombs to the north and south of ancient Potidaea, in the adjoining neighbourhoods of Nea Potidaea and Ayios Mamas. In 316 BC king Cassander built a new city that bore his name on the site of the earlier Corinthian colony, which had gone into decline after its conquest by Philip II (356 BC). The walls of Kassandreia enclosed a larger area than its prede-

7450-7453

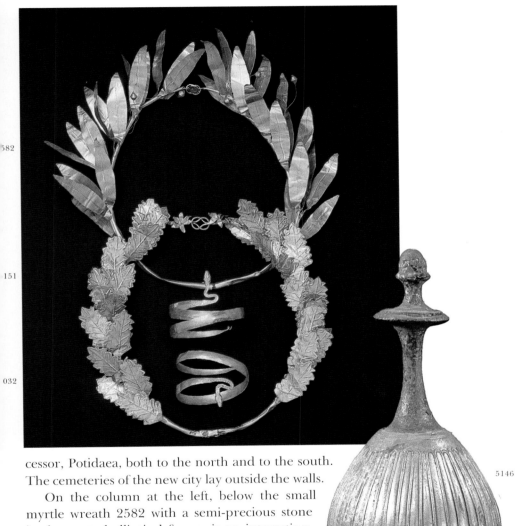

cessor, Potidaea, both to the north and to the south.
The cemeteries of the new city lay outside the walls.

On the column at the left, below the small
myrtle wreath 2582 with a semi-precious stone
in the central elliptical frame, is an interesting
piece of gold jewellery (2584), which was per-
haps attached to a head-band: three chains of
equal length, with semi-precious stones at their
ends, hang from a winding band, and lyre-shaped
gold wires connect the attachment ring and the chains
to the head-band. At the top of the column at the right

is a gold wreath of oak-leaves (5151), a small rosette from the decoration of a small box, and a gold *danake* (model of a coin) with a relief face, from tombs in the area of Nea Potidaea.

Lower down is a group of jewellery from tombs at Isba in Ayios Mamas: the pair of earrings 15033, each depicting a seated Victory framing the central disc with her raised wings, was found in the same tomb as the two bracelets 15032, which consist of a gold band ending in the body and head of a snake. The pair of small earrings 15034, ending in lion's heads, comes from another tomb.

The four impressive gold diadems 7450-7453 on the bottom of the vase are models of wreaths, made of a fine gold band to which dense clusters of leaves have been affixed. The band 2583 is also a diadem with relief volute ornamentation. Two of the three gold rings 5141-5143 at the left have a plain circular bezel, and the inlaid stone is missing from the third. At the right are three smaller gold rings (15171, 15175, 12339), of which the one at the left is engraved with a bee.

The three silver vases from tombs in Nea Potidaea – the ladle 5147, the perfume container 5146 and the strainer 5145 – are identical to corresponding vessels found in tombs at Derveni and Vergina.

Cases 30-41. These twelve cases present the most important finds from eight cist graves excavated in 1962 at Derveni, a site to the south-west of Thessalonike, which were part of the cemetery of ancient Lete. They are roughly contemporary with Megali Toumba at Vergina, and are dated in the second half of the 4th century BC (about 330-310 BC). Although they are much smaller than the royal tombs, they contained dozens of precious vases of bronze and silver, gold wreaths and wonderful necklaces, all attesting to the amazing flowering of metal-working in Macedonia during the 4th century BC.

Case 30 contains objects found in tomb B at Derveni. The finest find of all is the famous Derveni bronze krater, 0.91 m in height, which is a unique masterpiece without parallels (B1). The comparatively large proportion of tin in the alloy (15%) has resulted in the preservation of the Derveni gold

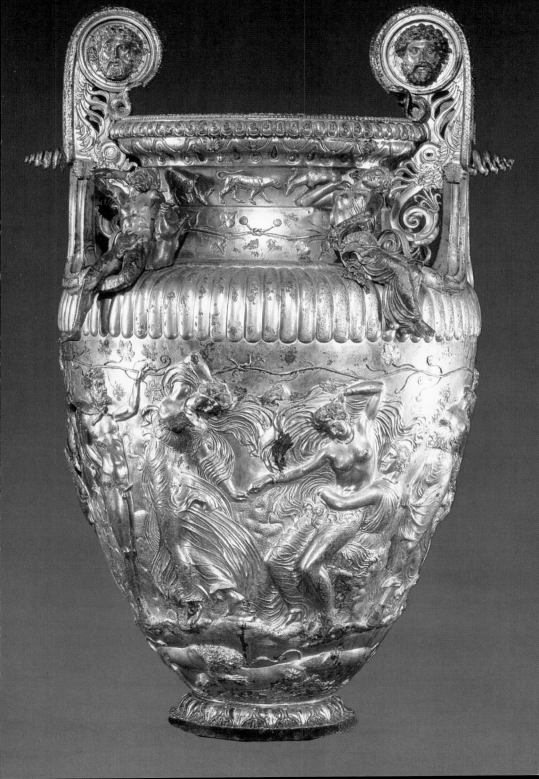

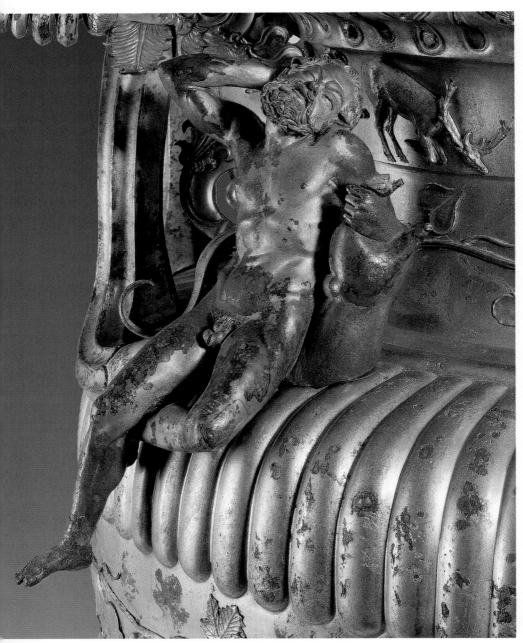

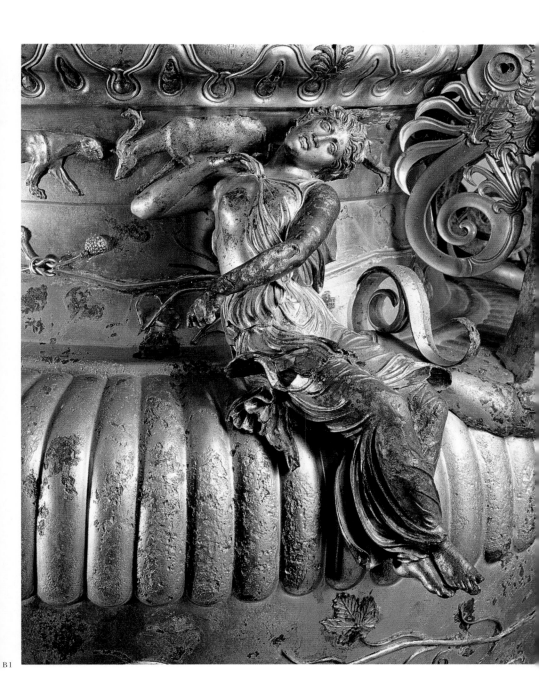

B 1

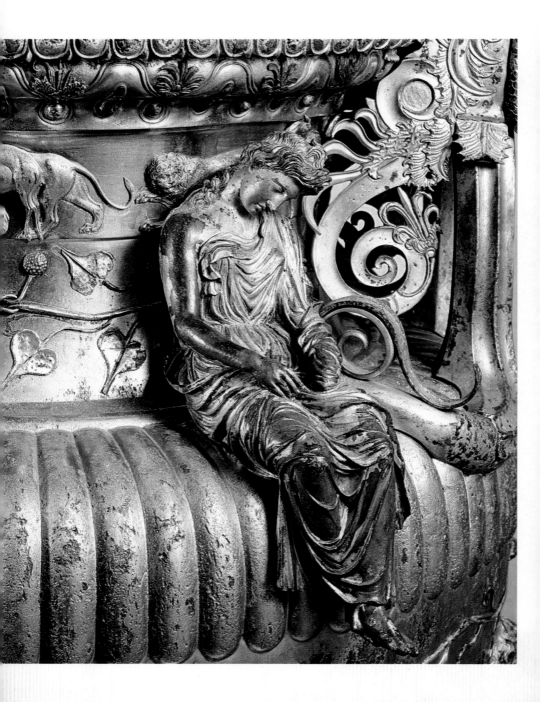

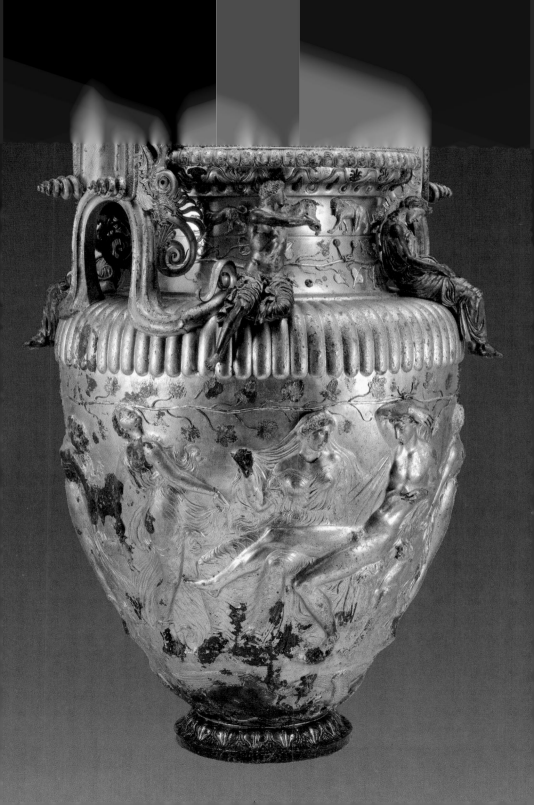

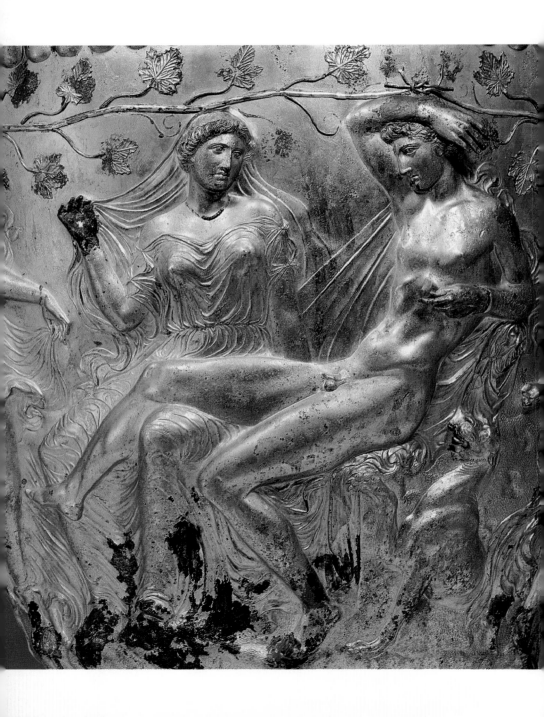

colour of the bronze, which initially led to the suggestion that the krater and other vases from Derveni were gilded, or that the alloy contained a significant proportion of gold. Chemical analysis, however, has shown that there is no gold present.

The krater was made by two techniques: the rim, the handles, the base, and the statuettes on the shoulders are cast, and the relief figures on the body and neck are cast and hammered in *repoussé* technique. The mouth is covered with a perforated concave lid that acted as a strainer for the wine. The decorative scheme is taken from the Dionysiac cycle, which was of course consistent with the purpose of the vessel, to contain wine, the gift of Dionysos to mankind. The relief composition on the body of the krater is dominated by the figures of Dionysos and Ariadne, serene, blessed and eternally young, in striking contrast with the orgiastic atmosphere of the ecstatic bacchic dance of the Maenads and Satyrs surrounding them. The bearded man wearing a single boot is an intrusive figure, which has provoked much debate; he is possibly the Thracian king Lykourgos who, because of his impious behaviour towards Dionysos was seized by madness and slaughtered his son Dryas with an axe, thinking he was cutting a vine shoot.

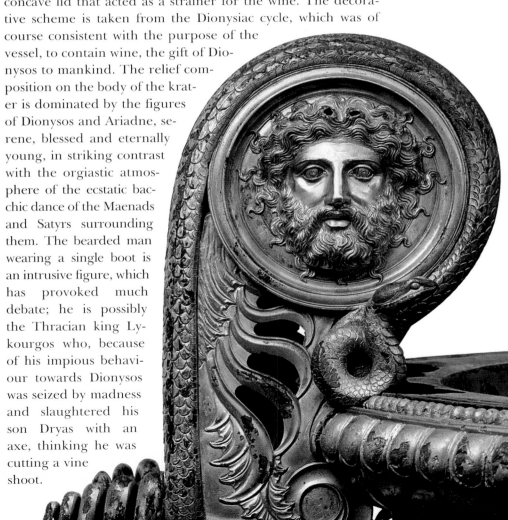

31

The four seated figures on the shoulders of the krater, the young Dionysos and the Silenus and Maenads wearied by the dance are amongst the masterpieces of ancient Greek bronze sculpture. The inlaid letters on the shoulders of the krater form the name in the Thessalian dialect of the vase's owner, who was from Larisa: Ἀστειούνιος Ἀναξαγοραίοι ἐς Λαρίσας (Asteiounios son of Anaxagoras from Larisa). Its presence in a Macedonian tomb is to be accounted for by a historical event: in 344 BC Philip took hostages to Macedonia from the aristocratic clan of the Aleuadae of Larisa, who had taken part in a movement for independence.

B4

The question of the workshop that produced the crater continues to be debated; it is not impossible that it is of Macedonian origin.

The krater was used in tomb B as a funerary urn.

Cases 31-34 contain the other objects from this same tomb B. Most of them are vases associated with symposia, and a few are military equipment. The badly rusted iron spearheads from this tomb are not on display.

Case 31 contains more objects from tomb B at Derveni. The dead man's armour is represented by a pair of bronze

greaves (B 38) and a leather pectoral covered with scales (B 46). At the back left is a bronze situla (B 29) with a lion's-head spout, and at the right an amphora (B 22) with a lid and swinging handle, with a relief mask at the lower handle attachment. Two bronze kylikes (B 30, 31), a silver strainer (B 4), and a clay fish-plate (B 53) were all vessels connected with the symposium, while the bronze semi-circular box (B 35), the small cylindrical pyxis (B 37), and the tiny goblet (B 43) held pigments. The two bronze spatulas (B 115) are connected with the use of these pigments. The small lekythos B 23 at the left was perfume vase.

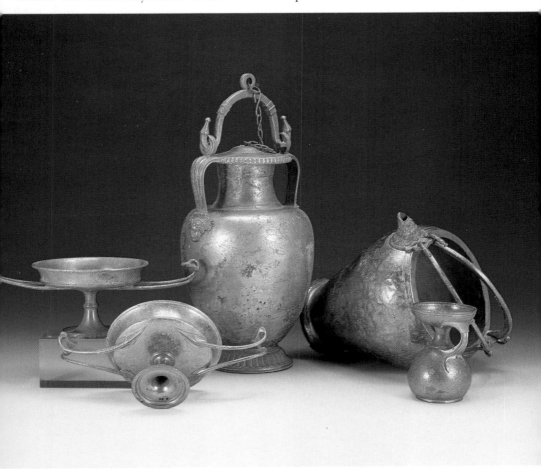

B30 B31 B22 B29 B23

B18

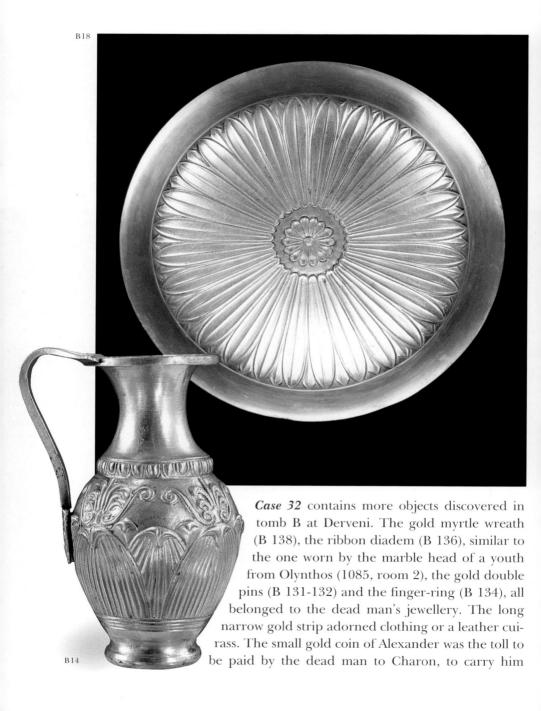

B14

Case 32 contains more objects discovered in tomb B at Derveni. The gold myrtle wreath (B 138), the ribbon diadem (B 136), similar to the one worn by the marble head of a youth from Olynthos (1085, room 2), the gold double pins (B 131-132) and the finger-ring (B 134), all belonged to the dead man's jewellery. The long narrow gold strip adorned clothing or a leather cuirass. The small gold coin of Alexander was the toll to be paid by the dead man to Charon, to carry him

B12 B5 B3

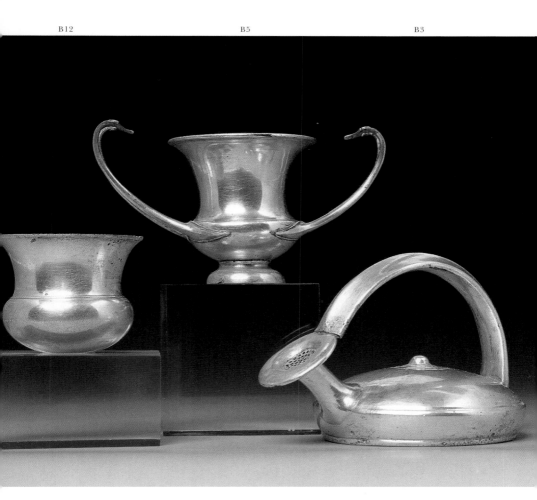

across Lake Acherousia to Hades. A rare find is displayed on a
separate pedestal: the transparent glass drinking cup (B 45).

The silver vases from tomb B are amongst the masterpieces
of ancient toreutics. The plain shallow plates B 15-17, the deep-
er plates with tongue-pattern decoration B 18-19, the two kan-
tharoi B 5-6, the two kalykes B12-13, the kalyx with relief dec-
oration B 11, the askos B 3 and the oinochoe B 14 with gilded
floral decoration, all reveal complete mastery of the secrets of
the art, the result of a long tradition.

Case 33 contains other finds from tomb B at Derveni. At

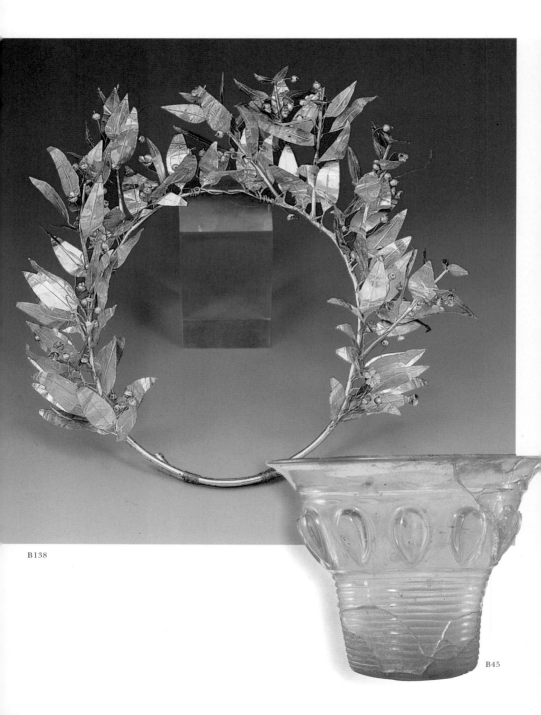

B138

B45

the right are four stone alabastra (B 62-64, B 77) and a black-glaze plate (B 48), with a small clay lamp at the front (B 52). Seven more bronze vases and vessels from the tomb: at the left a patera (B 36) with a handle ending in a ram's head, and a ladle (B 26), of the same shape as the silver ladle (case 34). In the centre is a deep bowl (B 25) and above it an oinochoe (B 33) with an exquisite handle in the form of a shoot, and a relief female head on the lower handle attachment. The unusual lagenos (flask) B 34 has two high-flung handles, and relief ram's

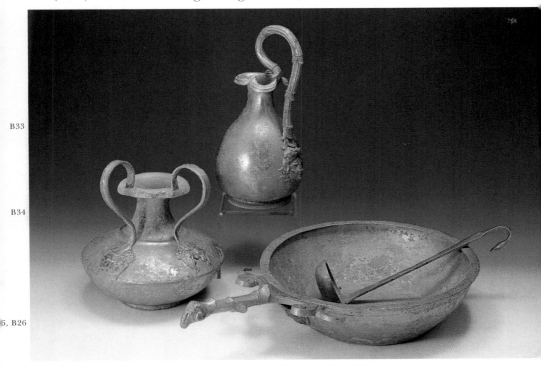

heads at the lower attachments. At the left is a situla with curving sides (B 28) and at the right a strainer (B 27).

The female head B 72 with necklace and earrings, and the head B 80, preserved in fragments, come from a silver mirror or vase. The six small gilded shields (B 87) are decorated with a relief sixteen-point star.

Case 34. The deep bowl (A 51), the situla (A 48), the jug

A49

(A 5), the clay bowl (A 40), the silver kylix (A 10) and the perfume vase (A 13) come from tomb A, all the other objects in this case are from tomb B. Of these, the silver ladle (B 2) and the small bowls (B 7-10) have an impressive austerity and purity of line. The two silver 'salt-cellars' (B 20-21) and the large bronze basin (B 39), which closely resembles the basin found in the main chamber of the tomb of Philip II (case 6), are also fine items. The list of finds from tomb B is completed by a bronze jug (B 41) and black-glaze plates.

Cases 35-37 contain the finds from tomb A, which had the second richest group of offerings in the cemetery at Derveni. Apart from the two silver vases in case 34 (A 10 and A 13), the vessels here were of bronze and clay.

Case 35 contains finds from tomb A at Derveni. The large

A2

A3

basin (A 52) has two swinging handles connected by strong attachments. The other bronze vases in this case are shapes known from the finds in tomb B: the situla A 49 with curving sides, A 42 with curving sides and a spout, the exceptionally fine oinochoe A 3 with a carinated body, the strainer A 14, the lekythos A 92, the pair of kylikes A 11-12, and the oinochoe A 7. The clay askos A 34 has fine linear decoration; the two 'salt-cellars' A 42-43 and the plate A 35 are black-glaze ware.

The ten small gilded shields A 19 are models of Macedonian shields. The curved surface has *repoussé* decoration: six of the small shields are decorated with the emblem of the sun with sixteen rays, and another ten are models of Macedonian shields in which

the central sun with eight rays is encircled by seven pairs of open circles with dots inside them. Two more small shields (A 20) are decorated with a relief scene of a Nereid carrying the weapons of Achilles and riding on a sea monster.

The large silver cut-out palmette A 18 has small holes by which it was attached probably to a wooden box or the leg of a couch. Two ivory female arms (A 24, A 99) blackened by fire, retain their polished skin and gilded bracelets in excellent condition.

Case 36 contains more objects found in tomb A at Derveni.

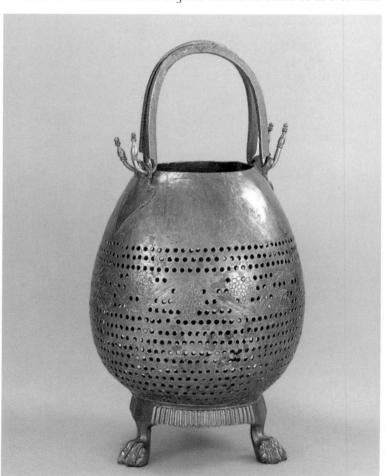

A4

A1

In the middle is a bronze lantern (A 4), with a tripod base with lion's feet and semi-circular swinging handles. It is decorated with an engraved vine shoot, and two thirds of the body are perforated. The quality of its workmanship is clearly inferior to that of the Vergina lantern. To the left of it is an unusual vase (A 9) with projecting handles, indicating that it was used to carry hot liquids. At the right is a jug with a globular body (A 6) and a familiar patera (A 8). Three glass Phoenician-type alabastra (A 44-46), two black-glaze small bowls (A 36, A 39), a fish-plate (A 37) and a bronze strigil (A 125) are on display in the centre.

Case 37. The bronze krater A 1 with volute handles, 0.595 m tall, was used in tomb A as a cinerary urn, like the unique krater in tomb B. The decoration of it focuses upon the cast handles with floral volutes and swan's necks at the lower handle attachments. This lends greater emphasis to the harmonious proportions and lines of the krater, which is perhaps much earlier than the other offerings in the tomb.

Case 38 contains finds from tomb Δ at Derveni. The gold myrtle wreath (Δ 1) differs from those found at Vergina and Stavroupolis in that the flowers are smaller and more closely set. There is a disc-shaped flower in the centre, above the forehead, from which spring delicate stamens ending in tiny flowers. The two bronze situlae (Δ 4, Δ 6) are of the familiar type with incurving sides;

a third situla (Δ 5), at the left, has a bull's head spout and a re-
lief female head on the handle attachment diametrically oppo-
site. The ladle (Δ 10), the strainer (Δ 11) and the two kantharoi
(Δ 8-9) are all types commonly found at the end of the 4th centu-
ry BC. The small black-glaze jug (Δ 22) is gilded. At the front is
displayed the iron sword from this tomb, a gold double pin
with case (Δ 3) and a gold coin of Alexander the Great. The
small black glaze bowl (Δ 23) contains a piece of cinnabar, a
reddish-coloured material with many uses in antiquity.

Case 39 contains objects found in tombs E and Z at Derveni.
The protome of Aphrodite or Persephone (E 26) was found in

Δ1

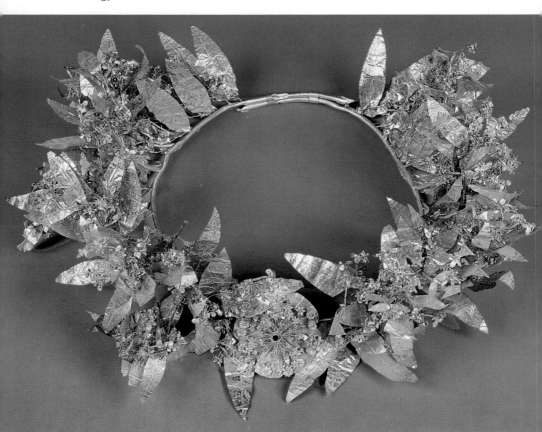

tomb E, along with fragments of the ivory decoration of a couch: delicate ivory plaques on which are preserved parts of the incised figures of Aphrodite, Eros and a man; rectangular, gilded bone plaques and relief decorative bands.

The other exhibits are from the rich female tomb Z. At the left, from top to bottom of the standing column, are displayed: a pair of exquisite gold earrings (Z 8), similar to ones found in a tomb in the Ukraine; two gold necklaces (Z 1-2). Z 1, with a braided band from which hang leaves, is in an excellent state of preservation and executed in an astonishingly difficult technique. Z 2 is composed of beads in the form of vases hanging

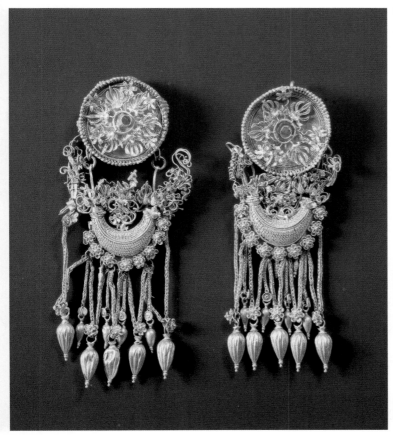

Z8

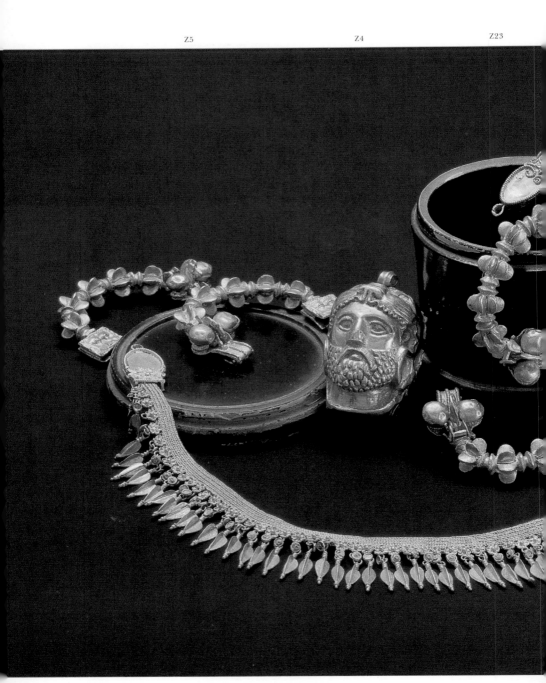

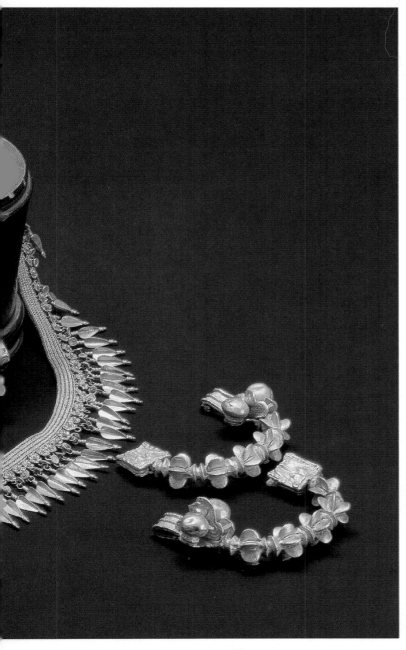

Z2

from tiny rosettes. The six bow fibulae (Z 5) are of the type common in the second half of the 4th century BC.

The translucent base in front of the column has a gold amulet (pendant) in the form of a head of Herakles (Z 4). The cult of Herakles was very widespread in Macedonia, for he was the 'Ancestral' god and founder of the Macedonian royal dynasty, which was descended from the Temenids of Argos, who were in turn descendants of Herakles.

At the left is a silver kalyx (Z 12) with a marvellous head of Silenus in the interior. The benevolent demon is crowned with an ivy branch. Some of the details are gilded for emphasis.

At the right, below the clay protome, are two gilded nipple-jars (Z 21 and Z 22) and a deep bronze bowl (Z 17).

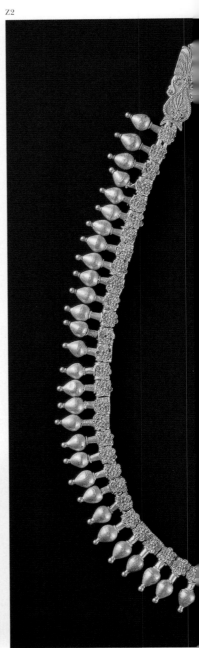

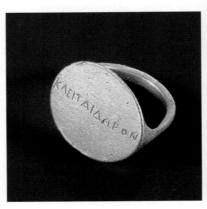

Z11

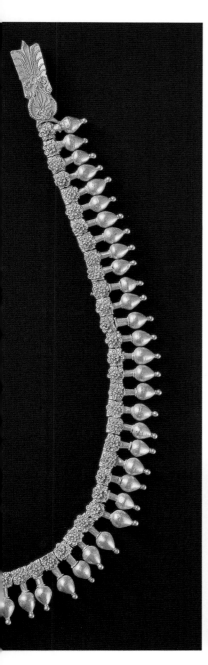

At the back, the bronze situla Z 15 is representative of a type common in the 4th century BC. In the centre are two elegant black-glaze Attic vases, the askos-perfume vase Z 20 and the cylindrical pyxis Z 23, and two small black-glaze bowls with impressed volutes.

At the front are the gold finger-rings of the dead woman. The pair Z 9-10 have semi-precious stones. Z 11 is solid gold and is incised with the inscription *Κλείτᾳ δῶρον* (a gift for Kleita). This was probably the name of the deceased in Tomb Z. The gold coin with the head of Athena is an issue of Alexander III, the Great, about 330 BC. It is a basic piece of evidence for the dating of the tomb to the middle of the second half of the 4th century BC.

On **Pedestal 40** stands a

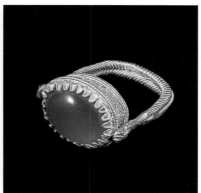

Z10

black-figure kalyx-krater (H 1) from tomb H. Its only decoration is a fine relief vine shoot half-way up. This manner of decorating black-glaze vases with applied clay or incised motifs was to become predominant in the Hellenistic period.

Case 41. In the funerary pyre of tomb A was found a burnt cylinder with the remains of a papyrus on it (A 122). In the fragments that have survived can be read a philosophical commentary in prose on an Orphic poem that was probably composed at the end of the 5th or the beginning of the 4th century BC. The papyrus was probably written in the middle of the third quarter of the 4th century BC; it is the earliest papyrus written in Greek to survive from antiquity, and is one of the most important finds from the Derveni cemetery.

Case 42. This case contains finds from tombs dating from the end of the 4th century BC, which were excavated in 1989 in building plots at the modern settlement of Lete in the 'county' of Thessalonike; all of them, like the tombs of Derveni, belong to cemeteries from the wider region of ancient Lete.

A122

The richest tomb contained a female burial with some fine gold jewellery. The diadem 17508 was found on the head of the dead woman. The main cylinder has antithetical spirals and five-petal flowers at the ends of small plaques fixed to it by means of gold wire. The point of attachment is covered by fronds of acanthus leaves. The centre of the diadem, above the dead woman's forehead, has a female head flanked by four acanthus leaves. The diadem is very similar to that from

tomb Γ at Sedes (case 23), with which it is contemporary. The two gold earrings ending in lion's heads (17511) were found attached to her ears, and the two gold rings 17509, 17510 were on her fingers. The fibula 17512 with a chain in place of the usual rigid bow is an original item. The bronze hemispherical vase at the far left end of the case (17682) was found in the same tomb.

Two pairs of exquisite earrings that come from Lete have no archaeological information associated with them. The pair 5160 have a bull's head suspended from a disc on which there is a flower with petals executed in filigree in three planes; the bucranium is flanked by two acorns. In the pair 5140, vase-shaped attachments hang from complex rosettes, and are flanked by a pair of smaller rosettes, also executed in the filigree technique.

The gold wreath 17242 with olive leaves was found in another tomb at Lete; it fastens at the back with a gold wire. This same tomb contained the black-glaze Attic plate 17235, the bronze pitcher 17244, the silver spoon 17240 and the drachma of Alexander the Great N 960.

5160

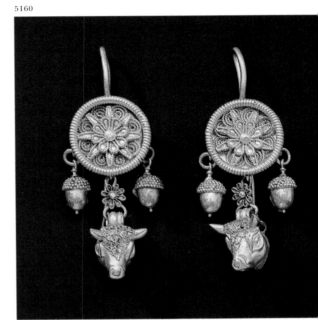

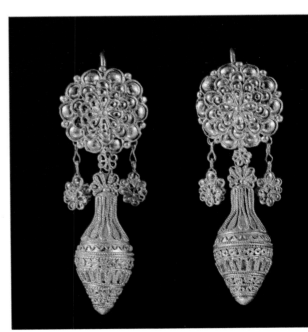

5140

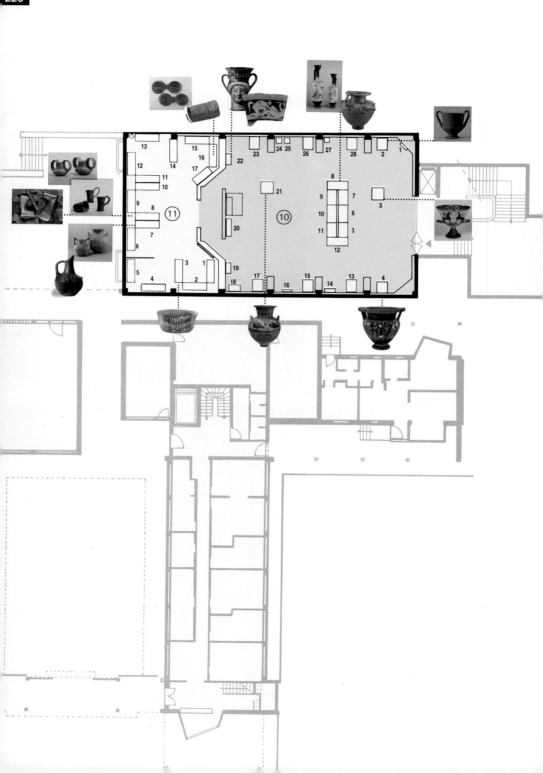

ROOM 10 Archaic and Early Classical Periods

(Temporary display)

The coasts of Pieria and Chalkidike were settled by several waves of migrants-colonists at the end of the 8th and in the seventh century BC, the period of the great movements of Greek populations known as the Second Greek Colonization. In several cases there are indications that the colonists infused new blood into earlier settlements dating from the First Greek Colonization, which took place at the end of the second millennium BC. The colonists came mainly from the two great rival cities of Euboea, Eretria and Chalkis, from which Chalkidike derives its name, though colonies were also planted by Andros and Corinth.

Intensive trade with Ionia and Aeolis in Asia Minor, Corinth, Euboea and Attica in the 7th and 6th centuries BC, together with the exploitation of the timber and rich mines of Chalkidike, led to a great economic flowering that is reflected in the finds from the 7th and 6th century cemeteries, and in the few well-built areas of cities that have so far been excavated.

The prosperity of the coasts directly affected the Macedonian towns of the hinterland that were the suppliers of the foods in which the colonists traded. The rich cemeteries of Sindos, Therme and Ayia Paraskevi attest to the wealth of the 6th and beginning of the 5th centuries BC.

The great economic flowering of the coastal cities, which is also clear from the large contributions paid by them to the Athenian Confederacy in the 5th century BC, continued with some fluctuations – due to the Peloponnesian and other wars – until the middle of the 4th century. The destruction of Olynthos (348 BC) and the rise to power of Philip meant the end of their independence, and the transfer of the economic centres to the cities founded and supported by the kings of Macedonia.

Cases 1-7. Five hundred tombs have been excavated at Ayia Paraskevi, near Thessalonike, dating from the 6th century and

Ayia Paraskevi.

Cemetery of
Ayia Paraskevi,
Thessalonike
(case 3).

partly contemporary with the tombs at
Sindos (room 8). Gold mouthpieces were
found here, too, though not the same
wealth of gold jewellery as at Sindos. In
contrast, the pottery has greater variety
and interest, with the local grey mono-
chrome pots coexisting with exceptional-
ly fine imports from Corinth and Attica. The exquisite poly-
chrome kalykes from Chios are rare masterpieces, painted with
charming floral designs on the interior and sphinxes and lions
on the outside, on an off-white slip (575-550 BC).

Case 1 contains gold mouthpieces, to cover the mouth of

the dead person. They are lozenge-shaped and have a hole at each end of the long axis, through which was passed a cord to tie them at the back of the head. Most of them are decorated with *repoussé* rosettes.

Case 2 contains grey bucchero vases from the tombs at Ayia Paraskevi. This is local pottery that begins in the 2nd millennium, during the Bronze Age, and was produced in local variations on the islands and coasts of the north-east Aegean.

Cemetery of Ayia Paraskevi, Thessalonike (case 4).

Case 3. During the 6th century BC, there were pottery workshops on the island of Chios, on the Ionian coast opposite, at Naucratis and in the Nile delta, that produced very fine-quality painted vases with distinctive shapes and decoration. The Chian high-footed, two-handled kalykes are typical of this pottery. Several Chian kalykes have been found at Ayia Paraskevi, five of which are displayed here. Pairs of sphinxes and lions and a group of dancers are depicted on the outside, on a white ground, and inside there are zones of coloured flowers and rosettes on a black ground.

Case 4 contains black-figure Attic vases of the 6th century BC. Amongst the most impressive of them are the amphora dec-

orated with the bust of a horse and the krater with a goat; the latter is one of a large group of similar kraters that were perhaps the product of workshops that were set up in Chalkidike.

Case 5. The black-figure krater with the panthers, the bronze 'Illyrian' helmet, the bronze bowl and the iron weapons – dagger, sword and spearheads – were found in the tomb of a warrior. The cylindrical clay pyxis at the left was probably made at Corinth.

Case 6. The 5th century Attic red-figure krater in the centre with a scene of a woman playing the lyre is surrounded by 6th century Attic black-figure vases, with an Ionian exaleiptron at the left and a Corinthian exaleiptron at the right.

Case 7. There is a large Corinthian kotyle in the centre and next to it an exaleiptron, a grave offering normally found in the tombs of this period (6th-beginning of the 5th centuries BC) throughout Macedonia. The bronze bracelets, bow fibulae and the two necklaces of shells and amber were found in a female burial.

Case 8. Rescue excavations have been conducted in recent years at Pydna in Pieria. The 5th century BC tombs attest to the wealth of the inhabitants, yielding fine gold and silver jewellery (the products of Macedonian metalworking) and choice vases, like the white lekythoi of bu-

Cemetery of Pydna, Pieria (case 8).

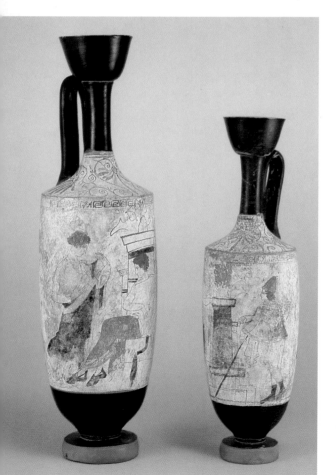

rial 51, dating from the second half of the
5th century. The colours have been pre-
served very vividly in the funerary motifs
painted on a white ground; in a work of
high quality art, the dead man is depicted
seated in front of his tomb, being visited
by his loved ones. The end of the 6th and
beginning of the 5th centuries BC are
represented by two bronze vases that re-

*Cemetery of
Pydna, Pieria.
(case 8).*

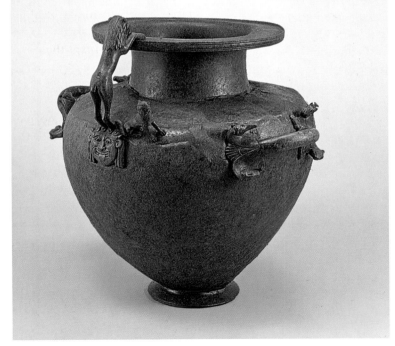

veal a direct relationship with the Greek colonies of South Italy
(Magna Graecia): a hydria with busts of horses on the horizon-
tal handles and a standing lion on a gorgoneion on the vertical
handle; and a basin with charming relief Sirens on the handle
attachments.

Cases 9, 10, 11. The adherence of the potters of Chalkidike to traditional motifs – which did not, however, inhibit them from adopting new ideas – is also illustrated by the funerary vases in the cemetery of Polychrono on the slopes of the Yiro-miri hill, on which are buried the remains of well-constructed houses belonging to another unidentified ancient city on the east coast of the Kassandra peninsula. The small vases displayed next to them accompanied young children who were placed inside amphoras. Although these are dated to the end of the Archaic period at the beginning of the 5th century, some of their decorative motifs, such as the concentric circles, have a history of six centuries, and the finds from Mende demonstrate that they are not revivals, but were in continuous use over this period. This ancient motif is surrounded, on one and the same vase, by floral designs that have come straight from Aeolis in Asia Minor, the source of a number of other innovations in the art of Chalkidike.

Cases 12-13. At the modern settlement of Therme, opposite Ayia Paraskevi, excavation continues of a densely occupied cemetery dating from the 6th and 5th centuries BC. Here too, the variety of the grave offerings points to the ease of communications and trade. At the beginning of the 5th century, Corinthian and Attic vases are found together with local kraters and cups with floral decoration from Chalkidike. Gold and silver jewellery is found along with bronze Macedonian pieces.

Case 12 contains grave offerings from tombs in the cemetery of Therme, dating from the 6th and 5th centuries BC. In the middle is an Attic kylix with two apotropaic eyes, and next to it a cup from a workshop in Chalkidike with linear and floral decoration. The few pieces of gold and silver jewellery belong to the same cultural unit as the other contemporary cemeteries of central and west Macedonia. The silver coin from Dikaia, a city probably to be located in north-west Chalkidike, is a rare find.

Case 13 contains finds from a tomb found at Therme in

1989. Next to the bronze helmet is a krater from Chalkidike decorated with a simple shoot of myrtle. An Ionian oinochoe, two Corinthian vases, a small iron knife, a gold mouthpiece and a finger-ring are all commonly found grave offerings at this period (500-480 BC). The silver coin of Alexander I (495-445 BC) found in the same tomb supports the dating of the grave offerings to the first quarter of the 5th century BC.

Case 14. The finds displayed from another sector of the cemetery at Sindos, dated to the second half of the 5th century BC, are scanty and rather poor when compared with the wealth of the 6th century: two clay protomes, Attic lekythoi, a glass amphoriskos, small items of silver jewellery etc. This contrast poses questions that will be of concern to historians of Macedonia.

Cases 15-16. The female tomb from Epanomi also contains a variety of jewellery, and the Late Mycenaean tombs of Nea Michaniona (ancient Aeneia) contained both jewellery and some interesting black-figure vases with scenes from mythology.

Case 17. The Corinthian vases in this case come from two burial pithoi found at Sane. The two small vases at the front right, an aryballos and an olpe, date from the middle of the 7th century BC. All the others were found in a pithos, which was the last resting place of someone who died in the middle of the 6th century BC.

Cases 18-19. The first clear evidence as to what was happening in Chalkidike at the end of the 8th and beginning of the 7th centuries was furnished by the recent excavations. At Sane, on the west coast of Pallini, the large-scale importing of clay vases from Eretria and northern Ionia began at the end of the 8th century BC, reaching a climax in the second half of the 7th century. No other site in Chalkidike has yielded a wealth and quality of Ionian pottery to compare with that of Sane. It therefore appears highly probable that there was a sanctuary in operation from as early as the 7th century, the outdoor cult area of which has been located in the marina of the Sane Hotel. The excavation of the marina has shown that nocturnal fire-lit sacrifices were held here in honour of Artemis: the clay figurines of the goddess, and an inscription incised on a sherd of a kylix

support this view. A large number of lamps were found, some of them candelabra, which were required for the nocturnal festivals. Items offered to the goddess, in addition to the figurines, included children's toys, bone dice, tiny models of vases, animal figurines, and a large variety of Corinthian, Ionian, Chian and Attic vases, on the basis of which the acme of the sanctuary is dated to the period from the end of the 7th to the middle of the 5th century BC.

Cases 20-21. Excavations at the Eretrian colony of Mende are taking place in two areas; the city and the cemetery. Trial investigations have been conducted at various points, making it clear that this large city spread over a fortified plateau, at the edge of which – modern Vigla – rose a small acropolis, and also over the seaward slopes of the hill, the ancient 'suburb' mentioned by Thucydides. A stratigraphic section at a point of the suburb near the coast has revealed successive levels of occupation, 5 m deep, the lowest and earliest of which are dated to the 10th century BC – the Protogeometric period – and the latest to the middle of the 4th century BC. At the end of the 7th century there was a major destruction by fire, and several burnt Corinthian, Eretrian, Cycladic and local pots come from the destruction level.

A small area of the cemetery has been excavated, with burials of the 7th and 6th centuries BC, and a few from the 5th. As in other coastal cities of Chalkidike, the dead, who were mainly children and infants, had been placed in pithoi and amphorae of various sizes which were then buried in the sandy shore. Most of the funerary vases were painted, or had incised decoration, which was the custom in Eretria, the colonists' mother city. The blend of the charm of Cycladic decoration, the Euboean tradition, and the influence of ubiquitous Corinth, with the Chalkidian faithfulness to age-old motifs produced some original, fresh works of art, like the amphora with a frieze of running animals and the small pithos with a row of aquatic birds. The few objects found inside them, mainly 7th century Corinthian aryballoi, helped to date the pithoi.

*Akanthos
(case 22).*

Case 20. On the bottom of the case are displayed vases found in the suburb of Mende, in a level associated with destruction by fire at the end of the 7th century BC. Higher up is a selection of grave offerings found inside burial pithoi: aryballoi and small vases of the 7th and 6th centuries, a clay figurine of an enthroned goddess and a cut-out *repoussé* sphinx.

The sand-box next to case 20 contains five funerary vases from the coastal cemetery of Mende. Infants and small children were buried in these vases. The unpainted amphora with incised decoration follows the Euboean tradition, and the two vases with concentric circles and semi-circles remain true to the traditional decoration of Macedonia.

Case 21. The monumental funerary vase 12724 from Mende has decoration that combines elements and influences from a variety of Greek workshops in an impressive composition, full of movement and charm.

Cases 22-23. More than 8,000 tombs, dating from the 6th century to the Roman period, have been excavated at the enormous cemetery of ancient Akanthos, on the coast near Ierissos.

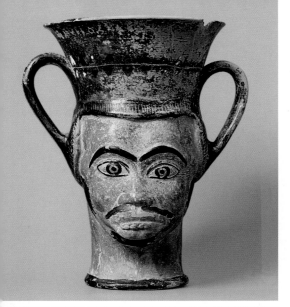

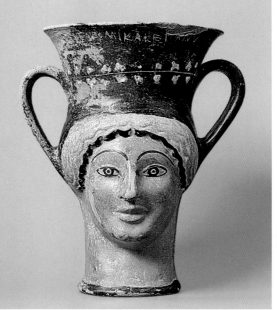

Cemetery of Akanthos (case 22).

Ionian influence is not so apparent at Akanthos, a colony of Andros. The presence of Athenian pottery is much more pronounced, and includes some superb examples of black- and red-figure vases, such as the two-faced kantharos with the head of a negro and a girl, and the witty inscription Τίμυλλος καλὃς hὃς τό[δε τ]ὸ πρόσὃπον. Ἐρὃνασσα εἰμὶ καλὲ̃ πάνυ (I am Timyllos, as handsome as this face. I am Eronassa, very beautiful).

The gold medallion – perhaps a coin – with the emblems of Akanthos, a lion tearing at a bull and a square incuse, is a unique find. It bears the inscription Ἄλεξις (Alexis), which is probably the signature of the artist who engraved it at the beginning of the 5th century BC.

Pedestals 24-25. The two vases from Pyrgadikia, dating from the middle of the 5th century BC, which are covered with palmettes, volutes and other floral elements, with the heads of young women amongst them, are also part of this current of influences from northern Ionia and Aeolis.

Case 26. At Torone, the strong colony of Chalkis, which was an ally of the Athenians in the 5th century BC, the excavations of the Archaeological Service and the Australian Archaeological Institute have revealed sections of the defence walls and houses of the city, as well as an important Protogeometric cemetery. A bronze Attic hydria with a relief bust of a Siren on the vertical handle comes from a tomb dating from the middle of the 5th century BC.

Pedestal 27. Two large vases from Chalkidike. It is not known where the dinos on the pedestal was found: it dates from the Early Archaic period. The large amphora next to it comes from the cemetery of Olynthos (c. 500 BC).

Case 28. The cemetery on the coast at Ai-Yanni Nikitis conveys us to a slightly earlier period, and to a place closed to foreign influences. The majority of the tombs belong to the 7th century BC, and are poor in grave offerings, which are restricted to local pottery of prehistoric type. Communication with Ionia is clearly attested in the later 5th century tombs.

Pyrgadikia (pedestal 25).

ROOM 11 Prehistoric Collection

(Temporary Display)

Toumba
of Thessalonike.

Three important excavations in the last decade, at the pre-historic tumuli (hills formed by the accumulated remains of mud-brick houses) at Kastanas, Assiros and Toumba in Thessalonike, have awoken interest in the investigation of prehistoric Macedonia. With one or two exceptions, including the

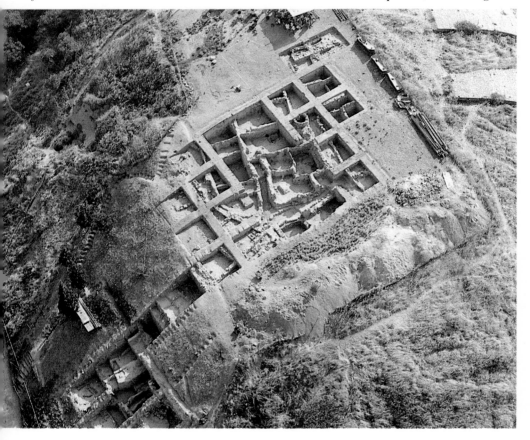

publication of the tumulus cemetery at Vergina by Professor Manolis Andronikos, this investigation had not advanced since the pre-war researches of the English scholar W. Heurtley, published in his book *Prehistoric Macedonia* (1939), which is still a basic reference work.

Room 11 is devoted to a series of finds from central and eastern Macedonia. The Middle Neolithic period (4400-3200 BC) is represented by bichrome vases from Servia, near Kozani, and by a selection of sherds from the huge Neolithic settlement Γ at Vasilika. These two settlements continued to be occupied in the Later Neolithic period (3200-2500 BC), and a number of other settlements were added to them, including

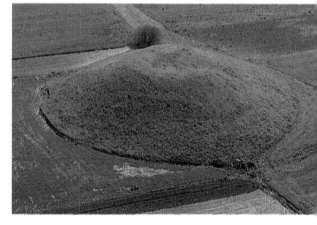

Toumba of Ayia Paraskevi, Thessalonike.

that on the south hill at Olynthos, from which we have several stone and clay figurines.

The Early Bronze Age (2500-2000 BC) is represented by finds from Mesimeri near Thessalonike, Axiochori and Kalindria in central Macedonia, and Armenochori near Florina, with its characteristic one-handled cups. The wheelmade grey 'Minyan' pottery from Ayios Mamas and Molyvopyrgos in Chalkidike is assigned to the transitional period between the Early and Middle Bronze Age; this ware was produced on the coasts and seldom travelled inland.

The hoard of bronze axes from Petralona in Chalkidike is of great interest for the study of early metal-working.

The Bronze Age and Early Iron Age finds from Assiros and Kastanas come from settlement complexes and have shed light on many areas of everyday life in the settlements of central Macedonia. The penetration of Mycenaean civilization was strong, to the degree that local imitations of Mycenaean vases were produced.

The discovery at Assiros of large numbers of storage

rooms in which large quantities of grains could be gathered has furnished evidence for the study of the social organization of the community.

Two major categories of pottery were predominant in the Middle and Late Bronze Age (2000-1100 BC): monochrome burnished ware and incised ware with the incisions filled with paint (some fine examples are displayed in the Assiros cases); at the same time, or perhaps a little earlier, when Mycenaean pottery began to be imported, matt-painted ware made its appearance, in which the predominant decorative motifs are the hatched triangle and the small spiral. Typical examples of this ware were found at Kalindria and in the recent excavations of Assiros and Kastanas.

The categories of pottery found in the Bronze Age continued into the Early Iron Age (1100-700 BC), though with a gradual decline in technique. Western Macedonia played an important role in the production of matt-painted pottery (Boubousti, Aiane, Ayios Panteleimon), which is directly linked to the north-west Greek tribes – the Macedonians, Epirots and Thessalians –, while the coasts (N. Anchialos, Karambournaki), Pieria and Emathia were open to the influences of the new Geometric style of the South. The tumulus cemetery at Vergina was a meeting ground for old and new cultural currents. Metalwork in bronze and iron flourished throughout Macedonia. Bronze jewellery (spectacle and bow fibulae, spiral bracelets, long pins) and iron swords, spearheads, and knives abound in the tombs. At the end of the Early Iron Age cast Macedonian bronze pendants made their appearance, in the form of birds, vases and large beads (Tsaousitsa etc.).

The simple decorative motifs of the Early Iron Age, consisting of concentric circles and wavy lines, together with the bronze pendants and the monochrome burnished pottery and grey vases, were to survive, alongside the new messages channelled through the colonies on the coasts, until the end of the Archaic period, which coincided with the end of the Persian Wars.

The case on the wall at the beginning of this display contains

sherds (broken pieces of pots) representative of the various cat-
egories of prehistoric pottery from Macedonia.

Case 1. The plain of Vasilika – ancient Anthemous – to the
south-east of Thessalonike attracted a sizeable population from
the Neolithic period onwards. One of the earliest tumuli is
formed by a low hill some 75 acres in area at an intersection of
the road to Peristera-Livadi. A trial trench excavated by D.
Grammenos has yielded examples of many pottery categories
of the Middle Neolithic period, some stone axes and a roughly
worked stone figurine.

Case 2. Before the Second World War, G. Mylonas under-
took the first systematic excavation of a Macedonian Neolithic
settlement at the south end of the South Hill of Olynthos.
Though it covered only a small area, it produced a large num-
ber of vases, some stone and clay figurines, and loomweights.
For many decades these finds were the basis for the study of the
Neolithic period in central Macedonia.

Case 3. The Middle and Late Neolithic periods are repre-
sented by the lustrous monochrome and bichrome vases from
Servia near Kozani (west Macedonia). Contact between Mace-
donia and the major centres in Thessaly is clear both from the
decoration and the shapes of these tasteful functional objects.

Cases 4-5 contain finds from the Kastanas Tumulus, to the
west of the settlement of the same name on the Axios river; the
river has caused part of the hill to collapse. In the prehistoric pe-
riod the tumulus was an island in the mouth of the Axios. It is
14 m high and is formed from the successive ruins of houses.
Twenty-eight settlement phases have been distinsguished, cov-
ering over two thousand years of unbroken occupation from the
end of the 3rd millennium to Roman times. The houses usually
have an apse at one end, or are rectangular, were built of brick
with a roof made of branches supported on dressed tree-trunks,
and consisted of one to three rooms. There is evidence for large-
scale fires at the end of the Bronze Age. Life went on, but there
was a change in the design of the settlement: houses with large
numbers of small rooms were flanked by small straight streets.
The pottery tradition of the Bronze Age continued, along with

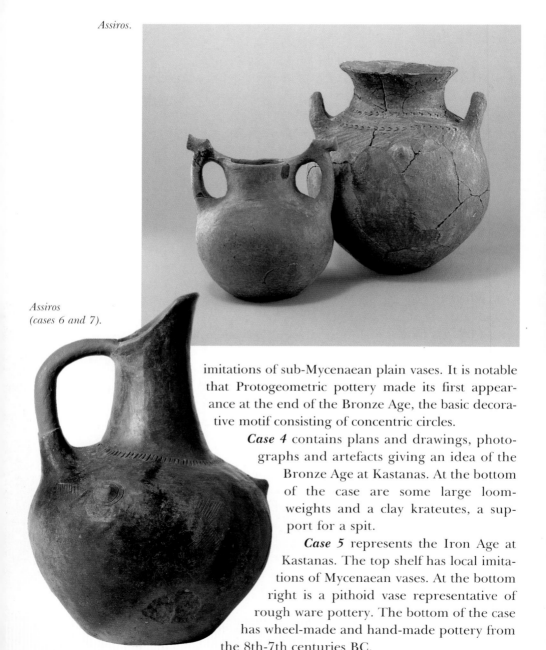

Assiros.

*Assiros
(cases 6 and 7).*

imitations of sub-Mycenaean plain vases. It is notable that Protogeometric pottery made its first appearance at the end of the Bronze Age, the basic decorative motif consisting of concentric circles.

Case 4 contains plans and drawings, photographs and artefacts giving an idea of the Bronze Age at Kastanas. At the bottom of the case are some large loomweights and a clay krateutes, a support for a spit.

Case 5 represents the Iron Age at Kastanas. The top shelf has local imitations of Mycenaean vases. At the bottom right is a pithoid vase representative of rough ware pottery. The bottom of the case has wheel-made and hand-made pottery from the 8th-7th centuries BC.

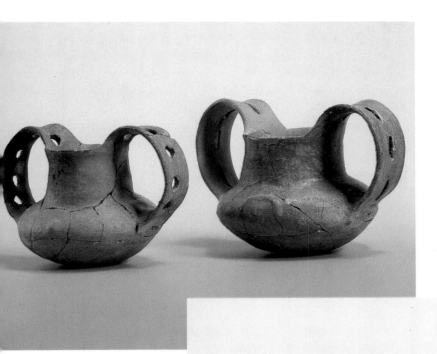

*Armenochori
near Florina,
and Mesimeri
near Thessalonike
(case 8).*

Cases 6-7. Assiros
Tumulus (2000-800 BC)
is 25 kilometres north
of Thessalonike, and
some distance from the
river Axios and the easy
communications provid-
ed by the sea. Because
of these circumstances,
life continued from one
millennium to the next
at Assiros without any
fundamental changes.
For centuries, every time
the houses were rebuilt,
the walls followed the
lines of those of the pre-

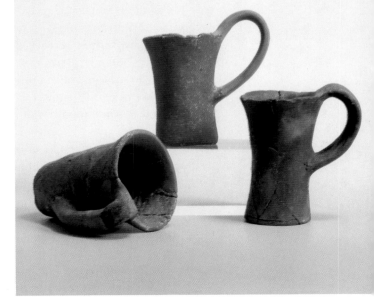

vious phase. The settlement was traversed by narrow, parallel streets, and encircled by earth deposits designed to prevent landslips. By the late phase of the Early Iron Age, the tumulus had reached a height of 14 m. The inhabitable area, which was now the summit of a cone, had become significantly reduced, and the settlement had to be abandoned.

One of the most important finds during the excavation of Assiros consisted of the large storage rooms for grain and pulses: baskets, pithoi and storage pits were found in large rooms. The contents of these storage spaces and the way in which they were organized furnishes valuable information about the social structure and life of the settlement at Assiros.

Case 6 contains examples of Bronze Age pottery, set against a background of photographs of the houses in which it was discovered. At the bottom of the case are examples of bricks from the masonry, and a stone mortar and pestle for grinding grain.

Case 7 represents the Early Iron Age at Assiros. Mainly monochrome pottery, clay spindlewhorls and loom-weights, bone tools, stone moulds for bronze tools and jewellery.

Case 8 contains Early Bronze Age pottery from Armenochori near Florina, Perivolaki near Langadas and Mesimeri near Thessalonike. The broad strap handles on the cups and kantharoi are a characteristic feature. The hoard of bronze axes from the countryside near Petralona in Chalkidike is a rare find for the north of Greece. There are no other archaeological indications in the place in which it was discovered, and it was presumably buried at some moment of crisis by its owner, who did not survive to dig it up.

At the bottom of the case are tools and small finds from Kritsanas and Molyvopyrgos in Chalkidike.

Case 9 contains finds from the Early Bronze Age. The necklace made of animal's teeth, and the vases with incised decoration and added white material in the incisions were found on the tumulus at Ayios Mamas, near Olynthos in Chalkidike. Three groups of vases come from Kalindria in the county of Kilkis and the huge tumulus at Axiochori in Kilkis. The vases in the centre are from the Gona tumulus near Thessalonike airport.

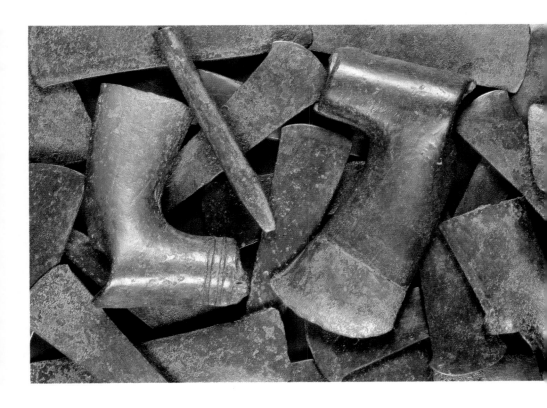

Case 10 contains Middle Bronze Age (c. 2000-1600 BC) pottery, mainly from Molyvopyrgos in Chalkidike, a small, low tumulus near ancient Mekyberna, the port of Olynthos. The dark grey pottery with horizontal grooves is characteristic of this period.

Case 11 contains Late Bronze Age pottery from Kalindria in the county of Kilkis and Perivolaki near Langadas. Kalindria is represented by characteristic examples of brown matt-painted pottery, which is first found in the 15th-14th centuries BC before Mycenaean wares began to be imported. It is clearly of local origin, with the production centres being distributed from the Pindus mountains to Chalkidike.

Case 12 contains matt-painted and incised Late Bronze Age pottery from west Macedonia (Boubousti), the site of Tsaousit-

Petralona,
Chalkidike
(case 8).

sa near Pondoiraklia in Kilkis, Ayios Mamas in Chalkidike and Sedes near Thessalonike. At the bottom of the case are potsherds and tools from the same period.

Case 13 contains Early Iron Age pottery from Ayios Panteleimon on the east shore of the lake of the same name in west Macedonia. The predominant shapes are beak-spouted jugs and closed nippled vases. At the bottom of the case are wheelmade vases decorated with concentric semi-circles, from graves at Kountouriotissa in the county of Pieria.

Case 14 contains pottery dating from the end of the Early Iron Age, from Tsaousitsa near Pondoiraklia and Axiochori in the county of Kilkis. The vases are predominantly small and wheel-made.

Case 15 contains finds from the tumulus on a plateau at Nea Anchialos – with the exception of the large fragment of a krater at the bottom right, which was found at Karambournaki near Thessalonike.

The tumulus of Nea Anchialos is now inside an army camp on the borders of the settlement of Sindos. It is the site of an ancient city mentioned by the ancient authors – either Chalastra or Sindos – to which belonged the rich cemetery at Sindos (room 8).

The Early Iron Age pottery reveals that the settlement on the Nea Anchialos tumulus flourished at this period, too, and had direct contacts with Attica and Euboea.

Case 16. There was a great flourishing of metal-working in Macedonia during the Early Iron Age. This is attested by the wealth of bronze jewellery designed to adorn the hair, clothing and hands, and of bronze pendants (top right) in the shapes of vases, birds etc. Iron-working was also very advanced: great experience was required to forge the long iron swords. The objects in case 16 come from Axiochori in the county of Kilkis and the tumulus cemetery at Vergina.

Case 17 contains the grave offerings from tomb AH-II at Vergina. The triple bronze axe, the only one found in the cemetery, is perhaps evidence for some special function performed by the dead woman, relating to religion.

Ayios Mamas, Chalkidike (case 9).

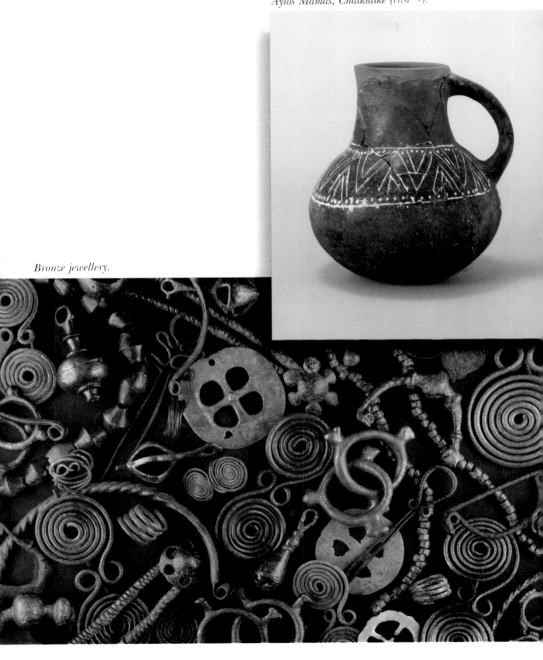

Bronze jewellery.

BIBLIOGRAPHY

ABBREVIATIONS

AA	Archäologischer Anzeiger
AΔ	Αρχαιολογικόν Δελτίον
AE	Αρχαιολογική Εφημερίς
AEMΘ	Το Αρχαιολογικό Έργο στη Μακεδονία και Θράκη
AJA	American Journal of Archaeology
AntK	Antike Kunst
ArchCl	Archeologia Classica
BCH	Bulletin de Correspondance Hellénique
BSA	The Annual of the British School at Athens
GRBS	Greek, Roman and Byzantine Studies
IG	Inscriptiones Graecae
JdI	Jahrbuch des Deutschen Archäologischen Instituts
JHS	The Journal of Hellenic Studies
MeditArch	Mediterranean Archaeology
MonPiot	Monuments et Mémoires. Fondation E. Piot
ΠΑΕ	Πρακτικά της εν Αθήναις Αρχαιολογικής Εταιρείας
PAS	Prähistorische Archäologie in Südosteuropa
SNG	Sylloge Nummorum Graecorum

PERIODICALS AND FESTSCHRIFTS

Αμητός, Festschrift for Prof. Manolis Andronikos, I-II, 1987.
Αρχαία Μακεδονία I 1968 (1970) - V 1989 (1993).
ΑΕΜΘ 1 (1987) ff.
Εγνατία 1 (1989) ff.
Μακεδονικά 1 (1940) ff.
Μελετήματα 1 (1985)-18 (1994).
Μνήμη Δ. Λαζαρίδη, Πόλις και χώρα στην αρχαία Μακεδονία και
 Θράκη, 1990.

EXHIBITION CATALOGUES

Αρχαία Μακεδονία – Ancient Macedonia, Catalogue of the Exhibition Organized in Australia, 1988.

Greek Civilization. Macedonia. Kingdom of Alexander the Great, Catalogue of the Exhibition in Montreal, Canada, 1993.

Η Μακεδονία από τα μυκηναϊκά χρόνια ως τον Μέγα Αλέξανδρο, Catalogue of the Exhibition in Bologna, 1988.

GENERAL BIBLIOGRAPHY

K. BURASELIS, Das hellenistische Makedonien und die Ägäis, 1982.

A. R. BURN, Alexander the Great and the Hellenistic Empire, 1962.

M. ΔΗΜΙΤΣΑΣ, Ἀρχαία γεωγραφία τῆς Μακεδονίας, I-II, 1870, 1874.

M. ΔΗΜΙΤΣΑΣ, Ἡ Μακεδονία ἐν λίθοις φθεγγομένοις καί μνημείοις σωζομένοις, 1896.

J. G. DROYSEN, Geschichte des Hellenismus, I-III, 1877-1878².

R. M. ERRINGTON, Geschichte Makedoniens, 1986.

N. G. L. HAMMOND, A History of Macedonia: I. Historical Geography and Prehistory, 1972; II. 550-336 BC, 1979; III. 336-167 BC, 1988 (N. G. L. Hammond - F. W. Walbank).

N. G. L. HAMMOND, The Macedonian State, 1989.

N. G. L. HAMMOND, The Miracle that Was Macedonia, 1991.

L. HEUZEY - H. DAUMET, Mission archéologique de Macédoine, 1876.

J. N. KALLÉRIS, Les anciens Macédoniens, I-II, 1954, 1976.

A. ΛΟΥΚΟΠΟΥΛΟΥ - M. ΧΑΤΖΟΠΟΥΛΟΣ (ed.), Φίλιππος βασιλεύς των Μακεδόνων, 1980.

Macedonia, 4,000 Years of Greek History and Civilization (ed. M. Sakellariou), 1983.

F. PAPAZOGLOU, Les villes de Macédoine à l'époque romaine, BCH, Supplément 16 (1988).

Θ. ΡΙΖΑΚΗΣ - I. ΤΟΥΡΑΤΣΟΓΛΟΥ, Επιγραφές Άνω Μακεδονίας, 1985.

A. H. STRUCK, Makedonische Fahrten, 1907-1908.

W. W. TARN, Alexander the Great, I-II, 1948.

PREHISTORIC PERIOD

Σ. ΑΝΔΡΕΟΥ - Κ. ΚΩΤΣΑΚΗΣ, Διαστάσεις του χώρου στην Κεντρική Μακεδονία, Αμητός, I, 1987, 57-88.

Σ. ΑΝΔΡΕΟΥ - Κ. ΚΩΤΣΑΚΗΣ - Γ. ΧΟΥΡΜΟΥΖΙΑΔΗΣ, Ανασκαφή Τούμπας (Θεσσαλονίκη), Εγνατία 2 (1990), 381-404; 3 (1991-92), 175-198.

M. ΑΝΔΡΟΝΙΚΟΣ, Βεργίνα I, Τό νεκροταφεῖο τῶν τύμβων, 1969.

I. ASLANIS, Kastanas - Die frühbronzezeitlichen Funde und Befunde, PAS 4, 1985.

J. BOUZEK, Graeco-Macedonian Bronzes, 1974.

Δ. ΓΡΑΜΜΕΝΟΣ, Νεολιθικές έρευνες στήν Κεντρική καί Ἀνατολική Μακεδονία, 1991.

Δ. ΓΡΑΜΜΕΝΟΣ - Μ. ΠΑΠΠΑ et al., Ἀνασκαφή νεολιθικοῦ οἰκισμοῦ Θέρμης, Μακεδονικά 27 (1989-90), 223-288; 28 (1991-92), 381-501.

B. HÄNSEL, Kastanas - Die Grabung und der Baubefund, PAS 7, 1989.

W. A. HEURTLEY, Prehistoric Macedonia, 1939.

A. HOCHSTETTER, Kastanas - Die handgemachte Keramik, PAS 3, 1984.

L. REY, Observations sur les premiers habitats de la Macédoine, BCH 41-43 (1917-1919).

J. VOKOTOPOULOU, La Macédoine de la protohistoire à l'époque archaïque, 24o Convegno di Studi sulla Magna Grecia, 1985, 133-166.

K. A. WARDLE, Excavations at Assiros Toumba, 1975-1979, BSA 75 (1980), 229-267.

ARCHAIC AND CLASSICAL PERIODS

J. ALEXANDER, Potidaea, 1963.

M. ΑΝΔΡΟΝΙΚΟΣ, Ἡ ζωγραφική στήν ἀρχαία Μακεδονία, AE 1987, 363-382.

I. ΒΟΚΟΤΟΠΟΥΛΟΥ, Οι ταφικοί τύμβοι της Αίνειας, 1990.

I. ΒΟΚΟΤΟΠΟΥΛΟΥ, Η επιγραφή των Καλινδοίων, Αρχαία Μακεδονία, IV (1986), 87-114.

I. ΒΟΚΟΤΟΠΟΥΛΟΥ, Αρχαϊκό ιερό στη Σάνη Χαλκιδικής, Αρχαία Μακεδονία, V 1 (1993), 179-236.

A. CAMBITOGLOU - J. PAPADOPOULOS, Excavations at Torone, MeditArch 1 (1988), 180-217 (with earlier bibliography); 3 (1990), 93-142; 4 (1991), 147-171.

E. ΓΙΟΥΡΗ, Τό ἐν Ἀφύτει ἱερόν τοῦ Διονύσου καί τό ἱερόν τοῦ Ἄμμωνος Διός, Neue Forschungen in griechischen Heiligtümern, 1976, 135-150.

E. ΓΙΟΥΡΗ, Ὁ κρατήρας τοῦ Δερβενίου, 1978.

Δ. ΖΑΓΚΛΗΣ, Χαλκιδική, Ἱστορία-Γεωγραφία, 1956.

A. ΚΑΜΠΙΤΟΓΛΟΥ, Ἀνασκαφές Τορώνης, ΠΑΕ 1988, 108-118.

ΣΤ. ΚΑΨΩΜΕΝΟΣ, Ὁ ὀρφικός πάπυρος τῆς Θεσσαλονίκης, ΑΔ 19 (1964), Μελέται, 17-25 [S. Kapsomenos, The Orphic Papyrus Roll of Thessaloniki, The Bulletin of the American Society of Papyrologists 21 (1964), 3 ff.].

N. X. ΚΟΤΖΙΑΣ, Ὁ παρά τό ἀεροδρόμιον τῆς Θεσσαλονίκης (Σέδες) Γ΄ τάφος, AE 1937, III, 866-895.

G. E. MYLONAS, Excavations at Mecyberna, 1934, 1938, AJA 47 (1943), 78-87.

Γ. ΟΙΚΟΝΟΜΟΣ, Μίνδη-Μένδη, ἡ πατρίς τοῦ Παιωνίου, AE 1924, 27-40.

I. ΠΑΠΑΓΓΕΛΟΣ, Τοπογραφικές παρατηρήσεις στα αρχαία Στάγειρα, Χρονικά τῆς Χαλκιδικῆς 35 (1979), 135-158.

D. M. ROBINSON, Excavations at Olynthus, I-XIV, 1929-1952.

ΑΙΚ. ΡΩΜΙΟΠΟΥΛΟΥ, Αττικός αμφιπρόσωπος κάνθαρος από τάφο της αρχαίας Ακάνθου, Αμητός, II, 1987, 723-728.

Κ. ΡΩΜΙΟΠΟΥΛΟΥ, Κλειστά ταφικά σύνολα ύστεροκλασικῶν χρόνων ἀπό τή Θεσσαλονίκη, Φίλια Ἔπη, Festshrift G. E. Mylonas III, 1989, 194-218.

Κ. ΣΙΣΜΑΝΙΔΗΣ, Το αρχαϊκό νεκροταφείο της Αγίας Παρασκευής Θεσσαλονίκης, Αμητός, II, 1987, 787-803.

Κ. ΣΙΣΜΑΝΙΔΗΣ, Ανασκαφές στα αρχαία Στάγειρα, AEMΘ 4 (1990), 375-378; 5 (1991), 320-333; 6 (1992), 451-465.

Ε. ΤΡΑΚΟΣΟΠΟΥΛΟΥ-ΣΑΛΑΚΙΔΟΥ, Αρχαία Άκανθος: πόλη και νεκροταφείο, AEMΘ 1 (1987), 295-304.

Μ. ΤΣΙΜΠΙΔΟΥ-ΑΥΛΩΝΙΤΗ, Τάφοι κλασικών χρόνων στην Επανωμή, AEMΘ 3 (1989), 319-329.

M. ZAHRNT, Olynth und die Chalkidier, 1971.

SCULPTURE

M. ANDRONICOS, Deux stèles funéraires grecques de Vergina, BCH 79 (1955), 87-101.

M. ANDRONICOS, Portrait de l'ère républicaine au Musée de Thessalonique, MonPiot 51 (1960), 37-52.

M. ANDRONICOS, Stèle funéraire de Cassandra, BCH 86 (1962), 261-267.

M. ANDRONICOS, Thessalonike Museum, 1981.

Μ. ΑΝΔΡΟΝΙΚΟΣ, Ἡ Ἀφροδίτη τῆς Θεσσαλονίκης, AE 1985, 1-32.

G. BAKALAKIS, Vorlage und Interpretation von römischen Kunstdenkmälern in Thessaloniki, AA 1973, 671-684.

Γ. ΔΕΣΠΙΝΗΣ, Τό ἀντίγραφο τῆς Ἀθηνᾶς Medici τοῦ Μουσείου Θεσσαλονίκης, Αρχαία Μακεδονία II (1977), 95-102.

ΑΙΚ. ΔΕΣΠΟΙΝΗ, Η στήλη από το Ωραιόκαστρο Θεσσαλονίκης, Congress "Archaische und klassische griechische Plastik", II, 1986, 45-50.

ΑΙΚ. ΔΕΣΠΟΙΝΗ, Πεσσός με ανάγλυφη παράσταση στο Μουσείο Θεσσαλονίκης, Αμητός, I, 1987, 293-300.

ΑΙΚ. ΚΩΣΤΟΓΛΟΥ-ΔΕΣΠΟΙΝΗ, Προβλήματα της παριανής πλαστικής του 5ου αι. π.Χ., 1979.

D. PANDERMALIS, Ein Bildnis des Severus Alexander in Thessaloniki, AA 1972, 128-145.

A. RÜSCH, Das kaiserzeitliche Porträt in Makedonien, JdI 84 (1969), 59-196.

ΘΕΟΔ. ΣΤΕΦΑΝΙΔΟΥ-ΤΙΒΕΡΙΟΥ, Στήλη λυρωδοῦ ἀπό τήν Ποτείδαια, AE 1980, 43-53.

ΘΕΟΔ. ΣΤΕΦΑΝΙΔΟΥ-ΤΙΒΕΡΙΟΥ, Τραπεζοφόρα του Μουσείου Θεσσαλονίκης, 1985.

THESSALONIKE

G. BAKALAKIS, Therme-Thessaloniki, AntK 1. Beiheft (1963), 30-34.

Γ. ΒΕΛΕΝΗΣ - Π. ΑΔΑΜ-ΒΕΛΕΝΗ, Ρωμαϊκό θέατρο στη Θεσσαλονίκη, ΑΕΜΘ 3 (1989), 241-256.

Γ. ΒΕΛΕΝΗΣ, Τα τείχη της Θεσσαλονίκης από τον Κάσσανδρο ως τον Ηράκλειο, I, 1989.

ΣΤ. ΔΡΟΥΓΟΥ, Τά πήλινα κτερίσματα τοῦ μακεδονικοῦ τάφου στήν πλατεία Συντριβανίου Θεσσαλονίκης, ΑΕ 1988, 71-93.

CH. EDSON, IG X, II 1, 1972.

«Θεσσαλονίκην Φιλίππου βασίλισσαν». Μελέτες για την αρχαία Θεσσαλονίκη, 1985 (reprints of the more important studies on Thessalonike).

Θεσσαλονίκη, Από τα προϊστορικά μέχρι τα χριστιανικά χρόνια, Exhibition catalogue, 1986.

L. GUERRINI, Las incantadas di Salonicco, ArchCl XIII (1961), 40-70.

Γ. ΚΝΙΘΑΚΗΣ, Το Οκτάγωνο της Θεσσαλονίκης, ΑΔ 30 (1975), Μελέται, 90-119.

H. P. LAUBSCHER, Der Reliefschmuck des Galeriusbogens in Thessaloniki, 1975.

CH. MAKARONAS, The Arch of Galerius at Thessaloniki, 1970.

ΧΑΡ. ΜΠΑΚΙΡΤΖΗΣ, Περί τοῦ συγκροτήματος τῆς Ἀγορᾶς τῆς Θεσσαλονίκης, Αρχαία Μακεδονία II (1977), 257-269.

ΣΤ. ΠΕΛΕΚΙΔΗΣ, Ἀπό τήν πολιτεία καί τήν κοινωνία τῆς ἀρχαίας Θεσσαλονίκης, 1954.

L. REY, La nécropole de Mikra-Karaburun près de Salonique, Albania 2 (1927), 48-57; 3 (1928), 60-66; 4 (1932), 67-76.

Κ. Α. ΡΩΜΑΙΟΣ, Ἀνασκαφή στό Καραμπουρνάκι τῆς Θεσσαλονίκης, Ἐπιτύμβιον Χρήστου Τσούντα, 1941, 358-387.

Κ. ΣΙΣΜΑΝΙΔΗΣ, Μακεδονικοί τάφοι στην πόλη της Θεσσαλονίκης, Η Θεσσαλονίκη 1 (1985), 35-70.

Μ. ΤΣΙΜΠΙΔΟΥ-ΑΥΛΩΝΙΤΗ, Ένας νέος μακεδονικός τάφος στη Θεσσαλονίκη, Μακεδονικά 25 (1985-86), 117-141.

G. VELENIS, Architektonische Probleme des Galeriusbogens in Thessaloniki, AA 1979, 249-263.

M. VICKERS, Towards Reconstruction of the Town Planning of Roman Thessaloniki, Αρχαία Μακεδονία I (1970), 239-251.

M. VICKERS, Hellenistic Thessaloniki, JHS 92 (1972), 156-170.

MACEDONIAN TOMBS

B. GOSSEL, Makedonische Kammergräber, 1980.

ST. MILLER, The Tomb of Lyson and Kallikles, 1993.

Δ. ΠΑΝΤΕΡΜΑΛΗΣ, Ο νέος μακεδονικός τάφος της Βεργίνας, Μακεδονικά 12 (1972), 147-182.

Φ. ΠΕΤΣΑΣ, Ὁ τάφος τῶν Λευκαδίων, 1966.

ΑΙΚ. ΡΩΜΙΟΠΟΥΛΟΥ - Ι. ΤΟΥΡΑΤΣΟΓΛΟΥ, Ὁ μακεδονικός τάφος τῆς Νιά-ουστας, ΑΕ 1971, 146-164.

Κ. ΣΙΣΜΑΝΙΔΗΣ, Ἀνασκαφή ταφικοῦ τύμβου στήν Ἁγία Παρασκευή Θεσσαλονίκης, Ἕνας νέος μακεδονικός τάφος, ΑΕ 1986, 60-98.

Κ. ΣΙΣΜΑΝΙΔΗΣ, Κλίνες και κλινοειδείς κατασκευές μακεδονικών τάφων, 1990.

Μ. ΤΣΙΜΠΙΔΟΥ-ΑΥΛΩΝΙΤΗ, Ανασκαφικές έρευνες σε ταφικούς τύμβους των Νομών Θεσσαλονίκης και Χαλκιδικής, ΑΕΜΘ 1 (1987), 261-268.

SINDOS

ΑΙΚ. ΔΕΣΠΟΙΝΗ et al., Σίνδος, Exhibition catalogue, 1985.

ΑΙΚ. ΔΕΣΠΟΙΝΗ, Χρυσά σκουλαρίκια Σίνδου, Αρχαία Μακεδονία IV (1986), 159-169.

Μ. ΤΙΒΕΡΙΟΣ, Εγχώρια κεραμική του 6ου και 5ου αι. π.Χ. από τη Σίνδο, ΑΕΜΘ 2 (1988), 297-306.

VERGINA

Μ. ΑΝΔΡΟΝΙΚΟΣ, Βεργίνα Ι, Τό νεκροταφεῖο τῶν τύμβων, 1969.

Μ. ΑΝΔΡΟΝΙΚΟΣ, Βεργίνα ΙΙ, Ὁ «τάφος τῆς Περσεφόνης», 1994.

Μ. ΑΝΔΡΟΝΙΚΟΣ - Χ. ΜΑΚΑΡΟΝΑΣ - Ν. ΜΟΥΤΣΟΠΟΥΛΟΣ - Γ. ΜΠΑΚΑΛΑΚΗΣ, Τό ἀνάκτορον τῆς Βεργίνας, 1961.

Μ. ANDRONICOS, Vergina, The Royal Tombs and the Ancient City, 1984.

ST. DROUGOU, et al., Βεργίνα, Η Μεγάλη Τούμπα, Αρχαιολογικός Οδη-γός – Vergina, The Great Tumulus, Archaeological Guide, 1994.

Ν. G. L. HAMMOND, 'Philip's Tomb' in Historical Context, GRBS 19 (1978), 331-350.

Δ. ΠΑΝΤΕΡΜΑΛΗΣ, Η κεράμωση του ανακτόρου της Βεργίνας, Αμητός, ΙΙ, 1987, 579-605.

Κ. ΡΩΜΑΙΟΣ, Ὁ μακεδονικός τάφος τῆς Βεργίνας, 1951.

ΧΡ. ΣΑΑΤΣΟΓΛΟΥ-ΠΑΛΙΑΔΕΛΗ, Τα επιτάφια μνημεία από την Μεγάλη Τούμπα της Βεργίνας, 1984.

ΑΕΜΘ 1 (1987) ff. (reports on Vergina excavations).

ANCIENT MACEDONIAN NUMISMATICS

Η. GAEBLER, Die antiken Münzen Nord-Griechenlands, III: Makedonia und Paionia, I-II, 1906, 1935.

G. LE RIDER, Le monnayage d'argent et d'or de Philippe II, 1977.

M. PRICE, Coins of the Macedonians, 1974.

SNG V, Ashmolean Museum, Oxford, III: Macedonia, 1976.

Ι. TOURATSOGLOU, Die Münzstätte von Thessaloniki in der römischen Kaiserzeit, 1988.

ACKNOWLEDGMENTS

This book owes much to the excellence of those who have cooperated in its production – especially to the translator Dr. David Hardy – and also to the artistic taste of Makis Skiadaresis and Sokratis Mavrommatis, who photographed the ensembles of objects, under the artistic supervision of Moses Kapon. Our warm thanks for providing photographs go to Professor Yorgos Despinis and Professor Theodosia Stefanidou-Tiberiou (Aristotle University of Thessalonike), and Mr. Yorgos Liondos (ICOM-Hellenic National Committee).

J. V.

TRANSLATION
Dr. David Hardy

DESIGN
Rachel Misdrachi-Kapon

ARTISTIC ADVISOR
Moses Kapon

PHOTOGRAPHS
Makis Skiadaresis, Sokratis Mavrommatis
Archaeological Museum of Thessalonike
Aristotle University of Thessalonike
ICOM-Hellenic National Committee
Archaeological Receipts Fund

COLOUR SEPARATIONS
Michailidis Bros.

STRIPPING
Andonis Boubalikis

PRINTING
Thanasis Petroulakis

BINDING
I. Iosifidis - V. Eftaxiadis